KU-516-488

The authors would like to thank Renee Last and Brian Morris at AVA, Alan McFaden for his product photography and all those who contributed images to this book.

For my mum and my brother Phil.
Also for Sharron and the boys
Nigel

For my big brother Stuart, for the years
of tireless help and support: thanks mate
Steve

AN ILLUSTRATED

A to Z
OF
DIGITAL PHOTOGRAPHY
PEOPLE AND PORTRAITS

WITHDRAWN

844280

An AVA Book
Published by AVA Publishing SA
Rue des Fontenailles 16
Case Postale
1000 Lausanne 6
Switzerland
Tel: +41 786 005 109
Email: enquiries@avabooks.ch

Distributed by Thames & Hudson (ex-North America)
181a High Holborn
London WC1V 7QX
United Kingdom
Tel: +44 20 7845 5000
Fax: +44 20 7845 5055
Email: sales@thameshudson.co.uk
www.thamesandhudson.com

Distributed by Sterling Publishing Co., Inc.
in the USA
387 Park Avenue South
New York, NY 10016-8810
Tel: +1 212 532 7160
Fax: +1 212 213 2495
www.sterlingpub.com

in Canada
Sterling Publishing
c/o Canadian Manda Group
One Atlantic Avenue, Suite 105
Toronto, Ontario M6K 3E7

English Language Support Office
AVA Publishing (UK) Ltd.
Tel: +44 1903 204 455
Email: enquiries@avabooks.co.uk

Copyright © AVA Publishing SA 2006

All rights reserved. No part of this publication may be reproduced, stored in a retrieval system or
transmitted in any form or by any means, electronic, mechanical, photocopying, recording or otherwise,
without permission of the copyright holder.

ISBN 2-88479-087-X and 978-2-88479-087-1

10 9 8 7 6 5 4 3 2 1

Design by Steve Crabb

Production and separations by AVA Book Production Pte. Ltd., Singapore
Tel: +65 6334 8173
Fax: +65 6259 9830
Email: production@avabooks.com.sg

A036831

WIGAN & LEIGH COLLEGE
LEARNING RESOURCES

LOCATION: CSF

COLLECTION:

CLASS MARK: 775 ATH

BARCODE No. 844280

DATE: 4/7/08

£9.95

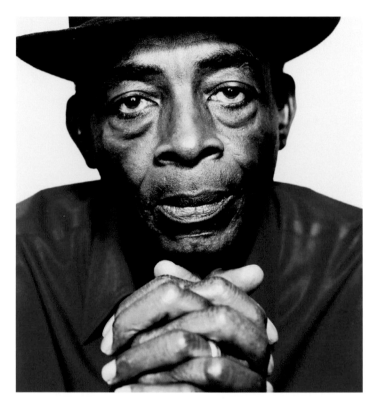

AN ILLUSTRATED

A to Z

OF
DIGITAL PHOTOGRAPHY
PEOPLE AND PORTRAITS

Nigel Atherton & Steve Crabb

AN ILLUSTRATED

A to Z
OF
DIGITAL PHOTOGRAPHY
PEOPLE AND PORTRAITS

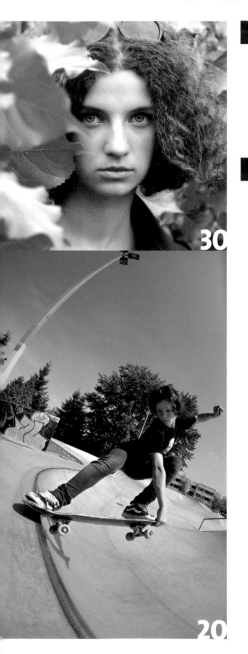

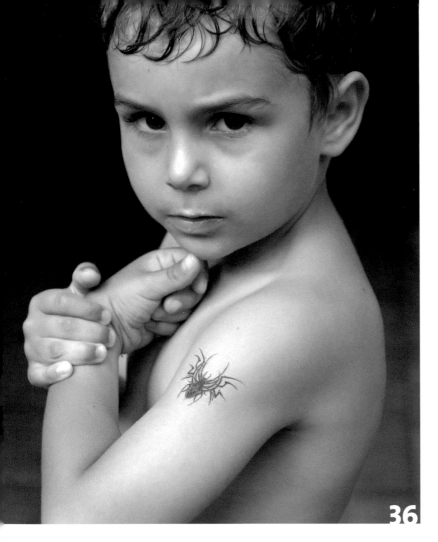

36

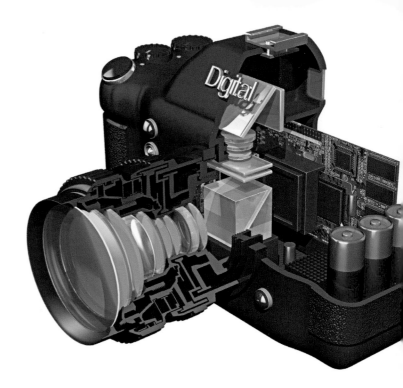

156

A **brief** introduction

Of the billions of photographs taken around the world every year, the biggest portion of them are of people. We photograph our families and loved ones, we photograph our friends, we photograph our work colleagues at the office party.

Our world is filled too with pictures of other people. In our magazines and newspapers, on billboards and posters, there are pictures of celebrities, models, politicians and ordinary people just like ourselves.

Digital technology makes portrait photography easier than ever, because we can see immediately whether or not the subject is smiling, grimacing or blinking. Our subjects can see too, so they can work with you to achieve a better result. But on the flip side of the coin the tools of the trade – digital cameras, computers, software, printers – are complex and offer numerous opportunities for the novice to mess things up.

That's where this book comes in. Hot on the heels of our previous book, *The A to Z of Digital Photography*, this one focuses purely on portrait photography, enabling us to cover the essential equipment and techniques in much more detail.

It's still laid out as an A to Z for easy navigation, so you can go straight to the topic you're interested in, or you can start at the beginning and work your way through.

We hope you enjoy this book and learn a few new things along the way which will help you to produce your best-ever portraits.

Nigel Atherton Steve Crabb

the images

The photographs and diagrams have been carefully chosen to both illustrate the points made in the text and provide inspiration to try the techniques for yourself.

the checklist

Found on all the subject-based pages, the checklist provides a brief summary of the main points covered in the text.

152 AN ILLUSTRATED AtoZ OF DIGITAL PHOTOGRAPHY travel

Above and left: Two contrasting portraits taken in Morocco. An unposed grab shot (left) and posed portrait (above).

Travel

If you're off on your travels, don't forget to capture interesting portraits of the locals as well as the views and architecture

CHECKLIST
- Choose locations other than typical landmarks.
- Try to use the subject to tell a story.
- Visit local markets and meeting places.
- Seek out small details.
- Pack spare memory cards.
- Ask permission from the locals first.
- Invest in good-quality camera bags.

PLACES ARE ABOUT PEOPLE TOO

Few genres are as rich in subject matter as other people's countries, but don't focus solely on the famous views – remember that a country is as much about its people as its landmarks, so make sure you dedicate plenty of attention to the human element in your travel portfolio.

Of course one man's travel destination is another's doorstep, but as tourists we're often more able to see potential pictures in things that locals may have long since failed to notice. It could be a particular style of dress, a type of job that doesn't really exist back home (tea-picking, for example) or perhaps just a different way of doing familiar things (for example, the floating markets of Bangkok).

In any event, adding people to your shots often makes them more interesting.

INTERACT WITH YOUR SUBJECTS

There are several ways to shoot travel portraits. The least confrontational is to fit a long zoom and stick to candids. A few shots like this are fine and you can capture some natural expressions. But too many will make your travel portfolio look voyeuristic and emotionally disengaged.

Getting up close can be intimidating for some photographers, but photographing people without their consent is a contentious issue. Some people don't mind being photographed, others dislike it, and a third group sees it as a source of income and expect to be paid. Try engaging your subject in a few moments of chat before reaching for the camera. If he or she seems hostile, move on – there are lots of other people out there who may not mind so much.

Some photographers object to paying for photos on principle, but it's usually only a few pence and for poor people this can mean a lot.

On the other hand, the resulting photos are often poor, as your subject, once paid, often stares blankly at you or strikes a well-rehearsed pose. Just take a shot, move on – and mark it down as an occupational hazard.

Keep it varied

These three pictures were all taken at Masai villages in Kenya, but are all very different. There's a traditional portrait (above), a close-range wide-angle shot (top right) which shows something of the subject's environment, and an atmospheric night shot (right), shot at ISO 1600 with fill-in flash.

PEOPLE AND PORTRAITS 153

Left: Shooting on a 10mm wide-angle lens has both emphasised the girl and shown more of her village.

Below: This very low-light shot was achieved by the use of a high ISO of 1600 and balanced fill-flash, which has retained the atmosphere created by the ambient illumination.

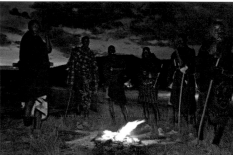

GADGET BAG

Choose a camera bag that you can carry on your flight as hand luggage – never check your cameras in the hold. Pack plenty of spare media cards and batteries. Take a tripod, even if only a pocket one, so you can get sunsets and night shots of spectacular views. If you have a lot of kit, pack a smaller day bag so you can leave some of the heavy stuff at your hotel. And don't flash your gear around, but keep it discreetly in your bag or under a jacket when not in use.

TOP *TIPS!*

1 TAKE A SPARE
Pack spare cards and batteries and take your gear on as hand luggage.

2 DIFFERENT APPROACH
Try to find new and original approaches to familiar icons.

3 TELL A STORY
Work to tell a story of the place, in pictures, convey its spirit and culture.

4 DETAILS
Look for small details as well as general views.

5 PEOPLE
Photograph the people, if they don't mind, but desist if they object.

Right: The Che Guevara beard and beret, the Cuban cigar – this street portrait could only have been taken in Havana, Cuba.

Get the most
from this book

This book represents an alphabetical journey through the world of portrait and people photography, covering both the shooting and the post-production techniques and processes.

Each topic is illustrated with real-life examples, and we have provided a simple summary or set of tips for each subject for quick reference. Here is a brief explanation of how the pages are laid out.

the text

Each topic is divided into columns, each of which explores one aspect of the subject under discussion.

top tips

Many pages contain a useful tip or nugget of advice on an aspect of the particular topic covered on that page.

before image

This is the original image before any corrections or enhancements have been made to it.

after image

This is the finished image after all the tutorial steps have been completed.

step image

This displays the state the image should be at during that step and any dialogue box that you need to use.

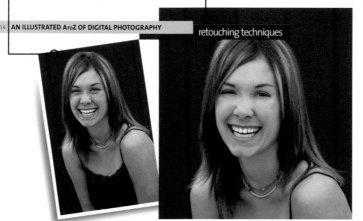

Retouching Techniques

Even the most glamorous of models are usually retouched before they hit the printed page. Learn how it's done and how you can do it too

Left: The portrait of the young girl could benefit from some light retouching around the eyes and removing freckles.

Above: The retouched portrait gives the girl a little lift, making her look fresher and brighter.

WHAT DOES IT ALL MEAN?
Retouching is an age-old skill that has been around almost as long as photography itself. In the time before computers, retouching was carried out by trained artists using special inks and paintbrushes.

Early Hollywood employed many artists to retouch their stars' publicity shots by hand. It was not uncommon for an actor or actress to have their spots painted over or their sagging chin airbrushed out. But in those days the shots were black and white and were easier to disguise than colour versions.

The term 'airbrush' has continued to stay with us even today with the use of the 'airbrush' mode in Photoshop. The mode allows us to spray virtual paint over your image using applied pressure on the mouse. But the sophistication of today's modern editing software means that the airbrush is not the only tool used in image-retouching.

TOOLS OF THE TRADE
There are many ways to retouch an image in Photoshop. Most of them are brush-based so the edges are soft and can easily be blended into the original image, making the art of retouching easier.

CLONE TOOL
One of the most popular retouching tools is the Clone tool. Found in Photoshop's toolbox, it works by copying a section of the image and then applying the copied pixels over the desired area. This is great when you have simple changes to do such as removing spots on a face. You can easily change to just about any brush shape or size, allowing for maximum effect. Opacity and flow settings can also be manually adjusted for greater control.

PATCH TOOL
This tool allows you to draw a marquee selection around an area that you wish to duplicate and then drag it over to the area that you wish alter. Alternatively, you can also do the opposite and draw a selection around the area you wish to alter and drag it to an area you wish it to sample from.

The pixels are then blended together to make a seamless join. This tool is really designed for areas of flat colour that has little details, such as sky, sea, etc.

HEALING BRUSH
The Healing brush works in similar way to the Clone tool, selecting a sampled area and then applying it over the desired area. Only this tool blends the tone, texture, shading and transparency with the underlying characteristics. Again, this blends like the Patch tool and is perfect for areas of flat colour.

USING THE CLONE TOOL

STEP ONE
Select the Clone tool from the tool bar. Click on the arrow next to the Brush Shapes button to view a selection of preset brushes which can be selected to suit the detail of work you want to do. Select a small-sized, soft-edged brush ideal for this kind of work. You can adjust the size of it using the size control on the tool palette.

STEP TWO
Zoom in on the object you want to delete. Carefully select an area that has the same shade and alt-click (option-click on the Mac) on it to set the pick-up area (area no. 1), then click on the area to cover over (area no. 2). Use lots of short clicks rather than one long stroke, since this is easier to delete if you make a mistake.

STEP THREE
The pick-up point follows the brush at the same distance and angle as the first stroke, so try to avoid accidentally picking up other objects in the picture, particularly the edge of the frame. Change your pick-up point regularly to disguise your work, but take care to match both colour and texture.

USING THE HEALING BRUSH

STEP ONE
Select the Healing brush from the tool bar. Click on the brushes palette up in the menu bar and select the options.

Use the sliders to adjust the size of the brush, along with the softness and spacing. Choose a suitable-sized brush with the softest edge, to help with blending.

Try not to choose a brush bigger than the area you wish to retouch, as it will become difficult to control.

STEP TWO
In a similar way to the Clone tool above, select an area that you would like to clone from. Alt-click (option-click) on the clean area and then click and drag over the area you wish to remove. In this example, I wanted to remove the eye bags, so I selected an area on the cheek that was clean and similar in colour and tone.

Dragging over the area in one sweep to begin with gives you an idea if your cloned area was the best place to pick. If it doesn't work, then hit Undo and try another area to sample from.

STEP THREE
The Healing brush will blend the colour and tone of the sampled area over the new area. This does not always work first time and may need a little experimenting first to get the most suitable area.

When you have finished, you may have to tweak the area further with the Dodge tool to lighten the area if it still seems a little dark.

Select the Dodge tool and set the options to mid-tones. Bring the strength right down to about 20 per cent. Dab around the chosen area to lighten the pixels.

intro text

As with all chapters in this book, you will be guided through the subject first with an introduction on what the tutorial is and why you should use it.

step text

Easy-to-use instructions on how to perform the required task. The step text will guide you to locating the relevant dialogue boxes and commands.

other tutorials in this book

There are various tutorials and step-by-steps throughout this book, but not all of them will follow the above design. You will also find there are quick fixes, useful tips and method explanations included.

But where possible, all the steps are designed in a similar easy-to-follow layout with an accompanying image or illustration.

mode dial

Some cameras place their mode selector on a rotating dial. This may be on a ring around the shutter release or on its own, as shown here. On simple cameras this may only be a choice of camera, movie and playback mode, while on more advanced cameras you may also have a choice of manual and automatic exposure modes, plus a selection of subject-based programs such as sport and landscape.

flash

Provides extra illumination when light levels drop too low for good results. Most cameras provide a choice of flash modes, in addition to the auto setting. These include red-eye reduction (which usually involves firing a pre-flash to close the pupils), flash on (fires the flash every time you take a picture – ideal for 'fill-in' flash shots in bright light) and flash off (for use in museums and places where flash isn't allowed). Most cameras also have a 'slow sync' mode which combines flash with a slow shutter speed for action photography or to record some of the ambient atmosphere in a low-lit interior.

The power of a flash is expressed as a guide number in metres, usually at ISO 100. The higher the number, the more powerful the flash. Some more advanced cameras also feature a hot shoe for the addition of a more powerful external flashgun.

shutter release

Press this button to take a picture. The shutter release usually has a two-stage action. Pressing the button halfway activates the autofocusing and metering, pressing all the way takes a picture. Holding the button at the halfway stage locks the focus and exposure so that when the decisive moment arrives a final push will take the shot instantaneously.

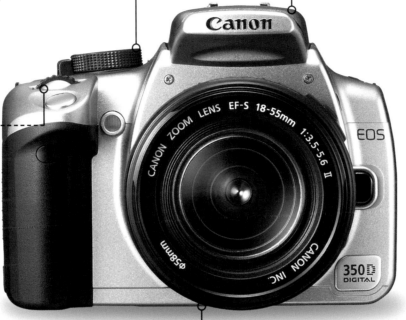

lenses and zoom

Lens focal lengths are usually described by their zoom magnification range (for example: 2x, 3x) and by their 35mm equivalent focal length (for example: 35–70mm). The actual focal lengths are different and relate to the physical dimensions of the sensor, which vary in size between the different cameras.

Most digital cameras offer an optical zoom range of at least 3x (in other words, the most telephoto position is three times the magnification of its most wide-angle position). These lenses will typically be in the 35–105mm (equivalent) range. Longer zoom ranges of up to 10x are, however, widely available and may be more suitable if you like to photograph wildlife, or take candid shots from a distance. In addition, most cameras offer a digital zoom which magnifies the central portion of the shot. These lower the image quality so aren't recommended for regular use.

Digital Cameras
learn the basics

Digital cameras can seem intimidating and unfamiliar at first, but they're simple really. Here's a quick guide to what's what

slots and ports

Most digital cameras provide a variety of terminals. The USB port enables the camera to be connected to a PC for downloading of images, using the supplied USB lead. The Video Out lets you connect the camera to a TV, where you can view a slideshow. There is often a DC port for mains power connection and invariably a slot for whatever media cards the camera uses (in this case xD PictureCard).

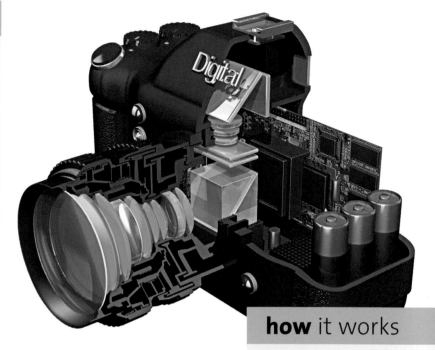

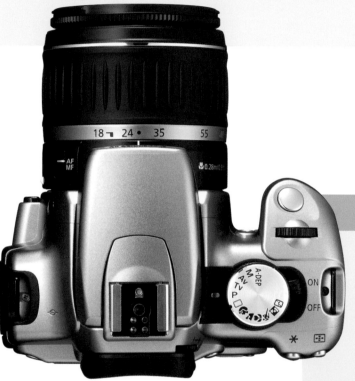

controls and buttons

Virtually all digital cameras feature a four-way rocker/controller, or toggle. This is the heart of the camera's interface, allowing the user to navigate through the menu options displayed on the LCD screen and, in camera mode, often doubling as flash, zoom, macro and other functions. On some cameras this controller is actually four separate buttons in a circle, placed north, south, east and west.

how it works

The viewfinder provides direct viewing of the subject and an alternative to using the LCD monitor. Not all cameras have a viewfinder, but they do offer advantages: although you can also compose using the LCD, these are sometimes difficult to see in bright sunlight. They also consume more battery power. As the viewfinder is to one side of the lens its view isn't quite the same as what the camera will record, and you usually get quite a bit more in your picture than you saw through the viewfinder to compensate. Some cameras have an electronic viewfinder, or EVF (like a camcorder), which overcomes this problem. EVFs do show the actual image you're recording, and offer more visual shooting data, but being made up of pixels (like a tiny TV) they're not usually as clear and detailed as a traditional optical viewfinder. Like LCD screens, they also consume more power.

LCD monitor

Invariably found on the back of the camera, LCD monitors come in various sizes, from about 1½ to 3 inches across (diagonally) and are sometimes hinged, allowing them to tilt and/or turn for easier viewing.

The monitor has three major functions: to display the menu options, to allow the user to view the subject as it will be recorded by the camera and to review images already taken. Many users compose their pictures using the monitor in preference to the viewfinder as you do see (more or less) exactly what you're going to get. Some monitors feature non-reflective glass and brightness controls so they can be viewed more easily in bright sunlight.

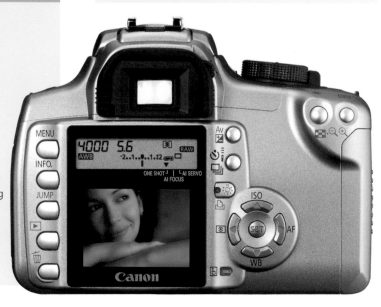

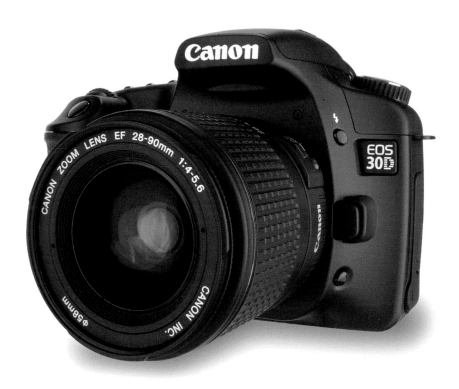

THE RANGE OF FEATURES

The best choice for image quality and versatility, digital SLRs can be expanded and customised for any type of subject, with dozens of specialised lenses, flashguns and other accessories available. They're also faster and more responsive than other types of camera, thanks to more powerful processing capabilities, larger optics and other factors.

Digital SLRs use an optical viewfinder, using a system of mirrors in the pentaprism to offer an accurate real-life view of the subject to be taken. The advantage is a large, bright, clear viewing of the scene to be captured.

The disadvantage is that some information such as menus or histograms, can't be displayed in the viewfinder (although a series of LEDs and projections do show essential shooting information and AF points), and the reflex mirror and mechanical shutter prevent video recording, as well as (in most cases) the ability to preview and compose photographs on the LCD screen.

Digital SLRs

You may be graduating from a digital compact or switching from a film SLR. Either way, there has never been a better time to buy a digital SLR.

The chief advantage for most people is the amount of control offered by a DSLR. As well as manual controls and the opportunity to use a vast range of lenses, the digital functions of a DSLR include the ability to choose between sRGB and Adobe RGB colour spaces, shoot in 16-bit RAW for maximum quality, as well as much more control of tone, colour and White Balance. In fact you can pretty much set the camera up to exactly the way that you want it.

Digital SLRs have many other advantages too, including a greater array of things like shutter speeds, and because of the larger sensors, noise, dynamic range and sensitivity is also much improved. In fact all the SLRs here can shoot up to ISO 1600. Because SLRs are system cameras, this means accessories are more readily available.

With so many to choose from, and seemingly little differences, what should you look for? It may be that simple brand loyalty may keep you locked into a system. For example, if you already have a range of Nikon lenses, then Nikon would be an obvious choice. In fact, the best results are to be had from newer lenses designed specifically for digital sensors, so this could be a good chance to switch. Of course, if you've used previous cameras from a certain brand, you may be more comfortable continuing with that brand, as many of the functions from film cameras have been transferred to digital.

Superzooms

Why do you need a superzoom? Well, they offer an all-in-one solution with exceptionally long telephoto lenses, so you don't need to carry lenses and accessories around. Second, many of the cameras are remarkably compact, and can easily fit into a coat pocket, so there's no excuse not to take it with you.

Most offer the same level of control that you find on a DSLR, including RAW shooting, manual modes, multiple metering and focus options and so on; while compact owners still find the simplicity and convenience of Program and scene modes available.

The reason these cameras can be so compact is that they use smaller sensors than DSLRs, allowing smaller bodies and smaller lenses. The lens magnification is therefore much greater than that of DSLRs, so longer effective focal lengths are possible.

Smaller sensors are, however, a compromise. Most have a lower dynamic range and sensitivity range so the cameras need to be used in brighter light conditions, even with the Image Stabilisation systems – or a tripod must be used. Obviously this negates to some extent the portable nature of the cameras.

Similarly, smaller sensors mean more noise, particularly in the higher ISO reaches and shadow areas. This may not be a problem for small prints, but if large prints are made, it can be very noticeable.

THE RANGE OF FEATURES

The zoom range of the lens is what defines this category, with most offering a 10x or 12x zoom. Most superzooms offer similar functions to a high-end SLR, while beginners benefit from Program modes and scene modes such as Portrait, Landscape, Night Landscape, and so on.

Superzooms use electronic viewfinders (EVFs) to compose the scene. These are small LCDs fitted into the top of the camera and display a video feed direct from the sensor. This means that what you see is what will be recorded. Other advantages include viewing of menu and previews as well as superimposed information such as live histograms, metering, AF points and more. Unfortunately, the clarity isn't as good as an optical viewfinder, with issues such as low resolution or poor refresh rates on some models.

Some cameras use rechargeable lithium-ion batteries, which are long-lasting and reusable, although it is wise to keep a spare just in case. Some of the models accept AA batteries which are readily available, even on Egyptian market stalls, so no matter where you are, you'll be able to find replacements.

Lifestyle cameras

Digital cameras categorised as 'lifestyle' models are primarily concerned with making you look good while you take your pictures. They're aimed at those who consider style to be at least as important as ability. But that doesn't mean these are the technology equivalents of clothes horses. They are often at the acme of technological achievement with lots and lots of innovation, but wrapped up in a gorgeous-enough package to do the contents justice.

We would never advise you to buy a camera solely on the basis that it looks nice, but it's not beyond reason to buy a nice-looking camera that does the job that you want it to do.

Most lifestyle cameras are well under an inch thick. While this is good for portability this sometimes makes them awkward to handle. It's fine to have a camera that looks great, but your cool won't be enhanced if you are unable to use it in front of all your mates!

THE RANGE OF FEATURES

Some lifestyle cameras in this class have internal zoom lenses. This means they don't have any protruding parts to be knocked out of kilter. It also means the camera doesn't get any bigger when you switch it on, as the lens stays within the body shell.

Lifestyle cameras are less likely to have optical viewfinders, but will compensate by fitting the biggest screen possible on their backplates. But big LCD screens mean less room for anything else on the back of the camera. Most models feature a four-way controller with a central OK button, used in tandem with a menu button, but often little else.

Lifestyle cameras are less accomplished in low-light situations. Their tiny sensors are more prone to noise (visible interference that resembles coloured film grain) and various optical abberations, while their often miniscule flashes have a very limited range.

Budget compacts

Digital cameras can be expensive and – despite the steady decline in price in recent years – not affordable for everyone, especially if they are only being used occasionally for holidays and birthdays.

Budget digital cameras are great for beginners, or anyone thinking about getting into digital photography and wanting to invest in a basic camera to find out if they like it, before spending more. They're also ideal Christmas presents for children, as a means of introducing them to a rewarding and inexpensive new hobby.

You may not get the most stylish camera on the market, but there are other factors that are more important, such as the range of features. Even the most basic of cameras nowadays tend to offer a minimum resolution of 3MP, which is suitable for 10x8in prints at 200dpi. Most, but not all, models offer a zoom lens, and of course an LCD screen, although at the lower price points it may not be very big.

Consider any camera carefully before making a purchase. How comfortable is the camera to hold? How durable is the build quality? Does it offer a wide selection of scene modes? Can it shoot movies with sound? Most importantly of all, what is the picture quality like? Read the reviews in magazines and on websites to get an idea.

THE RANGE OF FEATURES

Budget compacts are often aimed at newcomers to digital photography, with the emphasis on ease of use.

Exposure modes usually include auto or program, plus a selection of scene modes, such as Landscape, Portrait and Night scene, optimised for different shooting conditions. Any manual features will be limited to exposure compensation, White Balance and ISO. Most budget cameras include a basic movie mode.

At the cheaper end of the digital compact market, cameras will typically be built out of plastic; a metal body costs more to make and will increase the price. The camera should, however, be durable and able to withstand day-to-day wear and tear.

Many budget cameras have fixed-focus lenses, but if you can splash out a little more money to get an optical zoom, then do. It will offer you more creativity; enabling you to photograph far-off objects, and by zooming in or out you can exclude unwanted objects from the picture. At this budget most cameras include 3x optical zooms, with a typical focal length around 35–105mm.

The LCD size is an important consideration. Not only will you be using it to compose most of your photos, but you will also be using it to view the menu settings. Most LCD screens now start at around two inches. If you have problems with your eyesight, find out if you can read the text on the screen before you buy the camera, as the writing used in menus can be very small.

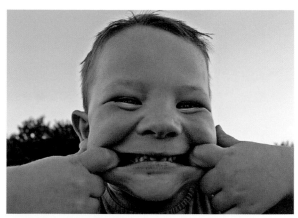

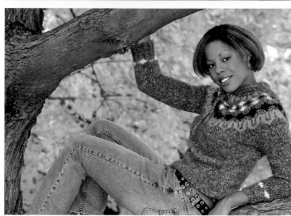

AN ILLUSTRATED

A to Z
OF
DIGITAL PHOTOGRAPHY
PEOPLE AND PORTRAITS

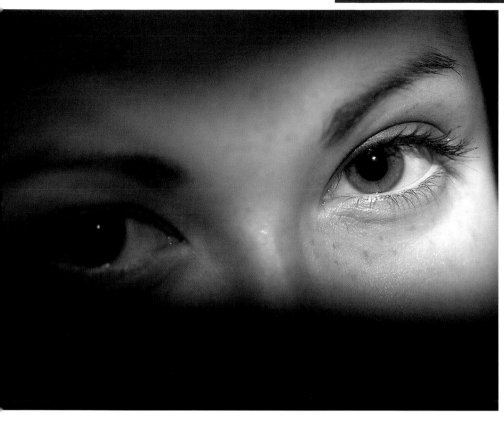

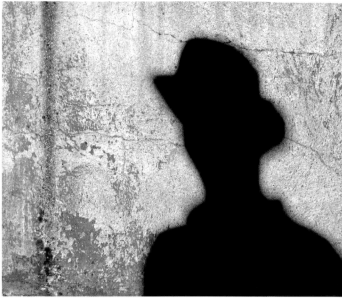

Above: Shadows and silhouettes make ideal abstract portraits.
Left: A 'portrait' of just the eyes can be surprisingly revealing.

Abstract Portraits

Portraits need not show the whole person. Abstracts are about creating interesting shapes and compositions using the human body

CHECKLIST

Try to look at the body in a different way.
Isolate interesting shapes and contours.
Be creative with lighting to enhance the detail.
Try breaking up the lighting with blinds, grids, etc.
Use natural props such as branches in your photos
Try unconventional crops and rotations on your PC.
Experiment with the Filters menu in Photoshop.

WHAT IS AN ABSTRACT?

A traditional portrait concentrates on the subject's face. It usually includes the entire head, and may end at the subject's shoulders, or the photographer could prefer to opt for a half-, three-quarter or full-length portrait.

But it need not be so. An abstract is more about creating an interesting composition than trying to capture the subject's personality. Abstracts usually focus on parts of a person, be it the face or body, rather than the whole. Good abstract photographers study shape, form and light and they're able to make the viewer see familiar things in a different way – just as abstract painters and sculptors have done for centuries.

Needless to say, abstract portraiture requires a different approach to photographing people than a traditional portrait would. For inspiration check out great photographers of the past, such as Horst, Edward Weston and Bill Brandt.

SHAPES

The abstract body part plays a major role in fine art nude photography. The aim is to show the eroticism of the human body as a whole, and not just the obvious erogenous zones. An image may focus on the nape of a woman's neck, the gentle curves of her back or hips, or the ripples in a man's six-pack. Often models are asked to perform physical contortions to create abstract shapes with their bodies, such as curling up into a ball, or stretching the limbs in an unnatural, but visually pleasing way.

The face, while not as flexible as the body, can still be given the abstract treatment. By choosing to focus on just part of the face, such as the nose or eyes, an interesting abstract can be achieved. Tilting the camera or shooting from an unusual angle can also be effective to make us see things in a different way – for example, by photographing a face from directly above or below.

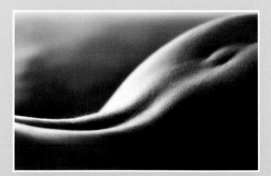

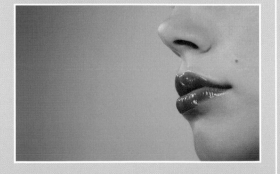

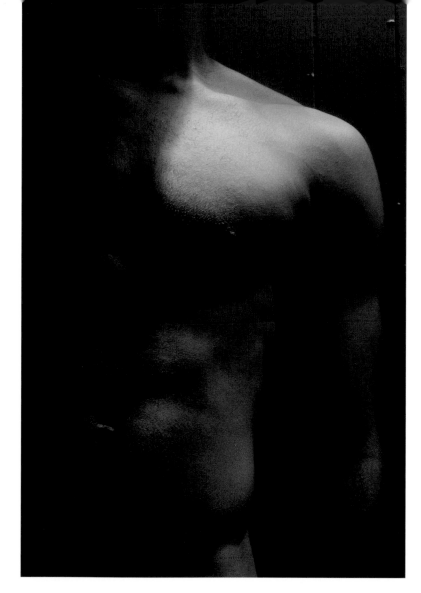

LIGHT AND SHADE

There's more than one way to create an abstract, and a popular method is by the use of light. By careful choice of lighting, abstract images can be created or enhanced. A simple example is the cliché of a body bathed in the patterned light coming through a venetian blind or an intricate lattice window. Although it is possible to find locations where this kind of light naturally occurs, it's often easier to recreate it in a studio setting using cut-out shapes ('gobos') over the lights.

Another technique is to go for a hard, narrow, light source, such as a studio light restricted by a snoot or barn doors, to cast long, dark shadows across the face or body. Hard light glanced across the surface of a body enhances the texture of skin, making goose pimples and any contours more prominent.

Although indoor locations offer more control, the outdoors is very popular with abstract photographers, who may choose locations which offer the type of light required (the dappled light coming through trees, for example). Outdoor locations also offer the advantage of props to enhance the abstract, such as gnarled tree trunks, jagged rocks, etc., of which the model becomes a part.

TREATMENTS

Although most abstracts are created in-camera some can be made (or enhanced) afterwards on the computer. Altering the crop of an image, and perhaps rotating the crop marks to create an entirely new composition, is an obvious example. But as anyone who has ever delved into the Filter menu in Photoshop will know, there is an infinite variety of special effects available, in varying degrees of tastefulness, at the click of a button. Strange embossing, fragmenting, recolouring and texturing effects can all be selected and the strength of the effect varied, and of course you can create your own simulations of popular wet darkroom techniques, such as solarisation (made famous by Man Ray) and posterisation (for which there's an 'instant' option in the Image > Adjustments menu).

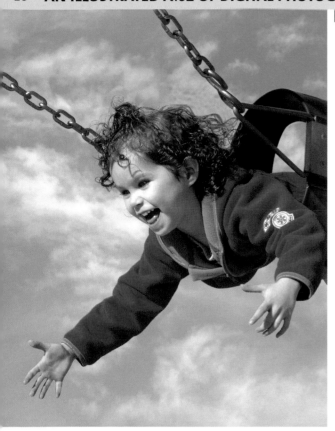

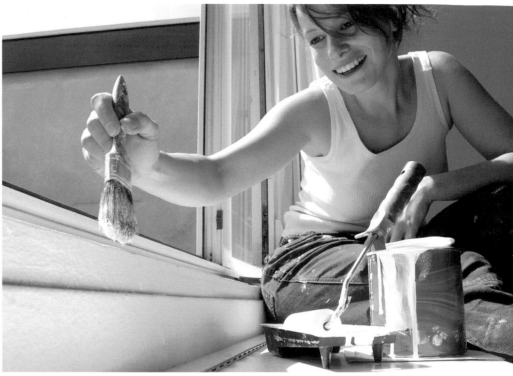

Left: Children playing make great action subjects. **Above:** Try photographing people engaged in an activity.

Action

People in motion make great subjects for the camera, but you need to be careful in your choice of camera settings to get a good result

CHECKLIST

Involving your subjects in an activity adds interest.
It's an ideal way to relax a nervous subject.
Children are at their most photogenic when occupied.
Try shots of people engaged in their hobbies.
People at work, perhaps in uniform, make great subject
Look for distracting clutter in location portraits.
Fast shutter speeds freeze action, slow ones blur it.

ACTION

Most people think of a portrait as a static picture, with the subject posing for the camera, but many great portraits are taken with the subject involved in some activity. Sport and candid photography, which are both covered in later chapters, are good examples, but subjects don't have to be physically exerting themselves or be unaware of the camera to make an action portrait. People at work is one example, but any picture where the subject is engaged in an activity can be considered an action portrait.

There are two main reasons for choosing this approach: the first is that it can make for a more interesting photograph, and the second is that it's an ideal way to get a relaxed portrait of someone who is normally nervous or 'wooden' in front of the camera.

EXAMPLES

Children lend themselves especially well to this approach. When they're playing they can get lost in their own little world, making your job as a photographer that much easier. But adults too can benefit from this approach. A portrait of mum or dad doing the cooking, pruning the roses in the garden or doing one of any number of mundane chores around the house can make for an interesting picture. Shoot them either while they're watching what they're doing or have them pause momentarily to look up to the camera for a posed shot.

Photographing people engaged in a hobby or leisure activity such as cycling, fishing or playing chess is even better, as your subject is more likely to be enthusiastically engaged in the activity.

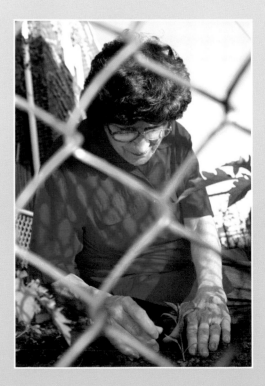

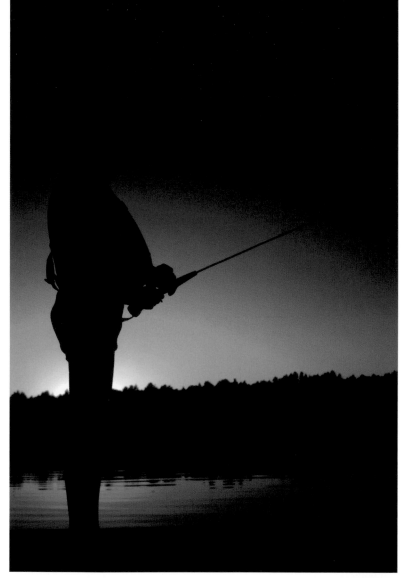

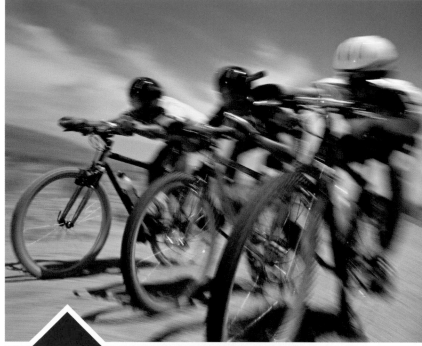

Left: Although just a silhouette, it's still obvious what activity this image depicts.

Capturing movement

Decide whether you want any subject motion to be sharply recorded or not. Some motion blur is often better at conveying movement than a picture which is sharp all over. Experiment with shutter speeds, from slow ones such as 1/30sec to fast ones such as 1/500sec, and check the results on the LCD screen till you get an effect you're happy with.

TECHNIQUE TIPS

With environmental portraits, such as the examples given, left, it's too easy to be so wrapped up in the activity that you forget to look around the image, but do take a moment to look for unnecessary clutter or incongruous items that should be moved, tidied away or cropped out of the shot. This will prove distracting to the viewer and probably irritating to the subject if left in shot ('I wish I'd moved those dirty dishes before you'd taken my picture'). Show some of the environment by not cropping too closely and by positioning your subject so that he or she sits comfortably (in a visual sense) within it, and there are no objects growing out of the back of the subject's head, for example. Avoid direct flash as this is likely to lead to either a heavy shadow or underexposure of the background. Natural light works best with pictures like this, as it gives the shot a more authentic, less staged look.

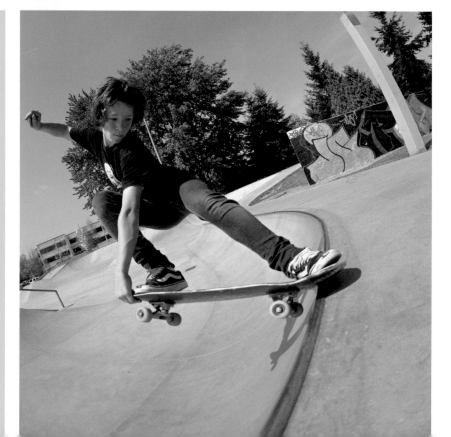

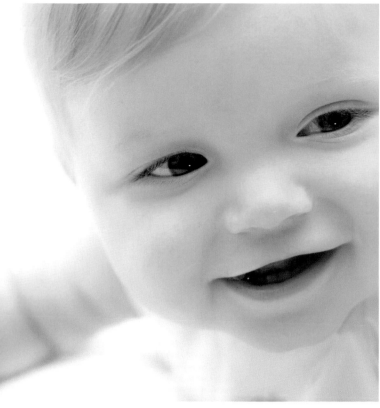

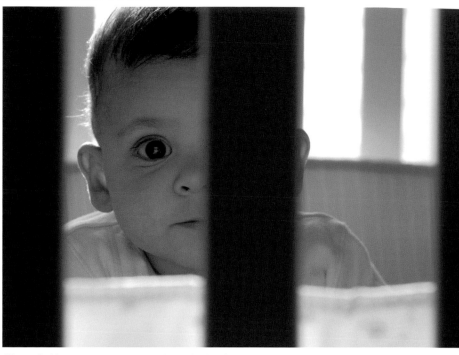

Above: Babies are naturally curious about what's going on around them. You can use this to your advantage.
Left: Candid shots while the child is occupied by something off-camera can produce lovely expressions.

Babies

For many, a new baby is the catalyst that launches a lifelong
passion for photography, but they're not easy to photograph!

CHECKLIST

Use soft, diffused light for the most flattering result
Avoid flash: it looks bad and may distress the baby.
Increase the ISO setting for sharp shots in low light
Lie newborns on the floor (on a soft towel, etc.).
Shoot from above or get low for more of a profile.
Don't use wide angles that distort the baby.
Keep sessions short. Be prepared to try again later.

GENTLY DOES IT

Babies, especially newborns, are notoriously
difficult to photograph well. Firstly they
can't sit up, so you're forced to shoot from
above (which is rarely flattering). Secondly
they spend a lot of time asleep or crying,
which leaves you a relatively small window
when they look both awake AND content,
and thirdly they're very small, so you have to
get in quite close, with all the challenges and
problems that presents. Their eyes are still
very sensitive too, so going in there with
flash blazing is unlikely to result in a
harmonious relationship, either with the
subject or its mother.

This is one time when a gently, gently
approach is essential, whether the baby is
your own child or not.

LIGHTING

Soft, diffused lighting is best for photographing
babies, not only for reasons of comfort, but it
also happens to be the most sympathetic. At
home, a large window opening on to diffused
daylight is the best option. A conservatory is
a good alternative, as long as it isn't lit by
direct overhead sunlight. Depending on the
weather and time of year you may need to
increase your camera's ISO setting slightly
to get a useable exposure, but remember
that you don't need a really small aperture
or fast shutter speed. If you use a tripod or
other form of support your speed can be
as low as 1/15sec, and wide apertures will
produce a flatteringly shallow depth of field,
which keeps the viewer's attention on the
baby, rather than the background.

In the hospital, you'll probably be confronted
by ugly, fluorescent strip lights. If you can go
over to the window so much the better. If you
can't at least be sure to set your camera's
White Balance to the appropriate setting.

COMPOSITION

You're limited in what you can do with a
small baby, but your first task is to find a
good viewpoint. This will probably be from
above, but take a look first. A popular
picture is to lay the baby on a soft white or
cream blanket and get a full-length directly
from above, using a standard or moderate
telephoto lens. (A wide angle will force you
to be uncomfortably close and will distort the
baby's features.) Getting down to the baby's
level may offer a good profile or three-
quarter profile. With the baby propped up
slightly, you can get a more dynamic
diagonal composition, either as a full-length
or head-and-shoulders shot. Do get some
close-up headshots as well as full lengths,
but zoom in from further back rather than all
but sticking your camera in its face, which
could intimidate it. Don't forget to go for
those endearing detail shots of fingers and
toes, that, combined with a shallow depth
of field, can be especially touching.

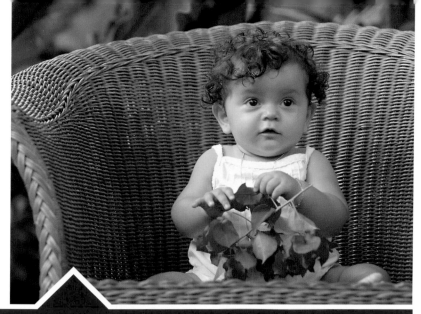

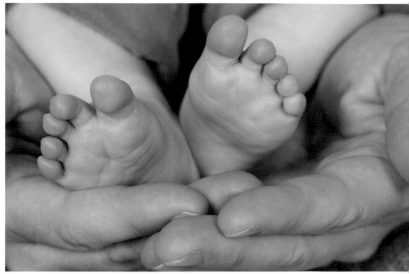

A little bit older

Once the baby learns to sit up your job will become easier and your posing options will expand. The child's expressions will become more varied and it will be easier to get a reaction. Once he is crawling things get better still, though more challenging in the sense of keeping baby where you want him. Try setting up an area on the floor with a few favourite toys and just letting him play with them, watching from a comfortable distance and being ever-ready for a shot if a good moment presents itself. At this age you may be able to use flash, but only if it's indirect and bounced or diffused. Even then, daylight is still the better option.

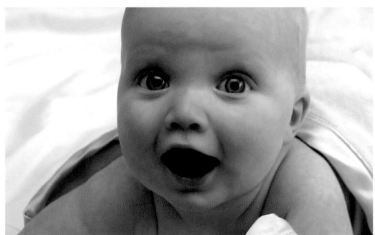

Top right: Babies' feet are a popular subject for photography.
Right: Once they start crawling, babies get curious!

EXPRESSION

You'll get a limited range of expressions from your infant subject: curiosity, contentment, boredom, sleepiness. Obviously the first two are better than the second two. Since you can't direct your subject, the only control you have over the expression is in your timing – the time of day that you choose to do the shoot and the exact moment that you press the shutter. All babies vary as to when they're at their best. If it's your own child you'll know when this tends to be – if not, ask. It's best not to plan a shoot too far ahead but to be ready at short notice, and be prepared to give up and try again later if baby doesn't want to cooperate.

During the shoot try squeaky toys, rattles and general cooing to elicit a response, and make sure the camera is pre-focused so you can press the shutter at a moment's notice.

WITH MUM

So much for baby on its own, but don't forget to get some intimate mother and baby shots too. By including the mother she will be able to hold the child in a good position for the photographs, and the closeness with its mother will give the baby a sense of warmth and comfort that may show on its face. Have the mother hold the baby higher up than she may normally do to get her face and the baby's close together and eliminate any unnecessary space between them. Get some shots of mother and baby looking at each other as well as at the camera, as these will be more intimate and, probably, better. Distracting clothing can spoil a shot like this, so keep clothes neutral and preferably light, or dispense with them altogether for a tightly cropped shot of skin on skin.

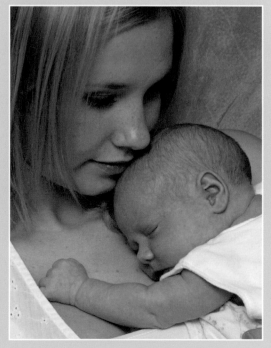

Above: A brick wall makes an ideal background for urban portraits.
Left: A wide aperture has produced a background of blurred foliage.

Backgrounds

Don't get so wrapped up in your subject that you forget to check
whether the background is suitable and not likely to distract

CHECKLIST

Look behind the subject before shooting.
Eliminate distracting backgrounds by moving the subject.
Alternatively, use a wide aperture to blur the background.
Shooting from a high or low viewpoint can work well.
Find a background that's sympathetic to the subject.
Indoors, look for natural backgrounds, such as windows.
Try dedicated backgrounds, for example: fabric or paper roll

OUTDOOR BACKGROUNDS

It's easy when you're photographing someone
to get so wrapped up in the subject that
you forget to check what's behind him or
her. The background in a portrait is usually
unobtrusive. If, when viewing a portrait you
find your eye wandering to the background,
then it probably hasn't done its job. Unless,
of course, you're shooting an environmental
portrait where the location is an integral
part of the shot.

When shooting on location photographers
have a limitless range of backgrounds. Green
fields, trees and flora are always popular, as
are brick or whitewashed walls, garage doors
and other settings in an urban environment.

When choosing a background make sure
it's appropriate for the subject. A romantic,
soft-focus portrait of a pretty girl in a floral
summer dress may look as incongruous
against a graffiti-covered wall as your local
grunge band would if photographed strolling
through a mass of bluebells.

DEDICATED BACKGROUNDS

Sometimes it's just easier to hang
up a white background and be done
with it. Plain backgrounds, whether
white, black or otherwise, provide
various advantages. A simple, non-
distracting backdrop keeps the
viewer's attention on the subject,
and eliminates the risk of something
going wrong. White isn't boring;
David Bailey and any number of
legendary photographers have
favoured them. White has the
advantage that, depending on how
you light and expose it, it can also
be grey. Black backgrounds are a
popular alternative.

Although you can buy photo
backgrounds of various types,
from paper rolls to painted canvas
or collapsible fabric, it's easy to
improvise. A bed sheet, or a painted
sheet or 8x4ft MDF are just as

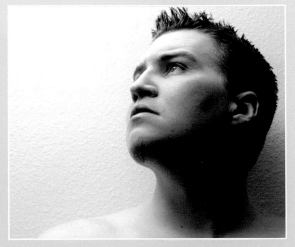

good, and I find that my obsolete 6ft slide
projection screen makes a fine white background –
and it even comes with its own stand.

INDOOR BACKGROUNDS

When photographing indoors your choices are more limited, but still plentiful. The obvious solution is to use a plain paper or fabric studio background, but before you go down that route consider the alternatives. Can you find an interior which can be used, for a more natural result? The fireplace of the great hall in a stately home has long been used by painters as a setting for portraits of the owner, but you can shoot effective portraits just as well on the staircase of a suburban house, or in the window of the main bedroom. Public buildings and places such as churches can also be good, but you may need to seek permission first.

When using settings like this it's especially important to look at the room from all angles to pick the one which offers the best background. Watch out for incongruous or distracting items in the background. Take a walk around and move or hide anything that may catch the eye in the photo later on. Decide whether you want to show the background and make it part of the shot or just include a hint of it for mood. If the former, you may need to choose a smaller aperture to get it all in focus.

THE NO-BACKGROUND APPROACH

So far we've assumed that the subject is either leaning on, or is close to, the background, but this need not be so. An alternative approach is to position your subject in an open space away from any vertical surface and use a long lens and/or wide aperture so that any distant detail is blown out of focus. Or select a low or high viewpoint so that the 'background' is the ground or the sky.

You can also use exposure control to help your subject stand out against a background. By positioning the subject in a patch of shadow with a brightly lit area beyond or in a bright patch with shadow behind and exposing for the subject's skin tone, you can create separation from the background by means of gross exposure differential – resulting in a very light or dark background in which detail is destroyed.

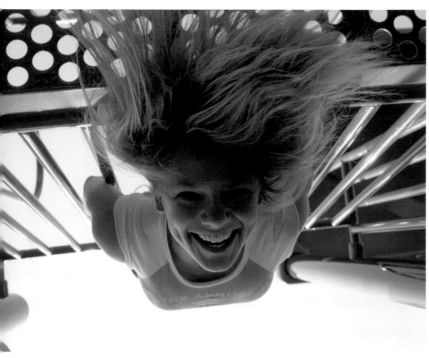

Above: This image could benefit from some basic corrections.

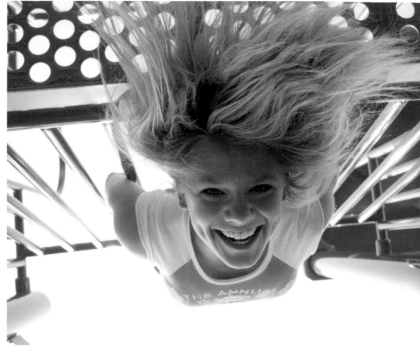

Above: After some quick adjustments, the image is vastly improved.

Basic Enhancements

Images straight out of the camera may be good, but with
a little creative tweaking, you can make them great!

CHECKLIST

Rotate image to correct the view.
Apply auto functions for quick fixes.
Crop images down to improve composition.
Use Hue and Saturation to improve colour.
Use Levels to adjust the contrast and tone.
Read a Histogram correctly.
Adjust Colors selectively.

WHERE TO START

Not all your photos may need enhancing or
altering, but they may just benefit if you take
some time to look closely at how you could
improve on them. For instance, depending
on your composition, you might have placed
your subject a little too much to one side,
when he or she may have been more suited
in the centre. In this case you could crop the
image down by removing the unwanted area
with the Crop tool.

If the shadow areas of your photo shows
very little detail, then you could consider
using the Levels feature in your image-
editing software to lighten them, increasing
the details.

When it comes to determining what may
need enhancing, don't hold back. Most
enhancements only take a few minutes to
perform, so try them out. If they don't work,
use the Undo commmand and try something
else. But remember not to over do it – less is
often more!

ROTATE YOUR IMAGE

It might sound obvious, but if you hold your
camera on its side to take a portrait-format
composition, then your image may appear on
its side when you view it on your computer.
Rotating your image to the correct view is
probably the most basic of all enhancements.
In Photoshop you can rotate your image
either 90 degrees clockwise or anti-clockwise,
180-degree flip or arbitrary, which allows
you to set the rotation in degrees manually.

In most cases you will only need to rotate
your image 90 degrees to correct the view.
To peform this in Photoshop, choose Image
> Rotate Canvas > 90 Degree. Remember to
save the image when you have finished.

AUTO FUNCTIONS

In most image-editing programs, there is an
array of automatic commands to help you get
the most out of your images simply and
quickly. These 'auto' functions are there for
you to apply basic enhancents with just one
click of your mouse.

In most cases you will not get any options
to adjust them; the software will work out for
itself just where it thinks the enhancements
need to be applied and by how much.

Auto Levels will take an average reading
of surrounding light and dark pixels and
try to balance them accordingly. This can
normally work pretty well, but it's worth
being prepared for some unexpected bad
results. Auto functions can be found under
Image > Adjustments > Auto.

CROPPING

Cropping can be an essential tool when used with portrait photography. It can change the whole perception of the image with a single stroke. Cropping in tightly to an image can increase the importance of the focal point dramatically. Similarly, altering where space around the subject is situated can create a whole new meaning.

Though you should not crop just because you can, it is worth experimenting with the tool to see how much difference you can make by moving the Crop marquee around the image.

Don't forget that you don't have to stick to your original image's dimension ratio. Why not try cropping it square or changing a landscape to portrait?

In Photoshop, the Crop tool has a number of great features that can help you in creative cropping. Firstly, you can adjust the opacity of the surrounding crop area to 100 per cent black, which may help you visualise the final result. To do this, select the Crop tool and draw a crop marquee across your image. The surrounding area should be a tint of about 75 per cent black, so you can see the underlying areas.

Up in the menu bar you will find the options for the Crop tool. In the opacity field enter the figure 100. This will make the opacity become completely black. If you click on the black square to the left, you can also set which colour you would prefer.

You can also move the cross-hair found in the centre of the crop marquee and then use the handles in the corners to rotate the crop around the cross-hair. You can keep the cross hair inside the marquee or outside it somewhere else on the image. The crop marquee will always rotate around the cross-hair, wherever it is.

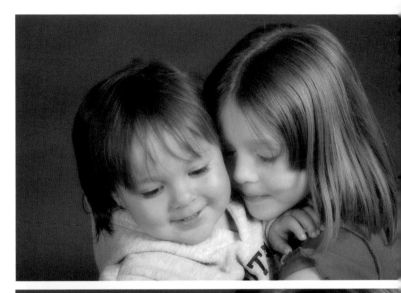

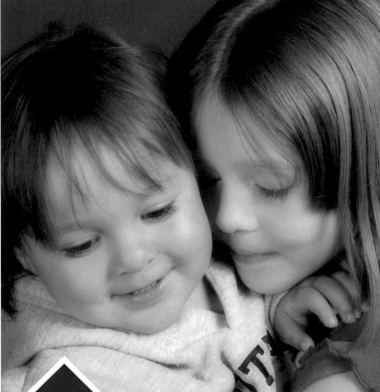

Left: When applied, the Crop tool is normally displayed with a tinted background.

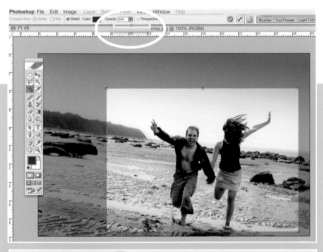

Left: By adjusting the opacity slider, the tint can be changed to 100 per cent black.

Crop in tight to convey emotion

The top portrait of two sisters is adequate as it is, but notice there is quite a lot of empty space surrounding them. This may be fine in a standard portrait, but this image is trying to show a loving bond between the two girls.

By cropping in very tight to the two faces and removing nearly all of the background, as in the bottom image, the eye is drawn into the central focal point. This creates an intimate composition that conveys more emotion.

Above: The brightness of a snowy day may cause colour and exposure problems with your image. By using your image-editing software to perform some basic corrections, details can be enhanced and annoying colour casts can be removed.

COLOUR AND TONE

Probably one of the most subjective enhancements to make are colour and tone. If your image is looking a little flat, punching up the colour satuaration can give it a fresh and warmer feel, but by doing this your subject's skin colours may begin to start looking a little strange. You may like the final effect, but others may see it as a bad choice of enhancement. Either way it's entirely up to you how you enhance your images, but if you are trying to achieve an overall realistic result then try not to go too far, and don't be afraid to ask for other people's opinions.

Bear in mind where your image has been taken. If it's a cold, snowy day, then the image may have a slightly blue cast and the highlights may be a little burnt out. Some minor colour corrections may be needed. Similarly if it's a indoor shot with fluorescent lighting, then the image could have a yellowish cast with dark shadows. Decide what to remove and what to increase accordingly.

HUE AND SATURATION

Hue is the actual pixel colour, i.e. red, green or blue, and saturation is the strength or intensity of that colour. This easy-to-use command allows you to adjust the image colour and how strong it appears in your image. From the Edit drop-down menu you can select each colour group – Red, Yellow, Green, Cyan, Blue and Magenta – as well as the composite colour.

Select each individual colour that you wish to alter and then use the Hue slider to adjust the colour. Don't go too far or the make-up of the colour will change completely. Then you can use the Saturation slider to adjust the strength of the new colour. Again, don't overdo it as it will start to look fake. You can also use the Lightness slider to adjust the tone of the colour to make the pixels lighter or darker.

STEP ONE

With your image open, select Image > Adjustments > Hue and Saturation from the image menu.

In the dialogue box select the Edit drop-down menu.

From here, you can select the colour that you wish to adjust.

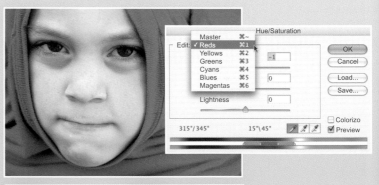

STEP TWO

Use the Hue slider to change the characteristics of your chosen colour. The colour bars at the bottom of the dialogue box will help you when navigating the colour spectrum.

Use the Saturation slider to increase or decrease the strength of the chosen colour.

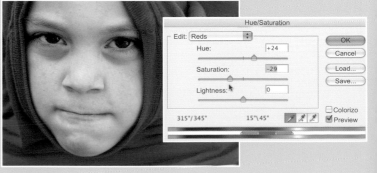

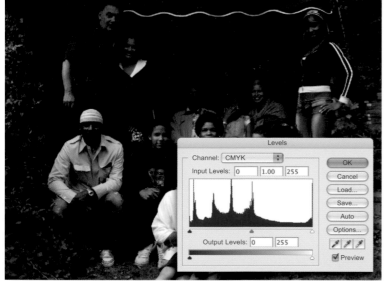

LEVELS AND HISTOGRAMS

Levels works in a similar way to Curves in that you can adjust the tonal range of the image as a whole or each individual colour channel. To select the Levels dialogue box, choose Image > Adjustments > Levels.

The jagged line is called a histogram and represents the spread of the light and dark pixels across the image. The dark areas (shadows) are to the right whereas the light areas (highlights) are to the left.

The image on the left is too dark, but by using the composite from the drop-down menu, the sliders underneath the histogram can be adjusted to enhance the image. The shadow areas are too dark and this shows as a peak in the histogram on the right-hand side. The shadow slider is moved slightly to the left along with the midtone slider to lighten the dark areas only.

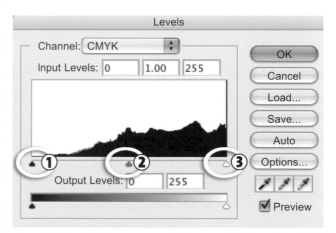

Above: The Levels histogram represents the spread of light and dark pixels across an image. The three sliders can be used to adjust their intensity.
1. Highlights 2. Midtones 3. Shadows.

SELECTIVE COLOUR

The Selective Color command in Photoshop is a lot more sophisticated than the Hue/Saturation command as it allows you to adjust the percentage of printing inks (Cyan, Magenta, Yellow and Black) within each individual colour.

Choose the desired colour from the drop-down menu and then use the sliders to adjust the amount of colour to add or substract from it. This is very handy when you need to alter a specific colour without affecting that colour in other parts of the image. For example, you can decrease the amount of Cyan in a green colour without affecting the Cyan in any of the Blues.

This can seem complicated at first, but with a litle experimenting, you will benefit from adjusting individual colours with a more controlled approach.

1 TAKE ANOTHER LOOK
Take some time out to look closely at your photographs. You may think that they are perfect at first glance, but most images can benefit from a few enhancements and tweaks. Don't be worried about experimenting: you can always undo it if it does not work first time.

2 CROP OPACITY
Try adjusting the opacity of the crop tool to 100 per cent black. This will give you a clearer idea of how your final cropped image will look.

3 SAVE A COPY
Remember to save a copy of your image before you start to work on it. If you decide at a later date that you don't like it, you will always have the original to make another copy from.

4 USE LEVELS
Use the Levels command if your image has become washed out due to too much flash. You will be able to adjust the brightness and darker tones seperatly.

5 COMPARE WITH THE ORIGINAL
As with all enhancements, don't hold back: give things a try. But just bear in mind that overdoing it can really spoil a good image. Try keeping the original untouched image open in a separate window to compare to as you progress.

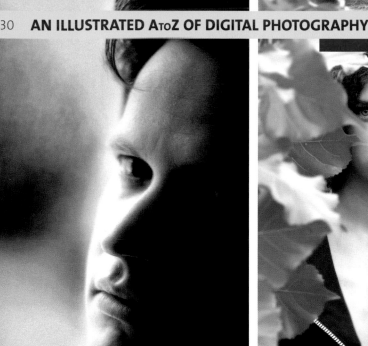
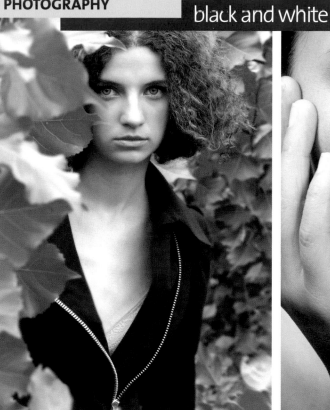

Black and White

Over 150 years old and still going strong, black and white is here to stay, because it offers qualities that colour simply cannot match

CHECKLIST

Black and white has a timeless quality that doesn't date.
It can be flattering for portraits, reducing skin blemishes.
It removes the potential distraction of colour.
Learn to visualise a scene in monotones before shooting.
For direct printing, set the camera to mono mode...
... but it's best to shoot in colour and convert to mono later.
Use one of the methods here to convert shots to mono.

WHY BLACK AND WHITE?

Despite the continuing advances in colour technology, black-and-white photography remains very popular, even among digital-camera owners, because it offers something different. Black and white (also known as monochrome, or 'mono') is especially suited to portrait photography for several reasons. First, the absence of colour seems to give mono pictures a timeless quality. They don't seem to date as quickly as colour images. Look through your old childhood photos to see this for yourself. More importantly, black-and-white portraits often appear to have more depth and substance to them. It's as if the colour distracts and gets in the way, and removing it makes it easier to reveal the true character and soul of the subject.

There's a technical benefit too, especially for those with less-than-perfect skin. Black and white is more forgiving of blemishes such as spots, and can disguise blotchiness, pastiness and ruddy cheeks.

SEEING IN BLACK AND WHITE

When you strip away the colour, other qualities in a photo become more important – in particular, the tonal range, and the interplay of light and shadow. The lighting therefore becomes very important. It doesn't really matter whether you go for soft, even light or hard, dramatic light, but take care over the exposure to get the tones right. Underexposed areas will look muddy and lack detail. Overexposed areas will be washed out and also lack detail.

Remember that different colours which look good to the eye will all record as shades of grey, and some colours which may contrast strongly in reality may record as a similar shade when the image is converted to mono. Primary red, green and blue colours could all reproduce to the same mid-grey shade, for example.

DIGITAL BLACK AND WHITE

Most digital cameras can be set to a black-and-white setting so you can get black-and-white shots straight out of the camera. While this may be useful if you want to make prints directly from the camera or media card, without passing through a PC, you'll find that you get better results if you shoot in colour and convert later using the computer. This is because in editing programs such as Photoshop you have much more control over how you convert, and are able to adjust the relative brightness levels for the red, green and blue areas of the image individually, as well as add hues and tones to create warm or cool mono images to suit the mood of the picture. There's also the not insignificant benefit that if you change your mind about wanting a black-and-white image you can always go back to the colour version, whereas if you shoot in black-and-white mode you can't.

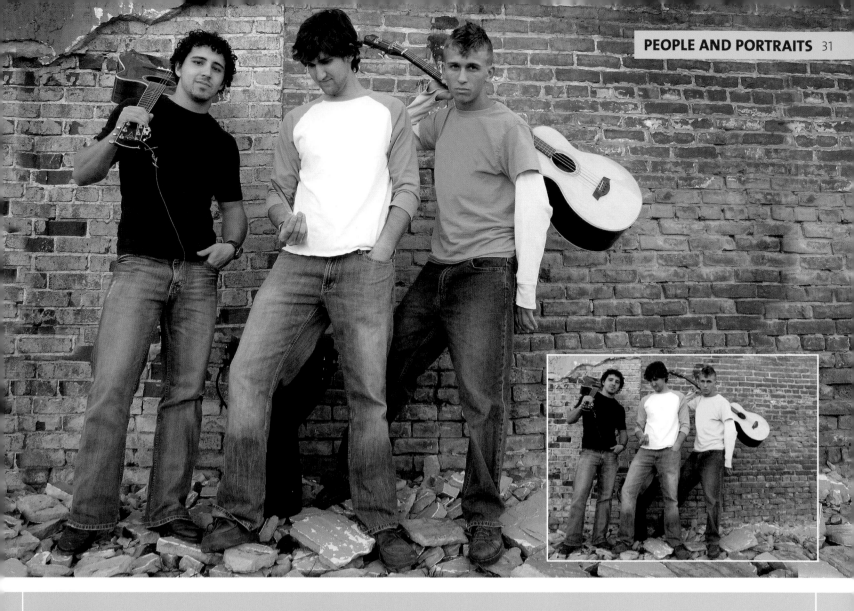

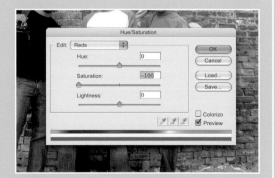

THREE WAYS TO CONVERT A COLOUR IMAGE TO BLACK AND WHITE

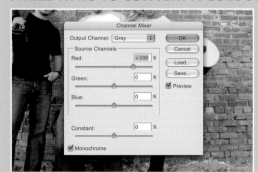

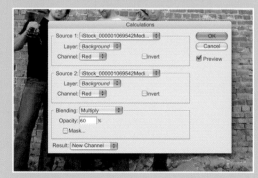

CHANNEL MIXER

With your colour image open, select the Channel Mixer from the image menu. Image > Adjustments > Channel Mixer. At the bottom of the dialogue box, click on the tick box 'Monochrome'. This will instantly convert your colour image to black and white, but retain the RGB colour channels. These can still be adjusted separately to give more control.

CALCULATIONS

Select Image > Calculations from the image menu. From the dialogue box select the Red channel in both source drop-down menus. This will provide the best skin tones and remove most of any unwanted blemishes. Use the Darken blend mode and set opacity to 60 per cent, but experiment for your own image. As the image is now in multichannel mode, select Image > Mode > Greyscale, and then Image > Mode > RGB.

HUE AND SATURATION

From the image menu, select Image > Adjustments > Hue/Saturation. Make sure the drop-down menu is set to Master. Drag the Saturation slider all the way down to the left to remove all the colour.

Each individual colour channel remains in place but these are now black-and-white tones and can be adjusted to suit.

Camera Phones

Once simply devices for conversing with people, but now the
humble phone is a sophisticated tool for visual communication too

CHECKLIST

Camera phones mean you always have a camera with you.
Newsworthy events captured on phones are now saleable.
Phones are ideal for self-portraits to show where you are.
Be careful about pointing your camera phone at strangers.
Get a phone with at least 2MPs, for printable images.
The bigger the image, the longer the transmission time.
Most phones now have cards/Bluetooth for downloading.

AS AN ALTERNATIVE

With the invention of camera phones almost
everyone in the western world has a camera.
This means it's unlikely that any disaster or
incident will ever again go unrecorded, as
it's almost certain someone on the spot will
record it on his or her phone. New photo
agencies are springing up to distribute and
sell newsworthy footage captured on camera
phones by ordinary folk, inspiring a new
phrase, 'citizen journalism', to add to the
modern vocabulary.

Until recently camera phones offered a
poor alternative to a camera, and no self-
respecting photographer would be seen using
one. But by following the trail blazed by early
digital still cameras, phone manufacturers
have been able to make vast improvements in
a short space of time. Phones with usable
cameras are here now and, the way they're
constantly upgraded through our contracts,
most of us will soon have phones capable of
producing reasonable 5x7in prints.

PHONES FOR PORTRAITS

Although few people would suggest using a
camera phone for serious portraiture there
are many uses for which it is ideal. One of the
most popular forms of portraiture on phones
is the 'look where I am' self-portrait – as in,
'Here I am at the Cup Final'. Then of course
there are friends and families. Snaps of mates
on a night out, your partner opening a birthday
present, your child riding his bike without
stabilisers for the first time. How often have we
seen a scene which would have made a great
picture if we'd had a camera? Or perhaps an
amusing or bizarre situation or juxtaposition.
These are examples of the many events
which, before camera phones, may have
gone unrecorded. The trick is to remember
that you do have a camera on your phone,
and to recognise those moments when it would
be a good idea to use it.

Turning the lens on people you don't know is
slightly more problematic. Street performers,
celebrities at book signings and so forth would

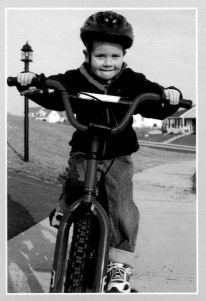

expect to be photographed, but for everyone
else it's a good idea to ask them first if you
can, as they could easily take offence at being
photographed without consent and may
misunderstand your motives.

TOP
TIPS!

1 GET IN CLOSE
Camera phones aren't good at small details so fill the frame for maximum impact.

2 KEEP AN EYE OUT
Look out for unusual or amusing scenes and always be ready to shoot.

3 USE THE SETTINGS
If your phone has the ability to adjust exposure or colour balance, use it to avoid bleached-out highlights or dodgy colour casts.

4 TRY UNUSUAL ANGLES
Camera phones often offer more flexibility in the shooting angles so be adventurous. Try low- and high-angle shots.

5 POCKET TRIPOD
In low light find some solid surface as a means of support, or carry a pocket tripod.

PHONE SPECS

A camera phone will never be a replacement for a high-quality dedicated camera but as an ever-present back-up to your main camera it's perfect. It helps though if the camera phone that you do have is as good as possible. Firstly, try to get one with at least two megapixels. Although a 1.3MP phone is fine for viewing on other phones, if you want to print any of your pictures you'll find the quality a disappointment. At two megapixels 6x4in print quality becomes passable, and so the phone becomes more useful as a recording device. Bear in mind that the more megapixels you have the longer it will take to send and the more it will cost to do so. But if you wait till you get home you can connect the phone to your PC and download or print the pictures, which will be cheaper. This can be done wirelessly via Bluetooth, by USB cable or a memory card that can be removed and slotted into a card reader. You can also upload camera phone pictures to websites for display or printing or get prints from many high-street retailers.

Some phones now offer sophisticated features such as zoom lenses, exposure compensation and even flash. While useful, many of these features consume more battery power, risking the possibility that you could find yourself without the use of your phone.

6 AVOID DIGITAL ZOOM
Avoid the digital zoom if your phone has one. It simply crops into the image, making it even lower in resolution than it already is.

7 ANTICIPATE SHUTTER LAG
Camera phones suffer from lengthy shutter lag so learn to anticipate the key moment. Some cameras offer a 'sports' or 'sequence' mode, but this reduces the resolution.

8 TAKE LOTS OF SHOTS
Don't be afraid to take a lot of shots to get one you're happy with. You can always delete the others.

9 USE THE OPTICAL ZOOM
If you have an optical zoom don't forget to use it. But start with the wide-angle first and see if you can get a better composition simply by walking closer to the subject. It will give you a more impactful shot than zooming.

10 EXPERIMENT
Experiment. Phones are a new medium and the old rules of photography are up for debate. Be bold, but if your plans involve other people be sure to gain their consent.

candids

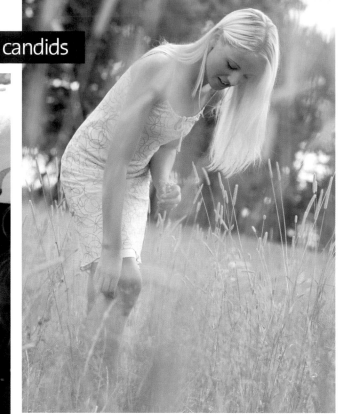

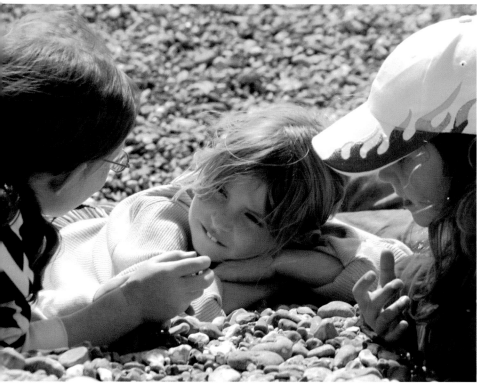

Above: Shooting 'blind' from the hip makes photography less conspicuous.
Left: Children are more natural when they're unaware they're being photographed.

Candids

A candid is an unposed picture usually taken without the subject noticing – but that doesn't mean lurking in the bushes!

CHECKLIST

Candids make it easier to get natural expressions.
Children are more relaxed if they can't see a camera.
Long telephoto lenses can be useful for candids.
Wide angles have a less voyeuristic feel.
Try keeping the camera down until you want to shoot.
Tilting LCD finders make waist-level shooting easier.
Avoid photographing strangers in public, especially kids.

WHY CANDIDS?

Most portraits are taken with the subject looking into the camera, but sometimes it's better if they're caught unawares. Taking unposed pictures, often without the subject's knowledge, is known as candid photography. The purpose is not to spy on the subject, but to try to catch him or her in a relaxed and natural state or engaged in some activity.

Some people just clam up when they're being photographed. The very thought of it is enough to make them break out in a sweat.

Children, too, behave differently when they know they're being photographed. They play to the camera, and the natural wide-eyed innocence you're trying to capture disappears. If you want their true personalities in a picture you often have to do it by stealth.

When travelling it's nice to get shots of local people working and going about their lives, but, again, the camera tends to bring natural proceedings to a halt.

STEALTH TACKS

There are various techniques to avoid detection. The first is to use a telephoto lens and shoot from further away. Telephotos require faster shutter speeds to avoid camera shake, and have smaller maximum apertures, so you may need to raise the ISO to shoot handheld, as a tripod would obviously attract attention.

Telephoto shots have a voyeuristic feel. Some prefer to use wide angles and get in close, keeping the camera away from their eye until the last moment, when it is quickly brought into position, a shot taken and lowered again within a second or two. To work, the camera must either be set on program or auto mode, or the exposure preset beforehand. The lens should also be manually pre-focused. Even when shooting from further back it's a good idea to keep the camera out of sight until you need it. Some cameras offer a tilt-and-swivel LCD screen which makes this technique a lot easier.

HEALTH WARNING

We seem to be living in paranoid times these days, when photographers at large are treated with suspicion. Gone are the golden days when photographers from the likes of *Picture Post*, *Life* magazine, agencies such as Magnum and other organisations could walk around unchallenged, capturing nuggets of contemporary life for posterity, without fear of being arrested by some heavy-handed policeman.

In an era when many parents aren't even allowed to take photos of their kids' school play, it goes without saying that photographing other people's children without the consent of their parents is asking for trouble. Care must also be taken when taking pictures of, or from, private property (which covers a surprising number of locations, such as shopping centres) without permission. In general, it's best to use this approach only on people you know, such as family and friends.

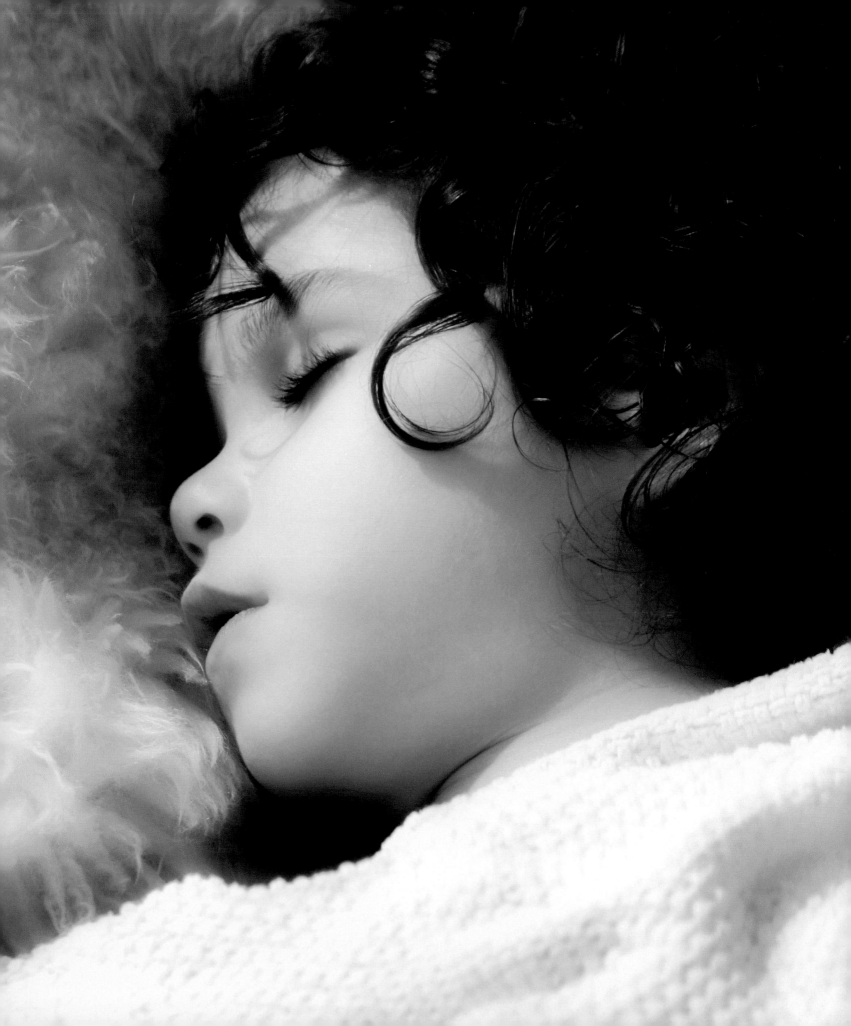

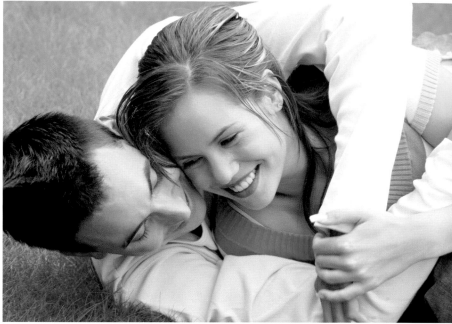

Above: With older children and teenagers, spontaneity works best.
Left: Turning your portraits black and white can give them a timeless quality.

Children and Teenagers

Children and teenagers need a special approach when it comes to photographing them. Follow these tips for success

CHECKLIST

Make a record of your children's lives as they grow up.
Photograph them all the time, not just at big events.
Take unposed candid shots as well as posed portraits.
Keep a camera with you always, set ready to shoot.
For posed shots, go for simple backgrounds.
Alternatively, try environmental portraits in a setting.
Involve them in an activity to make the shot interesting.

MAKE A RECORD

Making a record of your children's lives as they're growing up is something that both you and they will treasure when you're all much older. With digital cameras there's no excuse for not being trigger happy, since it doesn't cost anything and you can delete the failure later. But don't just record those key events, the big family get-togethers and so forth. And don't make them grimace into the camera with fake smiles. Instead, make an effort to capture those smaller, more intimate moments when they're playing in the garden, or riding their bikes or they're indoors doing arts and crafts. These are the moments you'll remember and treasure. You can set up fun activities for the kids especially with picture-taking in mind. They'll have fun, you'll get some good shots, and everyone's a winner.

CANDID KIDS

Unposed shots with natural expressions say more about your kids' personalities than posed portraits usually do, and may bring back more poignant memories later. Your best strategy is to be always ready and react quickly to events. Close-range shooting with a wide-angle lens will provide impact and a sense of intimacy. Presetting a camera to manual focus, a mid-range aperture and focal point of about three metres will cut down the shutter lag and make picture-taking almost instantaneous. In low light set a high ISO rather than flash, which will remind them of your presence. With SLR cameras, or models with good zooms, an alternative method is to step well back with a long lens so they forget you're there, and observe, with your finger hovering on the shutter. Don't just go for full-length shots showing what they're doing, zoom right in and get some frame-filling head shots too.

POSED PORTRAITS

For a more formal approach by all means pose them, but let them find a natural sitting or standing position rather than trying to over-direct them. Choose a location with an uncluttered background and, preferably, good natural light. Don't stand too close so that the lens becomes intimidating, but step back and zoom in a bit more. It will require more skill to get unselfconscious pictures when they're posed, but you'll have to work harder at interacting to make them forget about the camera. If they're your own children you have an advantage in some ways in that you know what to say to get the response you want, though on the minus side they're more likely to play up than if they were sitting for a friend or relative.

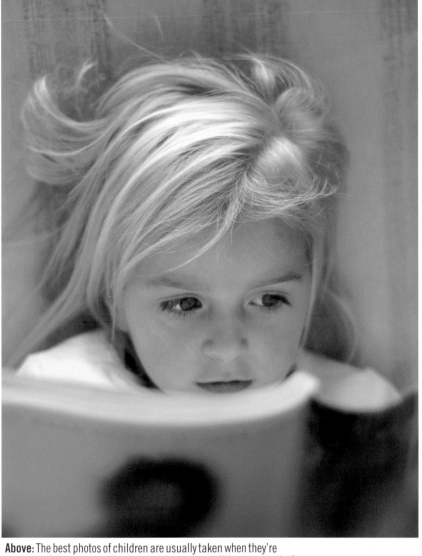

Above: The best photos of children are usually taken when they're unaware of the camera, allowing their true personalities come to the fore.

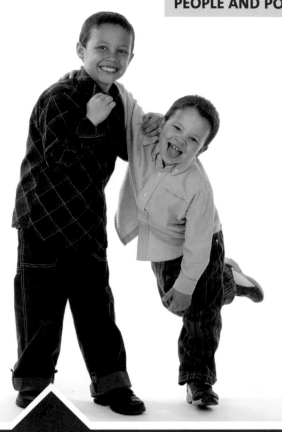

Above all... keep it fun!

Try to keep your photography fun and light-hearted. Instead of a forced smile, your subject will react spontaneously, resulting in a better, more natural pose.

SEMI-POSED

Getting good posed portraits of children isn't easy. When they're young they often tend to gurn and pull cheesy expressions. As they get older they become more self-conscious and shy. The simplest technique is to go for what we might call a 'semi-posed' portrait, which is like a candid except that they're more aware of your presence and are generally looking into the camera. Drawing their attention momentarily during an activity, then grabbing a quick shot, will make less of a deal of the whole thing than the 'sitting on a stool in front of a background' ritual. Try to get genuine expressions – smiles or otherwise – out of them. Indeed, even the odd tantrum or sulking shot will raise a smile when viewed in later years.

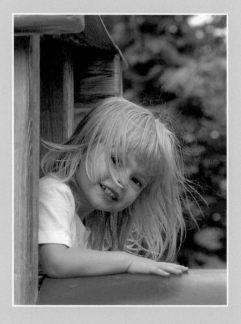

TOP *TIPS!*

1 GO LOW
When photographing children at close range it's generally best to get down to their level. This creates a more intimate image and gives the viewer a sense of entering the child's world.

2 NO FAKE SMILES
Go for natural expressions, not forced smiles. Get some sad and grumpy shots too.

3 PRE-FOCUS FOR SPEED
Pre-focus or set manual focus to cut the shutter delay and always be ready.

4 KEEP THEM BUSY
Try engaging them in an activity of some kind. This will make them forget about the camera.

5 STAND BACK
Try standing some distance away and shooting candids with a telephoto lens.

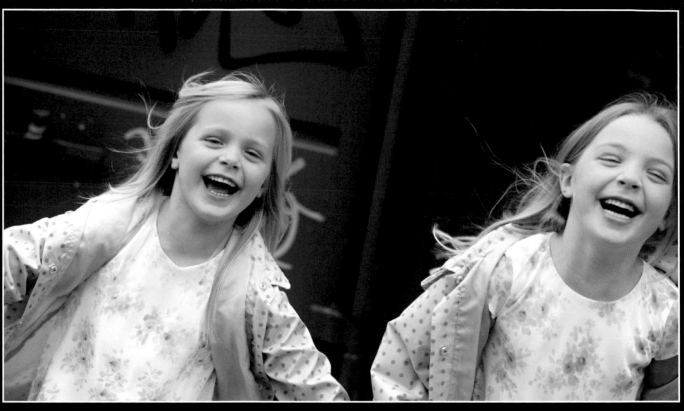

Annabel Williams

Above: A sense of spontaneity runs through Annabel's work.
Right: Annabel likes the unobtrusiveness of telephoto lenses.
Overleaf: Teenagers favour a fashion-magazine style.

Annabel is on a mission to banish forever the spectre of the mottled brown canvas background. Welcome to 'lifestyle portraiture'

One of the UK's most successful social photographers, Annabel Williams pioneered what is now often called 'lifestyle' portraiture, but which she also describes as 'fashion photography for ordinary people'.

She has a special talent for photographing children. Having worked with them in her previous career she instinctively knows how to get them on side. 'The way you behave in the first five minutes determines their behaviour for the rest of the day,' advises Annabel. 'If they come in clinging to mother I can see they're shy so I just ignore them. Sooner or later their curiosity will get the better of them and they'll come round eventually.'

Despite owning a large, well-equipped studio in the Lake District, Annabel now shoots almost entirely on location, usually outdoors. When she arrives for a shoot one of the first things she does is take a look around to find three or four different locations to do the shoot. 'I look for where the light is good – nice and soft – and where there is an interesting background. I don't mean picturesque backgrounds, as even a rusty tin shed can make a great background.'

Annabel's style is very informal. 'I don't pose people, I compose them,' she insists. 'There's a difference. If you pose children they become self-conscious and look uncomfortable.' Rather than have them sit and look at the camera Annabel usually gives children an activity to do, whether it's sitting on a bike or maybe picking up and throwing leaves at the camera. This makes the session more fun and produces more natural pictures. 'You have to be able to connect with your subjects. Photographing children is, as

with adults, 90 per cent psychology and 10 per cent technology.'

Annabel uses the Canon EOS 1DS MkII, usually coupled with Canon's 70–200mm f/2.8 lens. 'It's less obtrusive and intimidating for the subject when I'm not right on top of them,' she says. Telephoto lenses also have a flattering foreshortening effect on the perspective, too, with a shallow depth of field.

Annabel likes to shoot at f/5.6 as she finds it tends to give the best results, and takes a selective meter-reading off the subject's face to ensure a correct exposure. In order to make sure her shutter speed is fast enough to avoid camera shake she usually sets the camera to ISO 400 as a default – though she will go up to ISO 800 if necessary. She never uses fill-in flash, or reflectors: 'I've learned how to find the best light and just position the subject accordingly.'

Above: Venice carnival presents a colourful photo opportunity.
Left: The colourful costumes of Masai villagers in Kenya.

Colour

Colour is more than just incidental in your pictures. Sometimes
it can be the reason for taking the picture itself

CHECKLIST

Look out for pictures with strong single colours.
Try to find pictures where the colours are complementary.
Polarising filters are useful to maximise colour saturation.
Observe how the colour of the light changes constantly.
Experiment with the White Balance in mixed lighting.
Colour manage your workstation for consistent colour.
Use Curves in Photoshop to fine-tune the colour.

PHOTOGRAPHING COLOUR

Just as, sometimes, a portrait looks better in
black and white, sometimes it's the colours
in an image which make it special. Think of
travel pictures of Buddhist monks in their
saffron robes, or Masai tribesmen in their
rich red costumes, or even an individual's
intense blue eyes. It could be the setting that's
colourful, such as a brightly painted wall.

Pictures that succeed for their colour
do so for varying reasons, but the most
effective colour pictures tend to focus
mainly on a single palette or complementary
palettes, rather than a whole spectrum of
clashing hues.

Polarising filters are great for maximising
the colour saturation, by reducing reflections
on the surface, but they do cut the exposure
level by about two stops so they're best used
in bright light or with the camera on a tripod.

COLOUR OF LIGHT

To the unobservant eye light appears to be
much the same colour all the time, but in
fact it comes in a wide variety of hues and
is ever-changing. Candlelight is very orange,
fluorescent tubes tend to be greenish and
daylight varies from warm yellow-orange
at sunrise and sunset to bluish white on
cloudless sunny days, especially at high
altitudes. Your eye adjusts for this without
our noticing and so, in theory, does a digital
camera, via its auto White Balance control.

However, the camera doesn't always get
things right and when things go wrong you
get what is called a colour cast. This is
especially the case in mixed lighting, where
there is more than one light source, and the
camera can't decide which one to balance
for. Fortunately, there are options to override
the auto setting, including a range of presets
for specific lighting types and, in better
cameras, a means of measuring the colour
and setting the camera to the precise 'colour
temperature' (which uses the Kelvin scale
of measurement).

DIGITAL COLOUR

All digital cameras record what they see by means of sensors, which are grids made up of millions of tiny squares or 'pixels'. Each of these pixels is covered by one of three filters – either red, green or blue – and by measuring the relative values of adjoining pixels the camera's processor is able to work out what colour that part of the scene is supposed to be.

When an image is transferred to the computer the monitor uses the same 'RGB' colour system so colours should reproduce more or less the same, but variations in hardware and other factors mean that they probably will not unless some form of colour management system is used.

To further confuse things printers use a different system known as CMYK, which uses Cyan, Magenta, Yellow and Black inks to make an image and these produce a very different 'gamut' or spectrum of colours to RGB systems.

Managing these varying colour systems, and keeping them within defined parameters, is important if you want to be sure that what you print is what you saw when you took the picture.

COLOUR CORRECTIONS USING CURVES

Correct colours are essential when you are trying to achieve pleasing skin tones. There is nothing more off-putting than seeing a portrait of a person with slightly green skin, or if it has been over-corrected, seeing them with bright yellow skin.

There are lots of ways to alter the tone of your image's colour in Photoshop, but one of the most popular is called Curves.

Curves is found by selecting Image > Adjustments > Curves. The pop-up dialogue box displays a diagonal line that runs from corner to corner. This line represents the light area of the image at the top to the dark areas at the bottom. It allows you to manually adjust each colour separately from the drop-down menu, by dragging the line either up or down.

If you select Red from the drop-down menu and then drag the diagonal line upwards, your image will start to contain more red. If you drag the line down, it will contain less red, which in turn means it will start to look more green.

Follow these next steps to perform colour tone alterations using Curves.

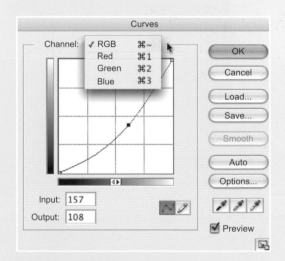

USING CURVES

Select Image > Adjustments > Curves from the image menu bar to bring up the Curves dialogue box. Then select the desired colour from the drop-down menu. From here you can choose from Red, Green, Blue or a composite of all three, depending on which colour space you are working with. Click and hold your mouse on the middle of the diagonal line in the dialogue box. Slowly drag the line either up or down to adjust the colour tone.

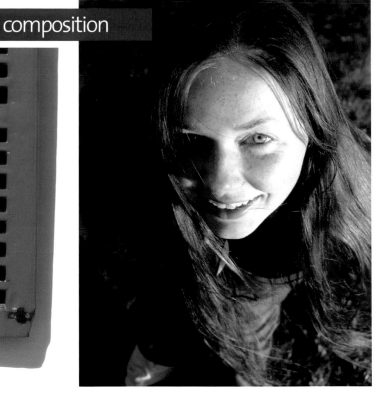

Above: Shooting down from above has created an interesting compositic
Left: Experiment with unusual compositions and crops.

Composition

Composing and cropping your subject are fundamental
decisions that have a profound impact on the result

CHECKLIST

Decide whether you want a full-length or head shot.
Crop just below the shoulders for a head shot.
You can crop into the head itself for a real close-up.
Most portraits are shot 'vertically', but try horizontals too.
Choose a pose that uses the frame if shooting horizontally.
Crop at the waist for half-length shots.
An unusual shooting angle can improve composition.

HOW CLOSE

People can sometimes be among the most difficult subjects to compose a picture around, as there are so many variables to consider.

Non-photographers – the snapshooters who take most of the world's pictures – tend to make the common mistake of shooting from too far away and placing the head right in the middle of the frame. The result is a portrait with loads of dead space around it, including a large area across the top of the frame.

One of your first decisions is how close you want to be to your subject. Do you want to see just his or her face or the whole body – or the whole body with some environment, too. Even assuming you only want to see the face, you have a choice as to whether you go right in close with a short focal-length lens or stand back and use a zoom or telephoto. Your decision will have a profound effect on the final result.

HEAD SHOTS

If you want to show only the face, the usual place to crop is just below the shoulders (hence the term 'head and shoulders') but it's also fine to crop across the mid-chest. It isn't a good idea to crop at the neck as this makes the head look cramped within the frame – though there are bound to be examples out there where this has worked.

If you want to exclude the shoulders go in really close and crop into the face. Although it may seem radical to crop out the top of the head, it's more common than you realise. Cropping out the top of the head makes a strong statement about the person you're photographing, and not everyone would be happy to be scrutinised in such detail, but it can work well.

It's best to stand back and zoom in if you want to crop this tightly. It will be less intimidating than shooting inches away and you're less likely to be standing in your own light and casting a shadow on the subject.

ORIENTATION

Traditionally, pictures taken with the camera held in the horizontal (standard) position are referred to as 'landscape', and when the camera is turned on its side the resulting pictures are called 'portrait'. I don't like this terminology because it implies that landscapes should always be horizontal and portraits vertical. In fact, horizontally arranged portraits work just as well as vertical ones, and there are thousands of great examples. However, it's probably fair to say that it's more difficult to get a good horizontal portrait than a vertical one, because you have the dilemma of what to do with all that space to either side of the subject. One obvious solution is to photograph the subject lying or sitting down, or doing something with his or her arms. By the angle at which you shoot, and where you crop, you can use the space well.

SHOWING MORE

So you want to show more of the person than just the face. Where do you crop now? Traditionally there are half-length, three-quarter length and full-length portraits, so start with these. Cropping at the waist is a natural and obvious place to crop. After all, the body itself bends and divides at this point. Three-quarter length portraits are more fraught with pitfalls. With a few exceptions, it's rarely a good idea to crop across the thighs, knees or calves. The main exceptions are if the subject is sitting or lying down, in which cases it can work well. If you do include the legs and feet in shot take care over the angle at which they're positioned. If they're pointing towards the camera they could end up looking disproportionately large in comparison to the face, especially if you're using a short focal-length lens. Unless that's your aim, try to keep the legs on a similar plane to the face.

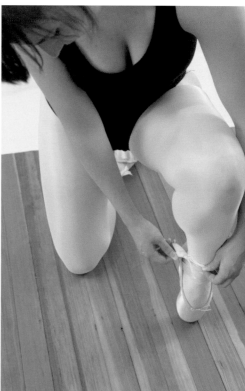

Left: Half-length shots are best cropped at the waist.
Above: Don't be afraid to crop off part of the head.

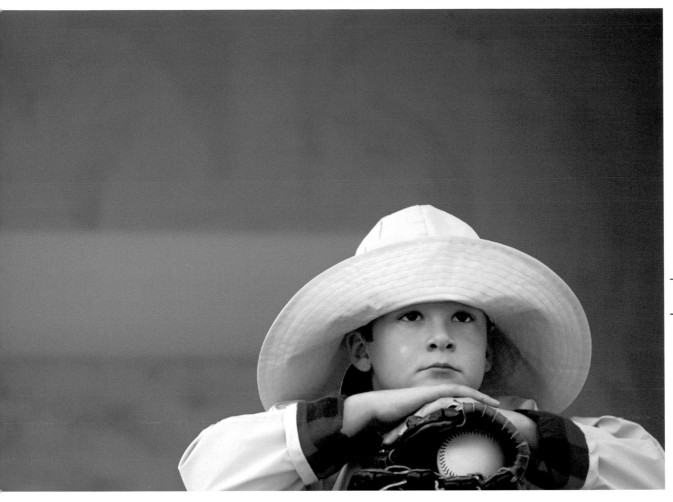

Left: Many people instinctively place the face in the centre of the frame, but off-centre compositions like this are often much more interesting. Here, the photographer has positioned the child according to the 'rule of thirds', placing his eyes on the intersection of a vertical and horizontal grid line.

ANGLES

Can't decide between vertical or horizontal? Then try the diagonal. Tilting the camera introduces a diagonal aspect to the image, which creates a sense of dynamism.

With close-up portraits, tilting places the eyes at different heights in line with the rule of thumb that recommends you avoid placing the eyes on the same plane. (Angling the head, by having the model lean on an elbow, for example, is another way to achieve this.)

When shooting, try tilting the camera, first one way then the other, to see if either orientation improves the composition. Take care, however, when the background includes buildings or the horizon, as these can end up at funny angles (though even this can work well sometimes).

Of course, you can leave the tilting till the editing stage if you prefer. Just leave a little space around the image to allow for rotation of your chosen crop within the canvas.

WHERE IN THE FRAME

The rules guiding the positioning of people within the frame are much the same as with other types of subject. The rule of thirds, whereby the frame is mentally superimposed with a 'noughts and crosses' grid and divided into nine equal parts, is a good place to start. Especially with horizontal portraits, where there is more space to manage, placing the subject on one of the intersections of the grid creates a harmonious composition. This also works with vertical shots. With full- and half-length shots aim to position the head on one of the thirds, and with head-and-shoulder shots make try placing the eyes along one of the horizontal grid lines. This of course is only a guide, and placing the subject dead centre can exude a sense of drama and confrontation, especially if he or she is looking directly into the camera at close range. Challenging the accepted rules can produce outstanding results, but only if it's executed in a deliberate, intelligent way.

VIEWPOINT

Most photographs are taken with the camera at eye-level, but by changing your viewpoint it's possible to create portraits with more impact. Looking down from above can portray the subject as small or fragile, or can simply present an unusual and unexpected point of view. High viewpoints are popular in fashion, nude and fine-art portraiture, with the model sitting or lying on the floor, a chair or sofa. Outdoors they may be on a beach or among fallen autumn leaves. The photographer may be able to get the shot from a standing position or may have to stand on a bench or shoot out of an upper storey window.

Low viewpoints are equally dynamic, but this time it is the photographer who must get down low, while the subject climbs to a higher position. Care must be taken to avoid unflattering 'up-the-nose' shots, and lighting can be tricky, but since these type of shots are fairly experimental in nature you can be a bit more creative in how you light them.

LINES AND FRAMES

Try using compositional devices to draw attention to your subject or create a more pleasing, harmonious image of them. One way is to use elements (such as a fence) to create a diagonal line through the image and lead to the subject. These leading lines help to guide the viewer's eye and draw it to the subject.

Placing a subject against a repeating pattern, such as vertical lines, can also be highly effective, if the subject is placed strategically to harmonise with or break up that pattern.

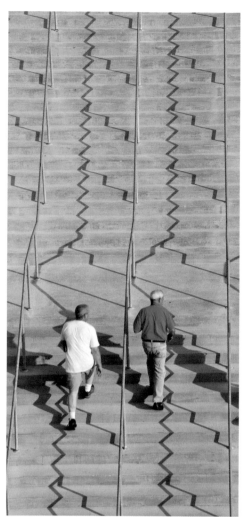

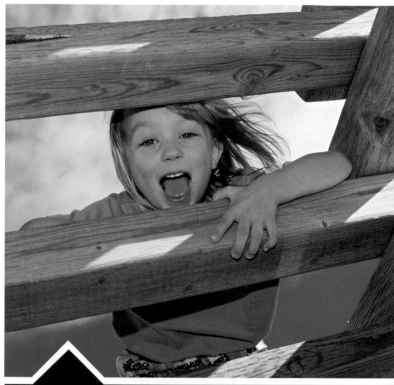

You've been framed

One of the best compositional tricks is framing. Place the subject in a window or have him or her leaning between the boughs of a tree or sitting in one of those concrete pipes you find in children's playgrounds. Alternatively, try using the subject's own hands and arms to frame the face. Framing the subject draws the eye to the face and creates a pleasing image.

PERSPECTIVE

The choice of lens plays a vital part in your composition. Wide-angles create a distorted sense of perspective, making nearby subjects appear bigger than those further away. Going in close with a wide-angle can be useful in group photos where you want one person to be more prominent (say, the lead singer of a rock band) or when you want to show a wide area of background (your kids standing in front of a cathedral, for example). The downside of wide-angles is they distort facial features if you get too close. Noses become elongated, faces become caricatures. The more wide-angled the lens the more extreme the effect.

Telephotos force you to stand further back and create a more flattering representation of the face. They draw the background closer but throw it out of focus, so they're ideal for making a face stand out against a blurred background, or making one face sharp in a busy street filled with blurred faces.

TOP *TIPS!*

1 RULE OF THIRDS
Try placing your subject one-third of the way in from either side of the frame.

2 USE LEADING LINES
Use lines within the frame to lead the eye to the subject, such as a wall or fence.

3 FRAME THEM
Place your subject within natural frames such as windows, arches or under a tree.

4 GET CLOSE
You don't have to include the entire person. Don't be afraid to crop in really close.

5 GO HIGH OR LOW
Change your viewpoint to a high or low one for a more interesting composition.

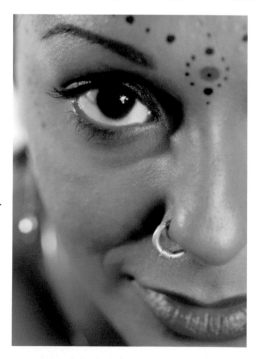

Computers

With digital photography taking the picture is only half the story.
To enjoy the full digital experience you'll also need a computer

CHECKLIST

You don't always need a PC to enjoy digital photography.
You do need a PC if you want to get the best results.
Get a minimum 80GB hard disc and 1GB RAM.
Download your images via USB or a card reader.
Use album software to file and organise your photos.
Editing software is for enhancing and manipulating them.
Most software can be downloaded from the Web.

THE DIGITAL WORKSTATION

While its fairly obvious that to get the best out of digital photography you need a computer it is by no means a prerequisite. It's simple to take your camera or media card into a high-street printing lab, just like you did in the old days of film, and have your images printed and saved on to a CD so you can reuse the card. In fact, you can even buy single-use media cards so you can skip the CD stage if you like.

There's no denying, though, that without a PC, you'll only be getting half of the benefits that digital photography offers.

If you don't own a PC, or you do but it's a few years old, then you'll find that an investment of a few hundred pounds in a new system will bring huge rewards to your photography. Not only will you be able to print your own pictures, you'll be able to enhance, improve and transform them, email them to friends and family, put them on a website and much more.

HARDWARE REQUIREMENTS

As camera sensors get bigger and software gets more complex the demands on your PC become greater. Most imaging applications now take up hundreds of megabytes of disc space and require at least 256MB of RAM.

A PC ready for digital photography should come with a minimum 80GB hard disc and 1GB RAM. You'll need a good graphics card too if you don't want to spend a lot of time waiting for your PC to process the images. Make sure you get plenty of USB 2.0 ports for the various peripherals you may attach.

There's still some debate about whether a Mac or Windows PC is best for imaging. Macs were better in the past (being designed specifically for imaging), but Windows XP has brought that platform pretty much up to parity. Macs still perhaps have the edge for ease of use and reliability, but it's marginal and you'll have to pay more for the privilege. There's also a lot less choice when it comes to software, which would be particularly disadvantageous if the PC is for family use.

DOWNLOADING IMAGES

Getting your pictures out of your camera and on to your computer hard drive is a relatively straightforward process. You can either connect your camera direct to the PC via the supplied USB cable (you may need to install the camera's driver software first in order for the PC to recognise the camera) or invest in a media card reader and insert your media card into that. Some cameras come with a docking station or 'cradle' which stays permanently connected to the PC. When the camera is placed in the dock it automatically downloads any images and recharges the battery.

Images can be stored anywhere on the computer, but with Windows PCs the obvious place is the 'My Pictures' folder. Most new Apple Macs come loaded with iPhoto for organising and viewing your pictures. It automatically downloads and stores all your images.

FREE SOFTWARE

If you've spent all your savings on a good camera and have nothing left over for the software you'll be pleased to hear that there's lots of free software available for download on the Internet, some of it of exceptional quality. GIMP is a free editing application with most of the professional functionality of Photoshop. Picasa, owned by Google, is a more consumer-friendly editing/sharing product with a user-friendly interface. IrfanView is a highly regarded image-organising application that's been around for a long time. Check out a website such as www.download.com for these and other applications.

Left: There's a lot of free photo software on the Web, some of it excellent.
Above: The more ambitious photographer may want to buy one of the numerous specialised applications on the market.

TYPES OF SOFTWARE

There's a huge variety of imaging software, which can be divided into several categories:

EDITING

One of the first things you'll want to do to your pictures is make improvements. You may want to improve the colour, contrast and brightness, crop out unwanted areas, remove red eye, and remove or rearrange elements within the image. The 'daddy' of editing software is Adobe Photoshop, but it's costly and offers more than most users need. While serious enthusiasts would benefit from this investment, the more casual user would find one of the numerous consumer programs more suitable.

ORGANISING

Leaving your pictures scattered over your hard disc is not a good strategy. You're liable to lose pictures, and it will be a nightmare trying to find them. Image-management software (or 'album' software) keeps all your pictures together (or keeps tabs on where they all are) and offers a simple interface for viewing, sorting and cataloguing them. You can add searchable keywords such as 'kids' and 'holiday' and share selected pictures in a variety of ways, from printing to slide shows.

Increasingly, consumer imaging programs offer both editing and organising in a single product, such as Adobe's Photoshop Elements.

RAW PROCESSING

Most digital cameras compress the images they take and save them as JPEG files, which take up less space on the media card, but do cause some loss of image quality. Some advanced cameras offer a RAW mode, in which images are unprocessed by the camera. They take up more space, but offer best quality. However, special RAW processing software is required to open and work with the images. Photoshop can open most RAW files, but there are a variety of specialised RAW processors offering greater functionality.

PLUG-INS

Photoshop can be souped up by any number of plug-ins, which add specialised functions. There are hundreds available, some free and some costing hundreds of pounds, offering everything from smart sharpening to image unscaling and special artistic effects.

DOWNLOADING SOFTWARE

Although it is possible to buy most software applications in traditional boxes, from online and high-street retailers, a popular alternative is to download it directly from the manufacturer's website. This has become especially popular with the introduction of broadband, where the large sizes of many applications are less of an issue. This offers the advantage of instant delivery albeit without a physical product at the end of it.

Concerts and Gigs

Thousands of young music fans dream of being able to get up close
to photograph their heroes, but concert photography is no easy gig

CHECKLIST

Make sure you have permission before the event.
Find an unobtrusive shooting position.
At small venues try to shoot from the back.
Use a 70–200mm lens for close-ups and wider sh
Make sure you use a hand-holdable shutter speed
Metering can be a problem. Take a test shot first.
Don't use flash. It will kill the atmosphere.

CONCERTS

Whether you aspire to shoot U2 or just get
some decent shots of the kids' school show,
concert photography presents challenges.
However, both scenarios share much in
common, it's mostly only a matter of scale.

The first step is to ensure you have
permission. Most schools allow parents to
photograph their concerts, but a few can be
paranoid about it. In any case, make your
intentions clear, especially if you're using
professional-looking equipment.

At all public venues – pubs, clubs and
concert halls – permission is essential.
Contact the management and explain what
you want to do. Many will say no, but the
smaller the venue the greater the chance of
success, especially if you offer pictures in
return. Some will ask you to sign a contract
limiting what you can do with your pictures
afterwards. At professional concerts you'll
probably only be allowed to photograph for
the first two or three songs, without flash.

VIEWPOINT

At any event with an audience, finding a
viewpoint that does not disturb the viewing
pleasure of everyone else can be a problem.
At big concerts there's usually an area in
front of the stage for photographers, and for
the short duration when you'll be allowed to
shoot, those behind just have to put up with
it. At smaller venues try to find a spot which
doesn't block anyone's view.

Perhaps the best place to stand at small
venues such as school concerts is the back
of the room, behind all the seats. Here you
won't be in anyone's way and will be able to
shoot over the top of the audience without
causing a distraction, though you'll need a
longer lens to fill the frame with what's
happening on the stage. Being at the back
also makes it easier to photograph groups
of performers on either side of the stage,
whereas if you're at the front you're bound
to be much closer to some performers than
others, unless you're in a good central position.

EQUIPMENT

The primary requirement is a zoom lens
which covers at least the equivalent of about
70–200mm. At big venues, even if you're
in front of the stage you'll need a lens of
this magnitude to fill the frame with the
performers. When you're at the back of small
halls it's even more essential to crop out the
audience and fill the frame with the stage.
An SLR is essential for all but the school
play, or you won't be taken seriously. You'll
also find that you get better results with an
SLR: they're more responsive, have better
metering systems and, essentially, lower
noise in low light. This last point is important
because light is often in short supply at
concerts. If you can afford a fast zoom with
an f/2.8 maximum aperture so much the
better. If not, a wide-aperture prime lens,
such as a 135mm f/2.8, or even a 50mm
f/1.8, may be a good addition and they're
easy to pick up secondhand.

EXPOSURE

With moving performers it's essential to use a shutter speed fast enough to freeze any movement, which generally means at least 1/125sec and maybe higher if you're using a big zoom. Tripods are not practical so you'll have to practise postures which hold the camera as steady as possible. Selecting shutter priority and a shutter speed of 1/125sec or higher will ensure that your speed stays high enough, but this will only work if the light level is high enough to keep the requisite aperture within the range of your lens, or underexposure will result. If you find that at 1/125sec you need an f/stop of f/2 and you only have an f/2.8 lens, you'll have to raise the ISO setting or underexpose and hope to recover any lost detail using Levels in Photoshop. Alternatively, set aperture priority and leave the lens wide open, which means the camera will select the fastest speed it can.

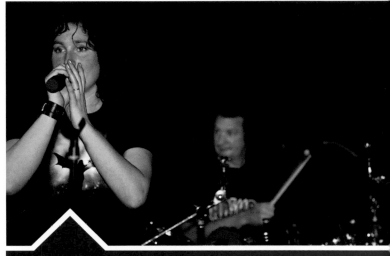

No flashing allowed

So far we haven't discussed flash. That's because, in general, flash is not a good idea at concerts. Leaving aside the fact that it may disturb the performers and distract the audience, it will surely kill any atmosphere that the show's lighting people have taken the trouble to create.

There's also the not insignificant fact that flash is useless anyway beyond about five metres, so unless you're very close (close enough to blind your performers) it will have little effect anyway.

There may obviously be a few exceptions, and in these situations TTL flash should give a reasonable result if you're within range, but if the subject is on a dark stage with an open space behind him the flash is very likely to overexposure. Check your histogram (or the overexposure warning display on the LCD) and adjust if necessary.

METERING

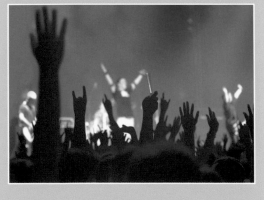

The light at most concerts is constantly changing, which makes metering a nightmare. Bright spotlights, strobes and coloured lights easily fool most meters so it's best to exclude them from your readings. If you can, use spot metering and take readings off your subject's face, as this is the crucial area to get right. Check the histogram on your LCD after a test shot and use exposure compensation if necessary. At school and amateur concerts where the lighting is more consistent and less spectacular you may have more time to make sure your exposures are accurate. You may be able to use evaluative metering if the light is even across the stage, but for spotlit performances revert to the spotmeter and zoom right in to the lit area of the stage.

Light levels are usually very low too, so you'll probably find yourself needing to set an ISO of 800 or even 1600 to get a usable handheld shot.

Above: This informal shot works well because of the eye contact between the couple.
Left: A posed portrait can still look informal and relaxed if your subjects don't feel awkward.

Couples

It takes two to tango – and to make a successful couples shot.
Posed or spontaneous, photographing couples can be twice the fun

CHECKLIST

Two subjects doubles the chance of a bad expression.
Make sure 'couples' are photographed in physical contact.
Try positioning them so they're facing each other.
Alternatively, place one behind the other, but touching.
Try setting up situations where you can get candid shots.
Have your subjects do fun things together.
Take lots of pictures to increase the chance of success.

TAKE TWO

Taking a great portrait of an individual isn't easy, so it stands to reason that when you introduce a second person to the picture your job becomes twice as difficult. Two faces means there's twice the risk that someone will be captured with a bad expression; two sets of eyes doubles the chance of someone blinking.

Then there are the posing challenges: four hands to wonder what to do with, four legs to look ungainly and awkward. Finally there's the orientation challenge: when you have two people in shot is it best to shoot with the camera vertically or horizontally? Sometimes neither option seems right – in which case you may have created yourself a composition that begs to be square.

Many successful high-street portrait photographers have a repertoire of half-a-dozen poses which work really well with most couples and they stick with those, so that's a good place to start.

COUPLING

Assuming that your couple is in a loving relationship, one of your main tasks is to convey this in the photograph, and the easiest way to do this is by physical contact between them.

One approach is to have both subjects next to each other but facing inward at a 45-degree angle towards each other, forming a 'V' shape. This works with both parties standing, or sitting on a chair or on the floor, or with one sitting and one standing. To add that extra sense of intimacy the couple could hold hands or hug. If you study portraits of couples you'll find a good percentage are a variation on this theme. In fact you can also photograph any pairing this way, whether they're a couple or not – though obviously if they're related you wouldn't necessarily have them holding hands.

INFORMAL APPROACH

So far we've talked about posed portraits of couples, but these can look a bit staged, especially if either party is self-conscious.

A more natural tack is the spontaneous, candid style. For this it's best to leave the backdrop behind and go for real settings, whether it be the living room sofa, the garden or a public place. You'll obviously need to give the couple some direction and a basic pose to work with, but the idea is to create a sense of fun and interaction. Try and get them to relax and to laugh, but always to remain in physical contact. Suggest some poses that may generate some laughter. Ask the guy to pick his partner up off the ground or give her a bear hug, and record the ensuing mayhem. Use outdoor props, such as placing your couple on either side of a pillar, peering round. Take lots of shots because great expressions are fleeting, and the chances of both parties having one are obviously considerably smaller.

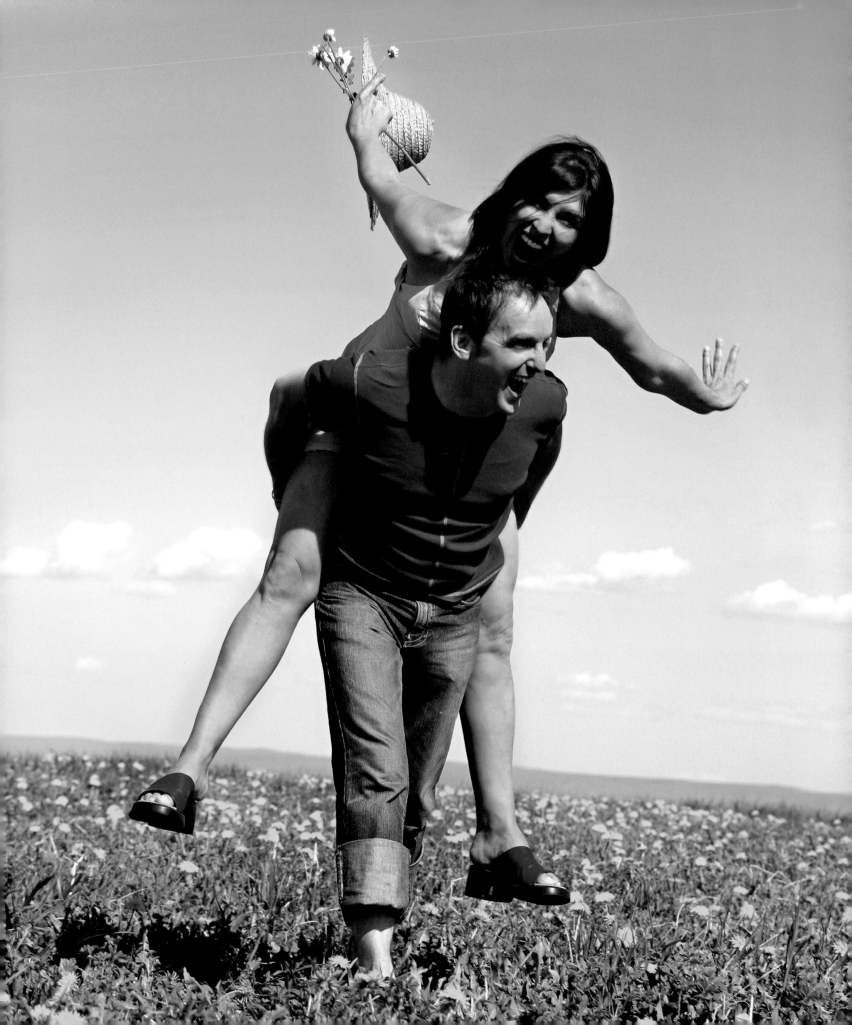

Above: 'High key' portraits are almost exclusively composed of tones at the light end of the spectrum.
Left: Including bright areas of sky in shot can fool the meter.

Exposure

Not too dark, not too light, but just right. Exposure is a balancing act that your camera performs every time you take a picture

CHECKLIST

Correct exposure is determined by your camera's meter.
The aperture controls how much light hits the sensor.
The shutter speed determines how long the exposure.
Cameras assume your scene averages to mid-grey in tone.
Exposure is subjective, depending on the result required.
Meters can be fooled by very dark or light subjects.
Set an exposure that will provide the result you're seeking.

EXPOSURE

A cake in the oven requires just the right combination of time and temperature to come out right. If the oven is too hot or the cake left in for too long, it will be burnt. But an insufficient cooking time, or too low a temperature, and the cake will still be uncooked in the middle.

Photography is, in some ways, very similar. A picture requires just the right amount of light to make a good picture. This amount is described as its exposure. Too much, or too little, and the picture will suffer. Exposure is controlled, primarily, by a combination of two controls: the aperture (the size of the lens opening), which is equivalent to the temperature dial on the oven, and the shutter speed (the amount of time for which the sensor is being exposed), which is equivalent to the timer.

As well as conspiring to produce a perfect exposure, the aperture and shutter speed have a strong bearing on the look of the final image.

MEASURING LIGHT

Cameras ascertain the correct exposure by the use of a meter built-in to the camera which measures the light and adjusts the shutter and aperture accordingly. Most scenes contain a mix of tonal areas, from bright highlights to deep shadows, and the meter's aim is to strike a happy balance between these. If the exposure is too great the highlights will be overexposed and burn out, losing all detail. But too little and the shadows will be underexposed and disappear into a black mass.

The precise exposure needed will depend on how bright the light is, and on the tonal range of the subject itself (dark subjects require more light than bright ones). It also depends on how sensitive the camera's sensor is to light. Fortunately, this can be adjusted, so if there isn't enough light to take a reasonable picture, the sensitivity of the sensor can be increased – albeit with some loss of quality.

IMPORTANCE OF GREY

Cameras assume that if you were to mix up all the tones in a scene from the lightest to the darkest, the resulting colour would be halfway between black and white – otherwise known as mid-grey, or 18 per cent grey. But this would only be the case if there were a roughly equal proportion of light and dark areas in the first place. In scenes where this is not the case (ski slopes, cloudy skies, beaches, night scenes, etc.) the meter will most likely be confused and get things wrong. Modern meters contain sophisticated programs to predict when this may occur and take evasive action, but although these programs work some of the time you need to keep a close eye on them, and you may have to step in and override the reading given by the meter, either by dialling exposure compensation or taking a selective meter reading off an area of the scene that you wish to render correctly (for example, a skin tone).

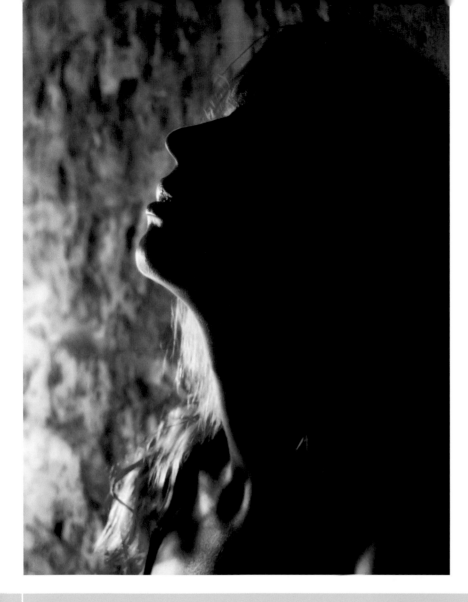

TOP *TIPS!*

1 CHOOSE YOUR METERING PATTERN
Multi-area metering is ideal for general use, though sometimes you may prefer to select the spot meter and take a reading off a small area of detail, or use centre-weighted and take an overall average.

2 CHOOSE YOUR METERING POINT
If taking selective readings, decide which part of your scene you want to be rendered mid-grey and take your reading off that.

3 RETAIN SHADOW AND HIGHLIGHT DETAIL
The usual aim is to select an exposure that will record detail in both the brightest and darkest parts of the image. Sensors struggle to retain bright highlight detail, making slight underexposure advisable.

4 EXPOSURE IS SUBJECTIVE
Sometimes for creative effect it's best to go for a brighter or darker result. You may want to turn a person into a silhouette or go for a washed out high-key portrait where the background is blown out.

5 CHECK YOUR HISTOGRAM
Don't just rely on the image on the LCD: use the histogram to check that you have a good spread of tones, or set the overexposure warning, in which overexposed highlights flash on and off on the LCD.

SHUTTER SPEEDS

The shutter speed control on a camera determines the duration for which the sensor is being exposed to light. A typical camera may have a fastest shutter speed of 1/8000sec and a slowest of 30 seconds or longer. The increments in between are called 'stops' and each stop represents a doubling or halving of time from those either side of it. For example, 1/500sec exposure time is twice as long as a 1/1000sec exposure, but half as long as a 1/250sec one. Most digital cameras offer manual adjustment in half- or third-stop increments, or stepless adjustment in the auto modes.

Fast shutter speeds have a variety of benefits, but the main one is that they 'freeze' movement. A fast-moving subject can be made to appear stationary if the shutter speed is fast enough. Slow speeds on the other hand can be used to create deliberate blur of movement for creative purposes. Caution must be used with slow speeds, however, to avoid the risk of blur caused by camera shake. The slowest shutter speed at which it is safe to hand-hold a camera without a support (such as a tripod) depends on the lens used, but with modern standard zooms it's typically around 1/125sec.

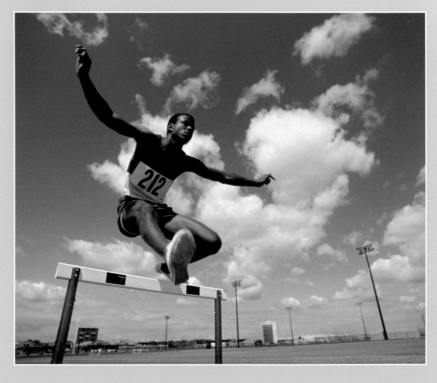

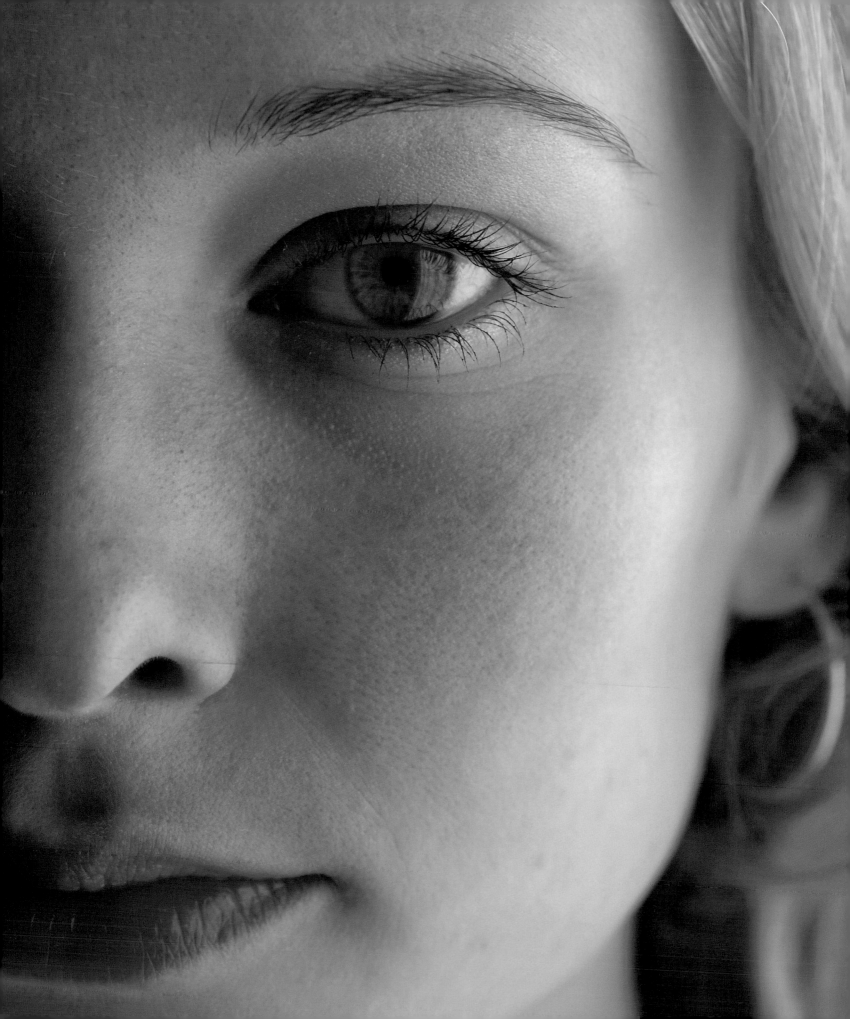

APERTURES

The size of the lens opening determines the intensity of light reaching the film. The wider the aperture the more light gets through and the less time the shutter needs to be open. Small apertures cut down the light, requiring longer shutter speeds to compensate. Apertures, also known as f-stops, are also marked in increments called stops, which halve and double the amount of light they let though as you go up and down the scale. Unlike shutter speeds, though, there isn't a direct mathematical relationship between the numbers. A typical consumer zoom lens may have an aperture range that goes from around f/4 at the widest down to f/22 at the smallest. Good professional zooms open as wide as f/2.8, and fixed focal-length lenses can go wider still. Wide apertures are useful in low light, but they have a useful side effect in producing very shallow depth of field (the zone of sharp focus in front of and behind the point focused on). Small apertures on the other hand require a lot of light or a tripod, as they cut out a lot of light, but they do create maximum depth of field – ideal for landscapes where you want everything sharp from foreground to background.

Above: Dark skin may underexpose if it's metered against a light background.
Left: For accurate skin-tone exposures, take a reading off the face and do a test shot.

SKIN TONES

With portraits it's important to capture the skin tones properly. Taking a selective reading from the face will ensure it's exposed correctly even if the surrounding parts of the scene are darker or lighter.

Some photographers like to overexpose the skin slightly to reduce any blemishes and create a smoother-looking skin tone, especially with fashion and beauty shots of women.

On the other hand, underexposure creates dark shadow areas which enhance a sense of mood or mystery.

EXPOSURE WITH DIGITAL

Digital camera users can easily get lulled into a false sense of security regarding exposure because of the LCD screen on the back. If the shot looks okay to the eye on the back of the camera it's assumed to be fine, but the LCD is only a guide. For one thing it's too small to see in detail, and in bright light it's difficult to view at all.

Fortunately, even some relatively simple cameras offer exposure aids to help reassure the user that all is okay. The most common of these is the histogram display, which shows the spread of tones within the shot as a graph. A good exposure should have a reasonable spread of tones across the range, not all bunched up to one end. Some cameras also have an overexposure warning in which any highlight areas which are 'blown' (in other words, all the detail has been lost) flash on and off on the display. Since overexposure is harder to fix on the PC than underexposure, it is the highlights that need a particularly diligent eye.

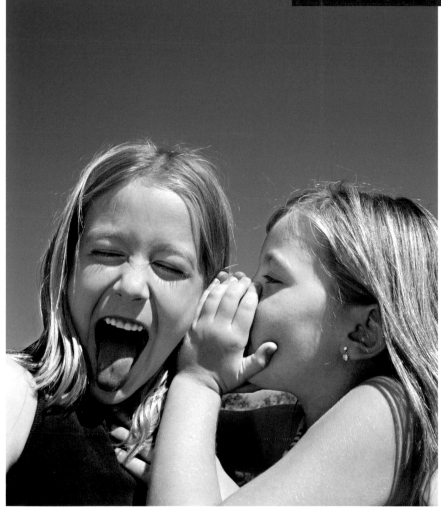

Above: Sometimes a serious expression says more about a person.
Left: Natural smiles can look great, but avoid asking for fake ones.

Expressions

Getting the right expression is key to a successfu
portrait – but that need not be a smiley face

CHECKLIST

- Try to elicit natural smiles rather than forced ones.
- Smiling isn't essential. Try a serious expression.
- Think about the mood you're trying to convey.
- Make sure the eyes are sharply focused.
- Take lots of pictures to ensure a winning expression.
- Don't over-direct models unless they're professionals.
- Silly faces can make fun pictures, especially with kids.

A WORD ABOUT SMILING

There's a misconception that the only suitable expression for portraits is a smile. As a result, the world is full of cheesy, wooden portraits which say nothing about their subjects.

Aspiring portrait photographers should spend time looking through magazines where portraits (posed, not paparazzi snaps) feature heavily. You'll notice one significant point – the almost complete absence of smiling.

Smiling isn't bad. A natural smile is great. But the difference between a real and an artificial smile is as obvious as the difference between real and artificial grass. The fact is, for most of us a smile is not our default expression. People simply don't walk around grinning for no reason, and on the rare occasions that we encounter such people our natural reaction is to cross the street to avoid them. There is, therefore, no reason why portrait subjects should be grinning and asking someone to 'say cheese' on command is a sure way to ruin a good photo opportunity.

NATURAL EXPRESSIONS

The aim of most portrait photographers is to capture the essence of the subject, to identify some aspect of his or her charisma and succeed in recording that. Many portraits are virtually expressionless; the subject simply looks straight into the camera, makes eye contact with the viewer and, in some way, bares his or her soul. As the cliché goes, the eyes are the windows to the soul, and should be the focal point of any portrait that attempts to expose it.

There's a famous story about legendary photographer Yousuf Karsh whose wartime portrait of Winston Churchill is the definitive image of him. Karsh wanted to capture that 'fight them on the beaches' expression that he was famous for, but wasn't having much luck. As the legend goes, Churchill was smoking a cigar, so Karsh snatched it out of his mouth. Churchill was palpably indignant and Snap! went the shutter. Karsh had his shot.

This isn't to say that you should set out to antagonise your subjects, just to think about just what it is about your subject that you're trying to capture. What expression sums up the subject? Try to elicit that expression. Usually you'll need to relax the subject first, chat, and get him or her to forget about the camera and 'open up'. If a happy, smiley shot is your aim, try to achieve it through humorous banter.

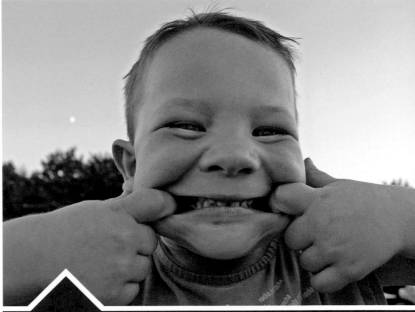

Pulling faces

Children like to play up to the camera and sometimes this can be annoying, especially when you're trying for a nice happy portrait for granny. But other times it's best to just go with the flow and keep shooting. On this occasion, during a picnic, we were messing around taking 'silly face' photos, but this one really summed up the 'cheeky monkey' character of the subject and has since become a family favourite.

PHOTOGRAPHER AS A DIRECTOR

There's one group for whom the intention is usually not to capture their soul: models. A model's job is to produce any expression required by the photographer, on command, and make it look real: happy, sad, angry, confused, tired.... Here is one group you can say 'smile' to and you should get something that looks vaguely like a real smile.

Models exist because, sometimes, photographers aren't seeking to capture who the person is: they have a concept or idea in their head and merely require someone to act that concept out for them.

Most of us can't afford to hire models so it's tempting to ask friends, relatives or the local barmaid to model for us but remember that it takes a special skill to be a good model. If you have a vision in mind you'll have to work harder with amateur models and be more patient. Try acting out what you want yourself, so they can see it, rather than just trying to explain it verbally.

TOP *TIPS!*

1 SMILING ISN'T ESSENTIAL
Genuine smiles are great. Fake ones aren't. It's as simple as that.

2 CAPTURE THE PERSONALITY
Aim for an expression that sums up the subject, whatever that may be.

3 THE EYES HAVE IT
The eyes are the windows to the soul, so make sure they feature prominently.

4 USING MODELS
Professional models are trained to express any emotion you ask for. Research agencies on the Web.

5 AMATEUR MODELS
Explain clearly the emotion you want and show it on your own face as a guide.

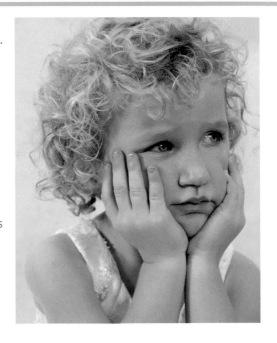

Above: Use the self-timer or ask a passer-by to get a shot of the whole family together.
Left: Adults should crouch down to the child's level so their heads are on a similar plane.

Family Portraits

Most portraits taken in the world are of the family. You can take great family shots if you follow a few basic tips

CHECKLIST

Photograph your own family often, not just at events.
Use the self-timer for group shots that include you.
At big family gatherings get shots of the extended family.
Always have a camera ready for candid moments.
Posed studio portraits make a great gift for framing.
Make sure you archive all your family photos.
Share them with others, via prints and email.

FAMILIES

Photographers often strive to create works of art in their photographs of the world around them, yet strangely fail to apply the same rigour when it comes to photographing the most important people in the world: his or her family. Your family deserves better than a haphazard, random collection of carelessly composed snaps to pass on to future generations, so if you haven't yet started to create a proper record then now's the time to start, before it's too late.

The best way to approach your family photography is as a long-term documentary project. You're capturing for all time fleeting moments in your family history, an archive that will fascinate your grandchildren and great grandchildren. This means not only taking the camera along to every major family event, from weddings to school concerts, but having it handy for those smaller moments that happen around the home when you're least expecting it.

LANDMARKS

Family histories are punctuated by landmarks: your wedding day, the birth of your first child, its first smile, first steps, first day at school – the list is endless, and continues through to university graduation, his or her wedding, the births of your grandchildren and so on. Taking on the role of family archivist is a lifetime's commitment, and will be taken up by your progeny once you're gone.

Even a snap of these occasions is better than no record at all, but if you can capture something a little more artistic it will be more rewarding both for you and those who view the picture. But try to avoid being a photo bore, and taking over every family occasion and turning it into an arduous photo shoot in which everyone loses the will to live, as your family will start to resent your good intentions. Be brief and as unobtrusive as possible. At larger family gatherings go for a quick group shot and then maybe stick to candid snaps.

POSED PORTRAITS

One good idea is to shoot a family self-portrait every year, possibly in the same style and maybe even in the same spot, so that over time these can be used to show how the family has grown and aged over the years. It's probably best to do it at the same time every year, and Christmas is as good a time as any, since you can also, if you wish, turn it into a Christmas card that you can send out to everyone. Birthdays are another good opportunity for some posed shots of both the birthday boy or girl and the family group.

Be creative in your choice of setting and posing: don't just stand the subject up against a wall and fire away. A comfortable chair by a window is a good spot, as is a shady spot under a tree in the garden. A plain wall is fine too, but at least pose the subject in such a way that he or she looks relaxed and comfortable. (For more on posing, see page 112.) Of course no family portrait would be complete without you in

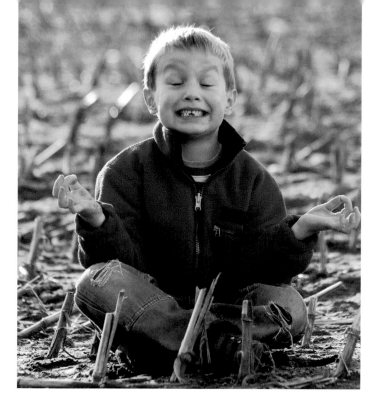

CANDID CAMERA

It's a cliché that kids do the funniest things when you least expect it. For this reason you should always keep your camera within easy access, with the batteries charged, so that if a photo opportunity happens all of a sudden, you can have a picture of it within seconds.

Take a camera with you when you go out. It can be handy not only if, heaven forbid, you're out with your family and have forgotten your main camera, but can also be used in an emergency to record an accident if you find yourself in that situation. Camera phones are increasingly fulfilling that role as the spare camera.

The studio portrait

Although candid outdoor portraits usually convey more character and emotion, posed studio portraits have their place too, especially as a record of how all the family looked, together, at a given moment in time. If you take them (or have them taken) at regular intervals you can compare directly how your family ages through the years.

the shot. The easiest way is to ask a relative or friend to get a few shots of your immediate nuclear family together, but you can also do them at home using the self-timer and a tripod or other support. Set everyone else up first and leave space for you to jump in after pressing the button. Take several shots and check them on the LCD to make sure you've got a good one before you put the camera away.

CREATING AN ARCHIVE

Recording your family's big moments can be in vain if you're not methodical about storage. If they're scattered over your PC your record will lack chronology. You will be staring at a shot of your child in ten years' time, thinking 'was he five or six in this picture?'

Keep your photos together in one place on your PC such as the My Pictures folder. But your family record will certainly outlive your computer so they should also be archived regularly to CD or DVD disc, or external USB hard drive (preferably both, as technology goes wrong sometimes).

Your camera should capture the 'EXIF' data for every picture – a record of the date each shot was taken, as well as camera and exposure data, but add a basic caption to each shot which describes it. Use image-management software to sort your shots into albums, label them and archive them. They're cheap to buy (some are even free) and greatly simplify the archiving process.

SHARING

Having your entire family archive on CD-ROM is a good way to store them, but isn't a convenient way to share them with others. Take every opportunity to let family and friends see your pictures. There are now more ways than ever to do this.

The easiest is to join one of the many online photo-sharing websites, such as Flickr, Snapfish and Photobox. These allow you to upload your photos to their website which you can allow the world (or just your family) to look at. Most offer a printing service and products like hardback books which you can order for relatives or they can buy themselves.

Not everyone in your family will have Internet access, so don't forget to give them prints on a regular basis. You can either order these online, from high-street stores or make them yourself. And how about a framed print as a present, either of a single family portrait or a montage of shots taken over the year?

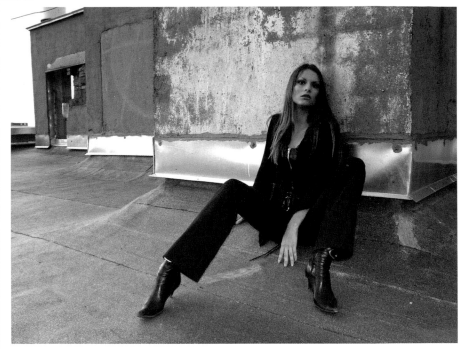

Left: Fashion is about the clothes and accessories. **Above:** A good model instinctively knows how to pose.

Fashion

This exclusive world of glamour, style and beautiful people sounds like a photographer's dream, but finding success can be a nightmare

CHECKLIST

An interest in clothes is essential.
Study the pictures in glossy fashion magazines.
Practise on friends and relatives.
Develop your own individual style.
Be experimental: break the rules to see what happens
Learn to master soft lighting for beauty work.
Build up a portfolio if you want to get published.

A LA MODE

Fashion photography may seem like one of the world's most glamorous professions, but it's also one of the most ruthless and competitive. It goes without saying that an interest in clothes and fashion is a prerequisite, as is an instinctive feel for social trends. Beauty photography is a sub-genre of fashion – it graces the same style magazines – but is more concerned with the face and body than what adorns it. Both genres, however, share a common goal: the pursuit of perfection.

HONING YOUR FASHION SKILLS

The best place to go to learn about fashion photography is the newsagent's. Study the pictures in the fashion magazines such as *Vogue* and *Elle*. Try to figure out how the photographer took the pictures. What sort of lens was used: was it a wide or small aperture? How was it lit? Look at the poses. Be critical. Cut out and file the pictures you really like and try to work out what it is that appeals about them. Next, find a volunteer (see Models, page 96) and try out some of the ideas you've picked up. At first, you could just try copying images you've seen, but eventually you'll want to develop your own style. As you do so, study your results critically, and keep shooting until you're quite confident in what you're doing.

Fashion lends itself to experimentation more than most other genres, so don't be afraid to push the boundaries with lenses, viewpoints and lighting, and with accessories such as flash.

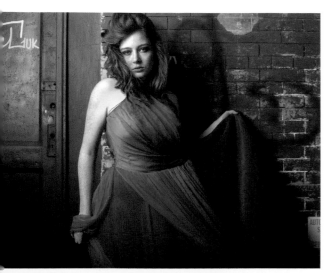

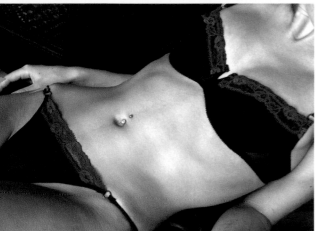

YOUR PORTFOLIO

If you're just shooting for your own amusement, as a hobby, that's great. But if you want to break into the industry and see your photographs published in fashion magazines, then the pictures themselves are just the start.

The first thing any aspiring fashion or beauty photographer should do is put together a portfolio. No magazine picture editor or commissioning editor will hire an unknown, untried photographer without being pretty confident they can do the job, and the only way they can gain this confidence is to see some examples of previous work. A website makes a great calling card. An introductory letter or email can refer whoever commissions the photography to your website, and they can take a quick look without taking up too much time or making any commitments, or without the potential embarrassment of the photographer being present.

Although this is a good starting point, most picture editors will still want to see a proper, real-life portfolio. Some photographers favour displaying images as prints, others as large-format transparencies in black card mounts. If you've been published before, tear sheets should also be included.

BEAUTY

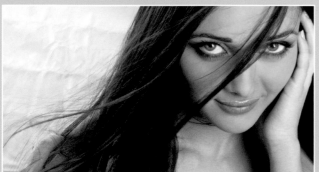

Most studio-based beauty photography is lit in a similar way, so much so that it tends to be called 'beauty lighting'. Large, diffused light sources (usually softboxes) are placed on each side of the model, at about 45 degrees and just above the eye-line, for shadowless, even lighting. Many photographers add reflectors under the chin to bounce light up from below. In fact the face can end up being totally enclosed by lights and reflectors, and tightly framed by a short telephoto for the most flattering perspective. When faces are subjected to close scrutiny in this way, the hair and make-up needs to be good, because it will become glaringly obvious in the picture.

flash

Above: The shadowless frontal illumination, and the tell-tale doughnut-shaped highlights in the eyes, confirm that this picture was shot using ringflash. Image by Matze Schmidbauer.

Flash

Flash can be your best friend or your worst enemy, depending on the situation and how you use it. Here's how to get the best out of it

CHECKLIST

The built-in flash is useful for daylight fill-in shots.
Use the modes effectively, including the flash-off m
A separate accessory flashgun is more versatile.
Look for one with a bounce head, for more options.
Bounce flash off walls and ceilings for softer lighting
Use flash off-camera for more creative illumination
Use flash in bright sun to fill in shadows.

PORTABLE LIGHT

Except for one or two professional SLRs, all digital cameras come with a built-in flash. The reason is that, sometimes, there just isn't enough ambient light to take a successful photograph. Unfortunately, the light produced by these tiny light sources is generally unflattering in the extreme, and while it's fine if your aim is just to secure a record of the moment, it's invariably a complete non-starter if you aspire to anything more artistic. The maximum range is quite limited too – usually five metres is stretching it.

Separate stand-alone flashguns are a step up in quality because they're more powerful and more versatile, but they're still best used to provide support to the available light rather than acting as a replacement. However, many basic digital cameras do not provide any means to attach an accessory flashgun, and while there are remote systems

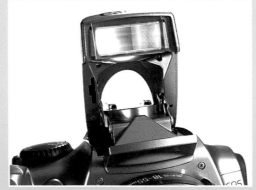

available to work around this problem, the results may not be worth the effort if the camera lacks the required sophistication in its flash metering system. Therefore an SLR camera, or an advanced compact with a hot shoe for external flash, is far and away the best choice.

BUILT-IN FLASH: THE MODES

Auto: The flash comes on when the camera thinks it is needed, and the exposure is worked out automatically. A variation on the auto mode is the anti-red eye mode, where the camera sends out a light pulse or pre-flash to close the subject's pupils before the actual picture is taken. The result is usually a dreadful, 'rabbit in the headlights' expressions, so it's best avoided.

FLASHGUNS

As well as offering more power and therefore a greater range, decent accessory flashguns also offer a variety of useful extra features to help create better flash shots.

If you can, get a flashgun with a tilt-and-swivel head to enable bounce flash. By bouncing the flash off a nearby wall or ceiling, the worst of the harshness is taken out of it, resulting in a softer, more flattering illumination which is especially good for portraiture. There are a couple of caveats though. Firstly, bounce flash severely reduces the range. In theory the distance is no longer flash-to-subject, but flash-to-ceiling plus ceiling-to-subject. But since some of the light hitting the ceiling is absorbed or scattered in other directions the reduction in range is even greater. The second caveat is that whatever surface you choose to bounce from, make sure it's white, as any colour will be absorbed by the light and bounced on to the subject. Flashguns lacking a bounce option can be diffused to some extent by clip-on diffusers and reflectors such as those by StoFen and Lastolite.

In addition to a bounce option some flashguns offer advanced features such as rear curtain sync, in which the flash fires at the end of the exposure rather than the beginning (for more natural light streaks in slow-sync flash shots), high speed synchronisation at shutter speeds up to 1/8000sec (instead of the more usual 1/250sec max), remote triggering for off-camera flash, and even control of multiple flash units.

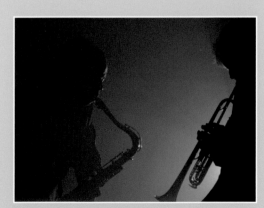

Flash off: Some places (for example: museums, theatres, concerts) forbid flash, so the camera provides the option to override the camera's desire to switch it on. What you'll get instead is a long exposure time (otherwise the picture would be very underexposed) so you'll need to support the camera on a tripod or a solid surface to avoid camera shake.

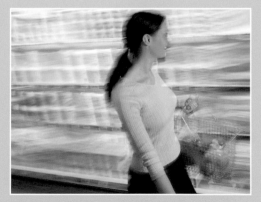

Slow-sync flash: Combines flash with a slow shutter speed to capture some of the ambient light in addition to the flash exposure. This means you avoid the pitch-black backgrounds you'd otherwise get, but with moving subjects you can get some motion blur along with the frozen flash image. Some cameras offer a 'second curtain sync' mode, whereby the flash goes off at the end rather than beginning of the exposure, for a more natural blur effect.

Flash on: Forces the flash to fire even when the camera thinks there's enough light to take a shot without it. This mode is used for fill-in flash shots in bright sun, and is pretty much the only situation in which built-in flash can enhance a picture.

Some high-end cameras offer additional features such as flash exposure compensation, where the output level of the flash can be adjusted.

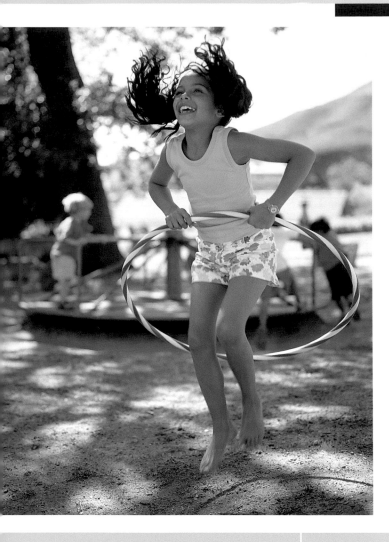

FILL-IN FLASH

It's perhaps ironic that although flashguns were invented to provide illumination when there isn't enough natural light, they are at their best when sunlight is in full flow. On cloudless sunny days sunlight is unflattering for portraiture, especially during the middle of the day when it's high in the sky. Deep shadows under the nose and chin and around the eyes (cast by the forehead) make it difficult to see the face clearly. One solution is to move the subject into the shadows, but another is to use flash to light the face.

With modern digital systems and dedicated flash, the flash should provide just the right amount of light to balance it with the surrounding daylight, thus filling in the ugly shadows. Often though a flash output equal in intensity to the daylight (in other words, a 1:1 ratio) is a bit too obvious, and a more subtle effect is achieved using a 1:2 or 1:4 ratio, where the flash is half or quarter as bright as the sun as measured from the subject's face. This adjustment can be made on the camera or the flash itself, depending on the system in use.

Fill-in flash can also be used with backlighting (in other words, with the sun directly behind the subject) to create great contre-jour lighting effects. Ordinarily you'd get either a silhouette, a very underexposed face or an overexposed background, but with fill-in flash you can light the face, expose the background correctly and get a lovely rim light around the edges of the subject.

OFF-CAMERA FLASH

Although the obvious place to put a flashgun is on the camera's hot shoe, direct flash is not flattering and can produce ugly shadows. This can be reduced through diffusion, but moving the flash so that it strikes the subject from a different angle offers advantages. The risk of red eye is eliminated for a start, but also by moving the light to one side you create modelling – which adds interest.

Modelling can be used to flatter a face (such as by making it slimmer) or create a mood. Lighting from directly below creates what is known as 'monster' lighting, for its Hammer-horror look. Used on a tripod with a diffuser, off-camera flash becomes a small, more portable alternative to studio flash.

For off-camera flash you'll need to attach the flashgun to the camera via a PC sync lead plugged into the PC socket (or the hot shoe, via an adaptor) or fit a light-sensitive trigger (or, 'slave') to the off-camera flash and use the camera's built-in flash to trigger it.

MULTIPLE FLASH

For the more ambitious user, several flashguns can be used together to create a portable multiple flash set up. Some systems, such as Nikon's Speedlite system, can be controlled wirelessly either from a master flashgun or the built-in flash on the higher-end SLRs.

Otherwise you'll have to employ a series of slave cells and trigger them from the built-in flash. On some cameras the exposure will all be worked out, but you may wish to play around with the ratios between the flashguns. With less sophisticated camera or flash systems you may have to manually adjust the output of each flash individually to get the desired effect, or, if you don't have that option, simply move each flash closer or further from the subject. With digital cameras you do at least have the option of taking a test shot and checking it on the LCD before going ahead, but don't do this with a live subject sitting in front of the lens. Do it all before they arrive, using someone else (or yourself, using the self-timer) as a model.

RING FLASH

While not designed for portraits, ring flash has been taken up enthusiastically by some people photographers due to the distinctive illumination it creates. It's a round, doughnut-shaped flashgun with tubes all around, which the lens pokes through for virtually shadowless macro shots.

When used on portraits the effect is a very faint dark line all around the edges of the subject (the shadow) and totally even, shadowless lighting on the face. The catchlights are often doughnut-shaped too, which is a tell-tale giveaway that ring flash was used. There are a limited number of ring flash manufacturers on the market, and those that do exist tend to be expensive, offer a limited range and must be attached to the camera via a PC flash sync socket (a hotshoe PC adaptor can be used instead).

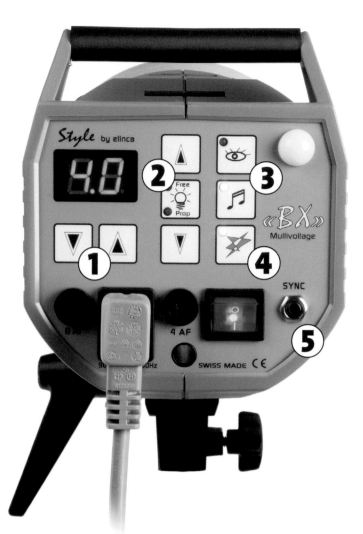

ANATOMY OF A *STUDIO FLASH HEAD*

1 FLASH OUTPUT
Reduces/increases the output level of the flash (indicated by the LED readout).

2 MODELLING LAMP CONTROLS
Determine whether you want the modelling lamp output proportional to flash level, and if you want it to come on only once the unit is fully charged or stay on full time.

3 SLAVE ON/OFF
Fires the flash without a sync cord, when it sees synchronised flash fire.

4 OPEN FLASH
Fires the flash manually (for metering, etc.).

5 SYNC SOCKET
Plug the flash sync lead in here, and the other end into the camera.

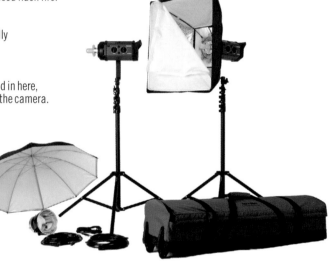

STUDIO FLASH

The most popular studio light source, studio flash heads come in various power settings. The more powerful the flash, the bigger and more expensive the head is likely to be. There are two types: those that require a power pack (aimed at pros with high power needs), and monoblocs, which are self-contained and, for enthusiasts, are the way to go.

Pros: They give out more light than tungsten heads, enabling the use of smaller apertures; they don't get hot; there's a wider variety of accessories; output levels are more controllable (most can be adjusted in fractions of a stop).

Cons: More expensive; you need a hot shoe/PC socket on your camera for synchronisation; more difficult to see what you're going to get since the modelling lamps aren't necessarily proportional in brightness to the flash output setting chosen. Shoot a test shot and review it on the LCD.

STUDIO ACCESSORIES

Dish reflectors: Imagine a shiny silver wok with the bottom cut off placed over the light source. Dish reflectors come in a wide variety of shapes and sizes, from the very shallow rims called 'spill kills' to deep, narrow-angled bowls for a tighter light spread. Ideal when you want maximum brightness and contrast over a fairly even area.

Barn doors: Four hinged flaps on the top, bottom and sides of the light. Adjusting the angle of the flaps controls the spread of the light. Popular with tungsten lights or fitted to a dish reflector.

Snoot: Produces a narrow 'spotlight' effect, by channelling the light into a narrow beam. There are two main types: conical and honeycomb, which use different methods to achieve a similar result. Often used for hair lights or to create a spot on the background.

Umbrella: Bare flash heads are considered too harsh for portraits (except for character studies of craggy old men) so some form of

diffusion is needed. Brollies are popular and inexpensive. They come in various sizes and surfaces, from translucent (so you can fire the flash through it) to opaque fabrics in white, silver and gold. When folded they take up little room.

Softboxes: Softboxes do a similar job to translucent brollies. They're square or rectangular, come in a variety of sizes and are designed to simulate natural light from a window or, if suspended over a table, the light from an overcast sky. They are more expensive than brollies and also more time-consuming to assemble.

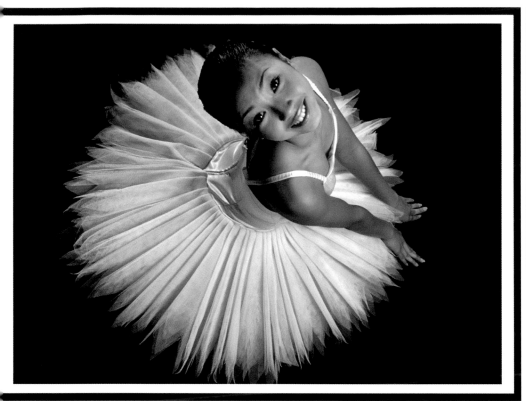

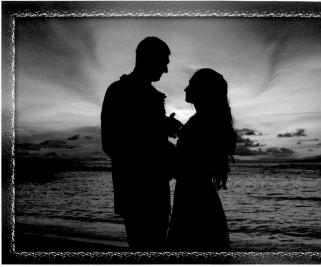

Above: With an artistic frame applied, there is more emphasis on the focal point of the image. It also helps to achieve a greater sense of intimacy.

Left: A simple black-and-white border can transform an image into a beautiful work of art.

Frames and Borders

Transform your photographs quickly and easily simply by adding a classic or artistic frame or border

TRANSFORM YOUR IMAGES

An average image can be completely transformed into a great one by adding a border or an artistic frame in Photoshop, and what's more, it's very easy to achieve.

If you take a look in any gallery, most images you will see that are for sale will be framed or bordered in some form. This is because a frame can help to draw your eye more clearly into the focal subject, without surrounding elements distracting you.

Frames can come in a variety of forms, from classic, thin black-and-white lines to graphic, bold ones that have been designed specially to complement the image.

Either way, it's good to experiment with them first as the first choice may not always be the best. Follow these next simple steps to create some interesting frames and borders.

A SIMPLE WHITE BORDER

STEP ONE

With your image open, make sure your colour swatches are set to black and white. If they are not, click on the default black-and-white icon on the tool bar or press D on the keyboard.

Click on the small arrows next to swatches to switch them, to make white the background.

STEP TWO

Select Canvas size from the image menu bar. Image > Canvas size. From the drop-down menu in the dialogue window, select Percentage and enter a value of at least 110 per cent. Make sure the background colour is set. Click OK and your image should increase in size with a white border around it.

A BLACK-AND-WHITE BORDER

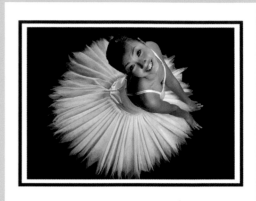

STEP ONE

Select Canvas size from the image menu bar. Image > Canvas size. From the drop-down menu in the dialogue window, select Percentage and enter a value of at least 105 percent and make sure background colour is set. Click OK.

STEP TWO

Switch the the colour swatches so that black is now your background colour. Click on the little arrows next to the colour swatches on the tool bar to swap them or press X on your keyboard.

STEP THREE

Select Canvas size again from the image menu bar. Enter a percentage of about 102 per cent. Click OK and the image should now have a white-and-black border. Now swap the colours again so white is the background. Select the Canvas size and enter a percentage of about 110 percent. You should now have a classic black-and-white border.

AN ARTISTIC FRAME

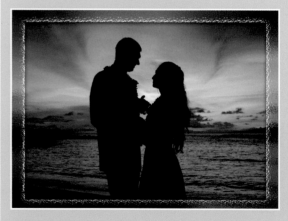

STEP ONE

The type of artistic frame you create is entirely up to you. Photoshop offers a variety of powerful filters that can aid you in creating a unique border.

Select the Rectangle Marquee tool and position it about an inch away from the top left corner of your image. Click, hold and drag down towards the right-hand bottom corner. Release the Marquee tool when you are about an inch away from the bottom corner. This will set the marquee about an inch all the way round the image.

STEP TWO

Now, from the image menu, select Select > Inverse. This will invert the marquee to create a border. Then choose Edit > Copy and then Edit > Paste so the selection appears as a new layer.

The new layer will appear directly over the top of the original so you won't see any change just yet.

Deselect the marquee selection via Select > Deselect.

STEP THREE

From the Filter menu select a desired filter. For this example, I chose Filter > Distort > Glass. The filter was then adjusted within its own dialogue window and applied.

The result is an artistic border that complements the image.

Glamour

What was once called 'pin-up' is now called glamour, but the aim remains the same: to capture the inherent sexiness of women

CHECKLIST

Glamour aims to show women looking sexy.
Sets, such as bedrooms, etc., can be used for realism.
Models often wear lingerie or swimsuits.
They may be nude, but rarely reveal more than breasts.
Outdoor settings provide a sense of voyeurism.
Plain studio backgrounds provide a more graphic look.
Find your own poses. Don't just stick with the clichés.

WHAT IS GLAMOUR?

The word 'glamour' has many connotations, but 'glamour photography' as a genre refers to sexy images of young women, usually (but not always) scantily clad in bikinis or lingerie, or perhaps topless. You'll find it in the tabloids, in the 'lads' mags and on the calendars covering the walls of many a car mechanic's workshop.

Unlike nude photography, which may be motivated by a study of shape and form, or fashion photography, which is about the clothes or brand, glamour photography is invariably about the sexuality of the model. The aim is to make the model look desirable through the choice of pose, expression, clothing and setting. Although the model can be nude, she generally isn't, and if she is she's usually posed in a way that conceals her modesty. In this sense, glamour photography is usually more about the tease, and leaving something to the imagination – which is where it differs fundamentally from soft porn.

THE SETTINGS

It can be argued that it doesn't matter where you photograph a beautiful, semi-naked woman: the effect would be much the same. But what lifts glamour photography from 'reader's wives' snaps is the skill involved in setting, lighting and posing.

Many glamour photographers like to tell something of a story by creating a setting. Given the aims of glamour photography it isn't surprising that one of the most popular sets is the bedroom. There is a sub-genre of glamour photography known as 'boudoir' photography, which takes place entirely in purpose-designed bedroom sets constructed in a studio or real bedrooms. Boudoir photography is often romantic, with soft-focus filters and rich, warm or pastel colours. Models often wear sexy, lacy lingerie or may be nude, wrapped in bed sheets. The genre is very popular in the USA where it's often commissioned by wives and girlfriends for their partners.

Other domestic situations are used as sets in glamour photography – every room in the house in fact – to provide an anchor in reality and give images a 'girl-next-door' quality.

Outdoors, the range of locations is as broad as for every other genre of portraiture. Beaches are obviously popular as they offer a reason for why the model is in a bikini, as are swimming pools for the same reason.

But you'll also find glamour models stretched out on yachts, or draped over sports cars. For the rural glamour photographer, barns, woodlands and fields with tall crops are popular.

If this sounds too complicated, remember that a high percentage of glamour photography is shot in a studio against a plain background. This creates a simple, graphic impact that would be harder to achieve using sets.

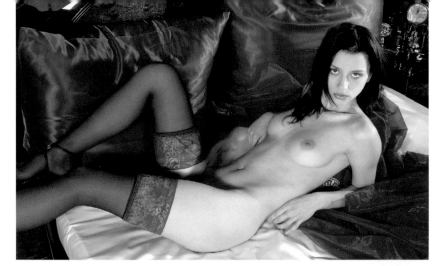

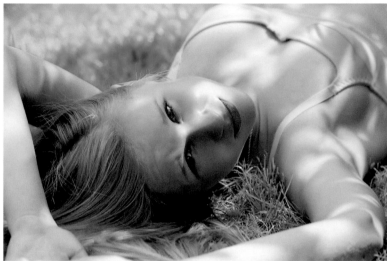

Top: Bedroom sets are very popular in glamour photography.
Above: Sets aren't essential though. This shot required just a patch of lawn.

LIGHTING

One of the advantages of shooting in the studio is the total control over lighting that it provides. Glamour photographers often favour soft, diffused lighting because it's the most flattering for a model's skin and creates a romantic feel, and for this they would probably choose two or three lights fitted with large softboxes, with additional lights on the background. There is no requirement however for the lighting to be soft, and harder, edgy effects can be achieved by removing the softboxes and fitting dish reflectors, snoots (for spotlight effects) or barn doors. Gobos are a popular accessory for casting patterns of light and shade on the model's body. Usually made from metal with shapes cut out of them, you can buy gobos which replicate the effect of venetian blinds, metal grids, filigree windows, dappled light or scores of other effects.

Outdoors, early mornings produce warm, low light, which can create a nice atmosphere, though care must be taken over shadows. Your camera's White Balance may be tempted to remove the warmth. Either shoot RAW files or override the camera's instincts if you see this on the LCD after your test shot. Diffused sunlight or overcast days creates soft, shadowless light which is ideal for glamour work, and you can also find similarly diffused light on bright sunny days by heading for the shade. However, take care with your exposure readings if the background is sunlit while your model is in shade. Fill-in flash may be useful to balance the light levels a little.

POSE AND EXPRESSION

There are certain stock glamour poses which have passed into the realm of cliché. These usually involve arched backs, forward-thrusting breasts – possibly arms up behind the head with hands running through the hair. These poses are often accompanied by pseudo sexy expressions involving strange lip gymnastics. Unless you're trying to start an Eighties revival it's best to avoid such things and go for something more naturalistic.

There are, however, sound reasons for some poses, to do with the body shape of the model. Lifting the arms raises the breasts, which makes it a flattering pose for women with large breasts. Small-breasted women, however, are often shot leaning forward, as this makes their breasts seem bigger. These and other guidelines are of course just that, and there is no need to try and even out such variations in body type. Smaller-breasted women are no less sexy than larger-breasted ones, so it isn't necessary to disguise them.

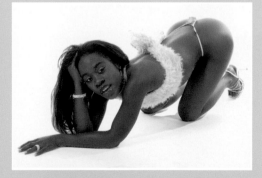

The pose isn't the only contribution to the sexiness of the model. The expression is at least as important. Sexiness can be conveyed in a range of expressions, not just a pout into the lens. Coyness can be sexy, as can a look of glazed dreaminess, and then there's the more direct 'come hither' look, which oozes confidence, often preferred by younger men's magazines – and also by women, who see it as the woman being more in control of her own sexuality than those girls with more passive expressions.

It isn't always easy to produce convincing expressions on demand though, so don't be afraid to offer direction and words of encouragement.

Above: Placing someone slightly closer to the camera gives them greater emphasis.
Left: A fun approach to group portraits works well with younger subjects.
Top right: Placing everyone in a row is acceptable with small groups such as this.
Bottom right: With large groups, create an interesting shape and vary the head heights.

Groups

The more the merrier, they say. But when it comes to group
photography your job gets harder with every additional person

CHECKLIST

With very large groups, placing people in rows is easiest.
With smaller groups try to create an interesting shape.
Place your subjects' heads at different heights.
Emphasise an individual in a group by making him or her centra
Bring the individual closer than the others and use a wide angle
Use a tripod to keep the camera level and correctly framed.
Take lots of shots to be sure of getting a good one.

GROUP THERAPY

Photographing groups of people is like
completing a jigsaw. Your task is to arrange
everyone so that they're all visible in the
shot, but so that the composition is pleasing
– so standing them all in a line is not often
likely to work. The exception is large groups
(for example, school photos) where you have
dozens – maybe hundreds – of people to
organise. In this situation the only practical
solution is to create several rows.

To do this you'll need to stagger the
heights of your subjects. Ideally there should
be at least a 50cm height difference between
each row so no-one's head is obscured by the
person in front of them. The classic solution
is to have the front row sitting on chairs and
a row standing behind them. If a third row is
needed they would stand on a platform at the
back. Unfortunately chairs aren't always
available. If the location is suitable try
having the front row crouch on one knee
or sit on the floor. Ensure the heads of the

front row are level with the chests of the row
behind. If not try asking the front row to sit,
the second row crouch and the third stand.

Take advantage of walls, benches and any
devices which can be used to create a height
differential. Sort your group into tall and
short people, but don't immediately put the
tall ones at the back unless there's a row
standing in front of them. For example, you
could have the tall ones sitting or crouching
at the front and the short ones standing
behind, to keep the height differential
between the rows at about the right distance.

SMALL GROUPS

Smaller groups require a different approach.
You need at least six to make two rows, so a
more creative approach is needed. The rule
with small groups is that every head should be
at a different height, so no two pairs of eyes
are on the same plane. While it's never a good
idea to follow these sorts of guidelines
dogmatically, this one works most of the time.

Most posed group photos are arranged to
create a pleasing shape, such as a triangle or
diamond. Triangles are an obvious one when
you're photographing three people, but they
also work with four or forty-four.

To achieve these height differentials take
advantage of furniture or geographical
features. You can also achieve this with
posing (sitting, kneeling, standing, etc.).

Bodies should also not be facing forwards,
but turned at angles, preferably in towards
the centre of the image. If you can, give each
person a different pose – one resting a head
on a hand, one with legs crossed, etc.

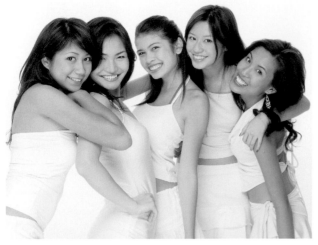

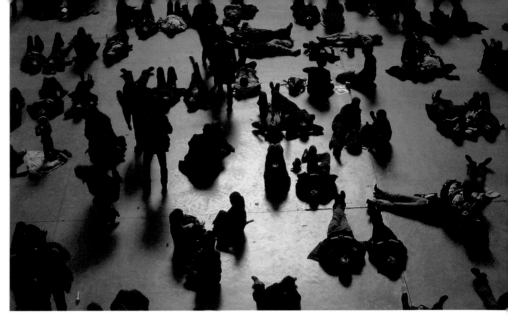

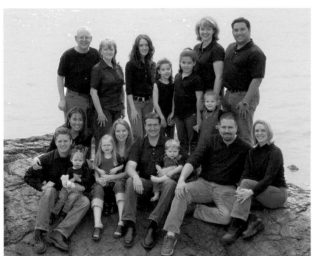

CROWD CONTROL

What do you call a large group of unposed people? A crowd. People gather en masse for a variety of reasons. It may be a carnival or festival where your subjects are happy to be photographed. It could be a crowd of tourists, or perhaps spectators at a big event, such as a concert or football match. Before attempting to photograph them give a thought to their attitude and mood; in some circumstances you could endanger yourself by taking out a camera. If so, then think twice. If you're still determined, plan a strategy to minimise any risk to yourself. A high viewpoint will enable you to more easily capture the crowd as a whole, so you can see the scale of it. Telephoto lenses may let you pick out sub-groups, or condense a very large crowd and make them appear more densely packed. Wide angles will make the crowd appear to stretch over a greater distance, or show more of the immediate environment.

Being part of the crowd with a wide angle allows individuals to come more to the fore, and viewers get a greater sense of being part of the crowd themselves.

CREATING EMPHASIS

If an individual is more important to a group shot than others – for example, granny's birthday or you're shooting the lead singer in a rock band – you should reflect this in your arrangement. Place granny in the centre, for example.

You can also achieve emphasis by placing one person closer to the camera than the others – especially if you use a wide-angle lens to exaggerate the perspective and make the closest person seem bigger, too. This is a common tack with album covers.

Once you've arranged everyone, make sure your aperture is small enough to get them all in focus. With three or more rows focus on the row that's approximately one-third of the way in. A tripod keeps the shot level and correctly framed, and allows you to concentrate on getting good expressions. Make sure you take lots of shots to be sure of getting at least one with everyone's eyes open.

HELP FROM PHOTOSHOP

With large groups, no matter how many shots you take someone will always be blinking or pulling a bad expression. The only real solution is to pick the shots with the most people looking good and, for those who look bad, find good shots of them on other frames and cut and paste them into your selected shot. If the group hasn't moved between shots it should be a relatively straightforward job.

TOP *TIPS!*

1 WATCH THE HEIGHT
With large groups don't stand the tall people at the back if the shorter ones are sitting. You'll have too great a height differential. Have the tall ones sit.

2 COUNTDOWN
Make it clear when you're going to shoot by counting down so everyone can be ready.

3 VIEWPOINT
Find a high viewpoint and look down on the group. This will make it easier to see everybody's faces.

4 AT AN ANGLE
Place your group with their shoulders at an angle – either all facing inwards or all facing the same direction.

5 TAKE LOTS OF SHOTS
Take lots of shots to be sure of getting one with everyone looking good.

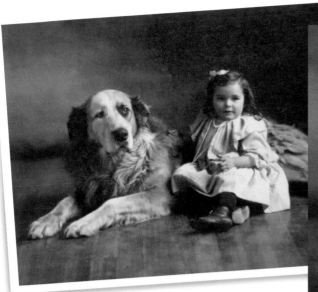

Above: The original black-and-white image was scanned and cleaned up first in Photoshop.

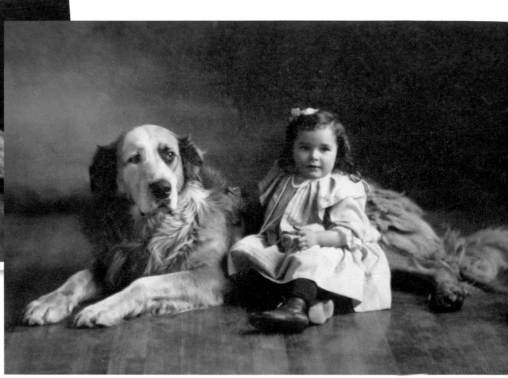

Above: The result of hand-colouring an old image can be rewarding. Just bear in mind that it can take a lot of work if you want to be accurate.

Hand-Colouring Black and White

Give your black-and-white photos a new lease of life. Learn how to apply realistic colour with the use of Color Picker and Layer blend modes

FRESH NEW COLOUR

Restoring old photos can be one of the most satisfying and rewarding projects you can undertake in Photoshop. Not only for yourself, but seeing the delight of others, as you present them with a restored image.

The restoration could be taken a further stage and colour could be added, too. In this chapter we will convert a black-and-white image into a fresh colour version by using the Color Picker, brushes and the layer blend modes.

It can help if you know the original colour of clothing, hair, etc., to start with. You could spend a lot of time colourising, only for the recipient to say, 'That wasn't the colour of my hair!'. So, for accuracy's sake, try to do a little research beforehand.

The picture we've used was taken around 80 years ago and the quality is pretty soft and grainy, so remember to take this into account when reproducing new colour.

You can't add sharp vibrant hues to a soft image: it will look fake and the colours will be distracting.

Try to match to the original era and make the colours look consistent. As this photo was from the early 1920s, I toned down the hues and made the colour slightly washed out. The best way to reproduce realistic skin colour is to use another colour image as a source to pick from. Try to use an image that is similar in subject and lighting.

I used an image of a baby of roughly the same age and also a similar dog from which to extract the new colours. From this the colour is applied over a transparent layer and blended with the layer blend mode to mix with the original tones. When colourising old black-and-white images, always remember to keep the colour subtle and natural.

SELECTING COLOURS

Select the Color Picker (the Eyedropper tool) from the toolbar to select your individual colours. Rather than clicking once in an area to select a colour, click and hold while dragging the picker across the desired area. You will notice that the colour swatch will change constantly as you move the picker. Release the mouse when you achieve the colour you want. You can also see the colour values change up in the info window, too.

The best way to sample any natural colour is to take it from an obvious source. In this tutorial I needed natural colours for the water, sand and rocks, etc., so I selected a new image that contained similar hues and tones and used the Color Picker to select them individually.

STEP ONE

With your black-and-white original open, make sure you are working in RGB.

Open your source image of a similar subject that is consistent with the original. Select the Color Picker and click on the source image: this will sample the skin tone and colour. Sample various areas and save them in your swatches palette for later.

STEP TWO

Select your original black-and-white image, and create a new layer, Layer > New > Layer. Name the new layer 'skin tone'. This will help you navigate as the layers start to stack up. From the layer blend mode found in the top left of the Layers palette, choose the Color mode from the drop-down menu.

STEP THREE

Choose a suitable soft-edged brush and make sure your main skin swatch is selected in the swatches palette. Then, with the main skin colour, brush over the face on the new layer. You will notice that when using the layer blend mode set to Color, that only the hue shows through and the original tone is left intact. Keep painting over the entire main subject.

STEP FOUR

Zoom in and erase any overlapping colour around the edges. Next, create another new layer and name it 'darker skin'. Set the blend mode to Color. From your colour swatches select a darker version of the skin. Paint over the darker areas of the subect to introduce the darker hue. Use the opacity slider to adjust the amount to a realistic level.

STEP FIVE

For clothes, try to select colours from other source images that may give you a realistic hue. Remember to create a new layer with a colour blend mode first. In tight areas such as fingers, resize your brush to a more manageable size. Again, use the opacity slider to adjust the strength of the new colour.

STEP SIX

When you're happy with your results, use the Color Picker to select the hair colour, eyes, teeth and background. Name each layer with the corresponding item. Remember to keep the colours subtle and in relation to the original. There is nothing more fake than over-saturated colours that jump out at you. Keep the colouring sympathetic and subtle.

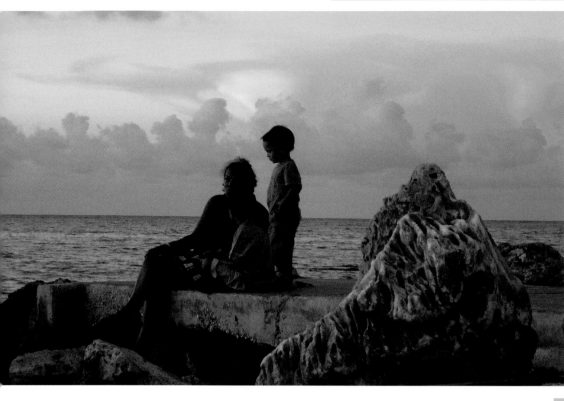

Left: On our way to dinner during a family holiday in Cuba, I saw th[is] beautiful sunset. I asked everyone to sit at the end of this nearby je[tty] and took this from the beach on a compact, hand-held, leaning on [a] palm tree, with the camera at full (3x) zoom, ISO 400 and flash off All of the pictures on this spread were taken during the same holid[ay] which just shows the variety of shots that can be obtained.

Holidays

This is the time of year when the most pictures are taken, but make sure you go for quality as well as quantity

CHECKLIST

Take some shots of people relaxing and having fun.
Keep the camera protected when near sand or water.
Plan to take some posed family groups in smart clothes.
Find a nice setting evocative of the trip, such as the pool.
Shoot while there's still enough light to avoid flash.
Make sure you get yourself in some family shots .
Don't forget to photograph any interesting locals.

A GOOD TIME FOR PICTURES

Family holidays offer the year's greatest opportunity for some good family portraits. Everyone is (hopefully) more relaxed, tanned and happy, you may have bought some new outfits to wear, and, most importantly, time is not an issue. No-one has to rush off to work, school or go shopping.

You may be engaged in fun activites too, such as horse-riding, skiing, swimming or wind-surfing, all of which can lead to some great photo opportunities. Even just relaxing on an inflatable bed with a pina colada can make for good pictures.

If the activity involves water, be careful with your camera. Stay at a safe distance and use the zoom, or protect your gear with a waterproof housing, or an Aquapac sealable plastic bag (try www.aquapac.com) which will keep your camera dry even under water to a depth of a metre or so.

POSED SHOTS

While you're all together get some posed family shots too, perhaps while you're dressed for dinner. Take them while there's still enough light to avoid using flash, which will spoil the ambience. Find a good backdrop – either a neutral one or perhaps a scenic setting, such as the pool.

To be in the shot yourself you may want to ask someone to take it for you. Explain to them whether you want some background in shot or just the family. If there's no-one around, or you don't like to ask, you'll need to improvise with a wall, table top or other flat surface. If you're shrewd you'll have brought a tripod, even if only one of those small pocket models that sit on a tabletop.

Try to find arrange the group in a relaxed way – don't all just stand to attention in front of the camera. Perhaps make use of a beach lounger, or bar stools, or a low wall. As always, take a few shots to make sure you have one where everyone looks good.

OTHER PEOPLE

Holidays are also a good time for photographing people other than your family. If you're in an exotic foreign location you may be able to shoot some interesting travel portraits of the locals, but do so with sensitivity to their wishes. Ask first, or shoot candids and try to stay inconspicuous and unobserved. (For more on travel portraits, see page 152.)

If you're staying in a hotel or resort you may notice that some of the staff or other guests have interesting, characterful faces that you'd like to photograph, and many will be happy to pose for a quick couple of head shots if you ask them and explain that you're a keen photographer, but try to keep it brief and don't turn it into a major event. And it's always nice to send them copies if they'd like some.

indoors

Above: Using wide apertures throws any distracting background details out of focus.
Left: Turning down the room lights and spotlighting the subject is another way to focus attention.
Right: In small, confined indoor spaces, concentrating on tightly cropped head shots can pay dividends.

Indoors

If you can overcome the challenges, such as less space and lower light levels, you can get some great portraits indoors

CHECKLIST

Indoors offers consistent lighting for shooting any time.
A permanent space in your home can save time.
Otherwise use natural props, such as furniture.
Make use of natural light from windows, etc.
Invest in a portable background for emergencies.
Try indoor locations outside the home, such as public building
Ask permission before shooting anywhere private.

GREAT INDOORS

Posed portraiture can be done anywhere, but one of the big advantages of doing it indoors is the relative consistency of the lighting. In northern European countries it's reassuring to be able to say 'Let's do it next Tuesday' and to know that, if it happens to pour down with rain on Tuesday, it doesn't really matter. Indoor portraiture can be conducted in winter or summer, day or night.

If the indoors in question happens to be your home there are other benefits too. You don't have to waste time travelling to and from the location, and you can leave your background and lighting set up while you download and inspect the images you've taken, so that you can go back and shoot some more.

Looking further afield for indoor locations can yield some fabulous settings, some with great natural light, but you may need to ask permission of whoever owns the building.

SETTING UP A HOME STUDIO

Some hobbyists are lucky enough to be able to set aside a dedicated space for a home studio – often a garage or spare bedroom. This is ideal, as backgrounds can be left up, lights left in position and there's no time wasted in preparation or packing up after.

Most of us, however, must improvise in a space that has another, everyday function. It may be a conservatory, bedroom or living room. This may be less convenient, but you do at least have a choice whether to put up a plain, portable background or use the room as an environmental background. If the latter make sure it's tidy (no empty coffee mugs or folded newspapers lying around, unless they're deliberate props for the portrait) and there are no lamps or flowers growing out of your subject's head.

Make sure that you have enough room to shoot the kind of pictures that you want to take. Head-and-shoulders portraits can be

done in quite a small space, but if you're using a background you'll generally need to allow at least a metre's distance between that and the subject to avoid ugly shadows. Unless you're using a wide-angle you'll also need to allow a least another one or two metres camera-to-subject distance. (Wide-angle lenses can be problematic in home studio situations if using a background, because their perspective requires that you need a very wide background to avoid getting the edges of it in shot.)

Half- and full-length portraits need even more space: at least three to four metres camera-to-subject distance, plus the metre behind the subject. In fact, if full-length portraits are what you want you're probably better off having the subject sit, crouch or find some other pose that compresses his or her length. Natural props such as sofas and chairs are ideal for this purpose.

HOME STUDIO ESSENTIALS

There are two ways you can go with indoor portraits: the minimalist approach, where you sit your subject next to, say, the bay window, with your white lounge wall as a background, and use only the light coming in from the window, or there's the bells and whistles approach: two or three studio flash heads on stands, a canvas background, white reflectors dotted about. Whichever you choose depends on circumstances, budget and the style you're after.

It can certainly be useful to have a background or two. Although there's a vast choice available to buy (from folding mottled fabric types to three-metre wide rolls of hanging coloured paper) you can just as easily make your own. A white bed sheet can work very well, as can a sheet of painted MDF. Smaller pieces of white fabric or painted board also make very good reflectors to bounce light into the shadow side of the subject's face. Again, you can buy readymade reflectors, many of which are white/silver reversible and fold out into a rigid frame.

Lighting is covered in more depth later on, but there is a wide choice of options available, including natural daylight, household lamps, flashguns and studio flash.

INSIDE PUBLIC SPACES

Using indoor locations outside the home can be very exciting. There are some fabulously photogenic settings available, depending on what you're looking for. If you happen to live in a 1970s semi in the suburbs, for example, you may find that a friend's period Edwardian residence has more character as a setting. Large public buildings such as the local library or museum may have a grand, sweeping staircase with long banisters on which your model can drape herself. Or they could be ultra-modern steel-and-glass structures, perfect for high-concept fashion or contemporary portraiture.

Industrial settings can work very well: warehouses, old factories, and so forth, though care must be taken with safety in such places. Empty offices are another option, though they can look quite messy if there's paper everywhere. Then of course there are hotels and guest houses, or perhaps a unused upstairs function room in a pub or social club. (You may find the seedy, faded, tattiness of some of these places a useful setting to incorporate into your portrait, rather than hide.) In truth the choice of indoor locations is vast, and limited only by your imagination.

Whatever setting you have in mind though, the chances are you'll need permission to shoot there. Find the name of the person in authority and make contact, explaining what you'd like to do. You may well get a few knock-backs, through fear of safety, litigation or suspicion about what you'll be doing, and if that happens move on and look for somewhere else. If you make your requests in a polite and professional manner your persistence will eventually pay off. It will help if you have a body of quality work you can show in support of your request. A link to a web gallery is the best way to

do this in an emailed request. In some cases the answer will be yes, but at a cost, and whether you wish to go ahead on that basis is up to you. If they suspect you're a professional or have a commercial motive the venue hire fee can be extortionate.

Left: Windows provide an excellent setting for indoor portraits, with plenty of natural light.
Below: Staircases are very graphic and offer plenty of posing options.
Right: A simple shot, using a plain wall as a non-distracting background and a window for illumination.

USING PROPS

Indoor locations lend themselves to the use of props and architectural features as props in your pictures. From the obvious environmental portrait of a chef at work in a kitchen, to grandma knitting in the conservatory, photographing your subjects while they're engaged in an activity (preferably one that

is identifiable with them) is one way around the 'what to do with their hands' conundrum, and makes posing easier. It also relaxes subjects not used to being photographed. Using furniture creatively is a gift some portrait photographers have naturally: sofas, chairs, tables and, depending on the type of shots your doing, the bed or bath. Staircases can be a great setting, as they offer so many posing options. In external locations there are bound to be architectural features, furniture or equipment that you can use. Many great photographs have been taken in nothing more elaborate that the humble lift, for example.

TOP *TIPS!*

1 STUDY THE LIGHT
Look to see where the illumination is coming from and how it falls on your subject. Move your subject to find the best light.

2 BEWARE OF CASTS
Take care with coloured walls and carpets, as they can reflect unpleasant colour casts on to your subject's skin. A green wall or carpet, for example, may bounce green light on to your subject.

3 USE ARCHITECTURAL FEATURES
Arched windows, spiral staircases, grand fireplaces – striking architectural features such as these make great props.

4 ENGAGE YOUR SUBJECT
If they're nervous, get your subject doing something. Engaging the subject in an activity will put him or her more at ease.

5 EXTRA LIGHT
Although natural light is usually enough, a slave-triggered flashgun can be used to bounce light off a wall or used to throw extra light on a background.

professional profile

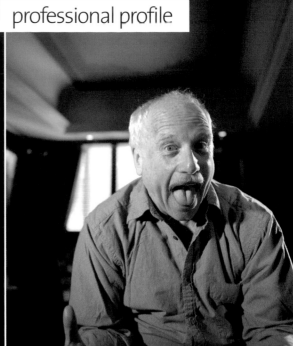

Above left: BBC economics expert Evan Davis in an informal pose.
Above right: Hollywood actor Richard Dreyfuss shows his comic side.
Overleaf: Peter uses colour and shape to good effect in his portraits.
It was shot on the stairs at the theatre in which Warren Mitchell was performing.

Peter Searle

Digital photography offers numerous advantages to
top portrait photographer Peter Searle, as he explains

Peter Searle's portraiture regularly graces the pages of the colour supplements and his subjects include film stars, scientists, politicians and artists. What's surprising is that, until relatively recently, much of it was shot on a humble Nikon Coolpix 990.

Peter's portfolio is proof that good photography is not about the cost of the camera, but the eye of the person using it. His striking environmental portraits are

Above: Cricketer Phil Tufnell relaxes in a traditional East End pub.

characterised by the clever use of bold colours, strong graphic shapes and interesting lighting. This is all the more impressive when you consider that Peter rarely gets to choose the locations and often has just 15 minutes to do a shoot.

'One of the things that appeals to me most about working digitally is that you can shoot much faster,' enthuses Peter. 'I rarely get a chance to look around much before a shoot, so I need a camera that allows me to work quickly. With digital you can really move around the subject and get a variety of shots in a short space of time.

'I shot Ricky Gervais for *Metro Life* recently and managed to get three sets of shots, in different locations, in 10 minutes. With digital I can check the light and exposure in seconds using the LCD. It also offers the ability to experiment at no cost, which of course is how you get the best ideas.'

Peter studied photography at Bournemouth and started out using medium- and large-format film cameras. When work started to dry up in the mid 1990s he became a picture editor on consumer magazines, which is where he had his first experiences with digital images. At the height of the Internet boom Peter was recruited to help launch a

major new website. Part of his brief was to kit out the journalists with digital cameras.

'I settled on the Nikon Coolpix 990,' he remembers. 'The quality was fantastic and it was ideal for website work. When the website folded he decided to return to his roots. 'I had the Coolpix 990, which I'd used for portraits for the website, so I approached the national press for work.'

Soon he was taking portraits of an eclectic range of interesting people for the supplements, using his Coolpix. 'It did cause a few raised eyebrows,' recalls Peter. 'In those days people weren't sure what it was. Some were curious, one or two said, "I've got one of those," but no-one turned their nose up at it, and clients were happy with the quality. I even shot a few covers with it.'

Peter soon became successful enough to invest in a Fujifilm S2 Pro DSLR. 'The resolution is great even at high speed. I often have to work at ISO 800, but you can't tell.'

He shoots in RAW format, converting them to 16-bit TIFFs later. After minor retouching and curves adjustment he then converts them to 8-bit JPEGs if they need to be emailed to a picture desk for a deadline.

To see more of Peter's work visit his website at www.petersearle.com.

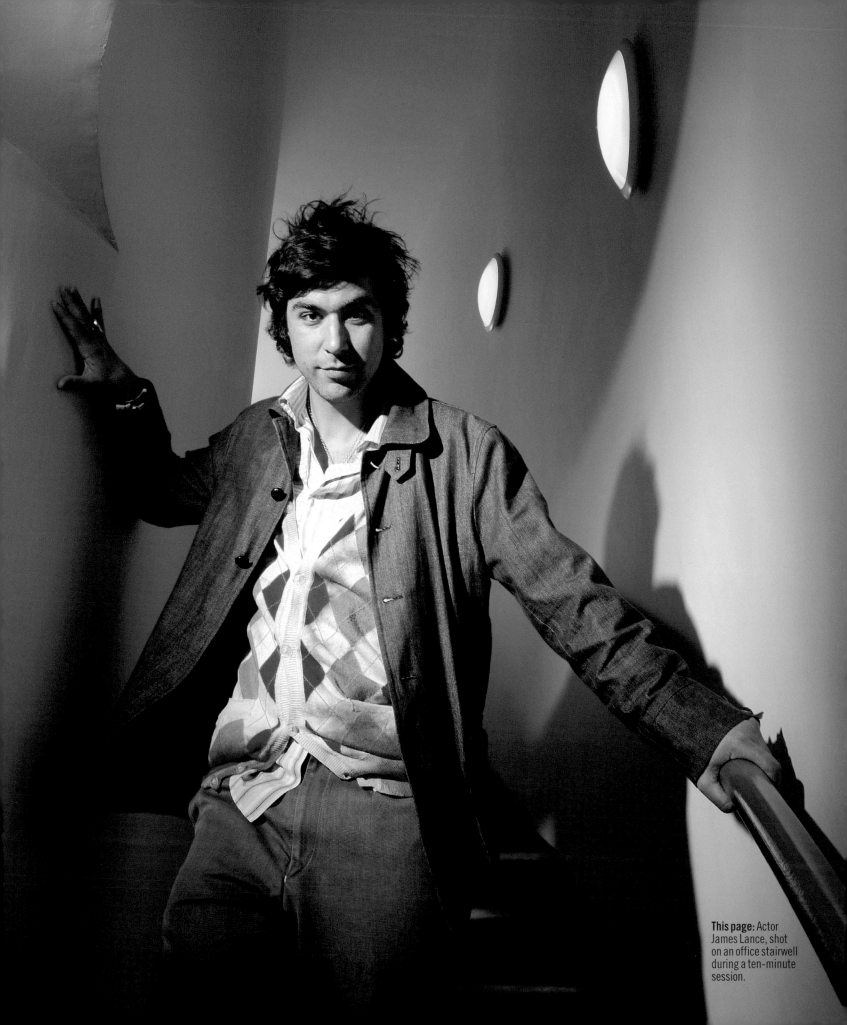

This page: Actor James Lance, shot on an office stairwell during a ten-minute session.

Above: Because all but a handful of digital SLR sensors are smaller than a 35mm frame, the field of view of any given lens is reduced when used on a DSLR, compared with a 35mm one.

Lenses

Arguably the most important component of any camera is the glass on the front. Without a good lens all else is a waste of time

CHECKLIST

The quality of the lens plays a vital role in picture quality.
Different focal lengths provide a different field of view.
Zoom lenses are convenient, but there are disadvantages.
Lenses designed for digital sensors offer better results.
Use a lens hood to reduce the risk of flare outdoors.
Telephoto lenses are most flattering for portraits.
Wide angles add drama and provide greater depth of field.

IMPORTANCE OF LENSES

People often refer to a camera's megapixel count to determine the image quality, but of equal importance is the quality of the lens. You can have all the pixels in the world on your sensor but if you put the bottom of a milk bottle in front of them you're not going to get a very good picture.

A good lens is much more than a piece of glass. For a start it's a collection of many pieces of glass, all precision-mounted in a finely tuned barrel which moves each lens in and out in relation to one another in order to zoom and focus.

The lens elements themselves are computer-designed to a specific shape which will bend the light rays passing through them at just the right angle, and are coated with a cocktail designed to maintain the integrity of the spectrum of wavelengths passing through, while minimising reflections off their surfaces.

FOCAL LENGTH

Lenses are described by their focal length, in millimetres. A lens which shows the world much as our eyes do (in its magnification of the scene) is known as a standard lens. In the days of 35mm this equated to a focal length of about 50mm, but with digital the equivalent focal length depends on the size of the camera's sensor. Lenses which magnify and make things appear closer are called telephotos, while lenses which make things look further away are known as wide-angles.

Photographers used to carry a selection of different focal-length lenses. But then came zoom lenses, which are able to offer a range of focal lengths, from wide angle to telephoto, just by turning a ring on the lens. The downside is that they're often bigger and heavier than fixed lenses, with smaller maximum apertures. The cheaper ones are also optically inferior. Professional-quality zooms are big, heavy, fast and of course expensive, but the quality is pretty much equal.

LENSES FOR DIGITAL

Lenses designed for 35mm SLRs can be used on most digital SLRs, but don't produce the same field of view, because the sensors of most digital cameras are smaller than 35mm. The exception is full-frame sensors such as those used in some Canon DLSRs. This means that, on average, a lens increases its effective magnification by around 50 per cent when used on a digital SLR. This is useful for sports, wildlife and paparazzi shots, and other users for whom big telephotos are essential, but can be a problem for wide-angle users. To get the effect of a 24mm lens on a 35mm camera will require a lens of around 16mm. To overcome this confusion most manufacturers quote a 35mm equivalence when describing their lenses' focal lengths.

Because of the differences between film and digital sensors, manufacturers now make dedicated digital lenses with smaller image-forming circles. This enables lenses to be made smaller and more cheaply.

Left: These examples show how the choice of lens affects how your portrait will look. All three images were shot on a the same 18–200mm zoom lens.
Left top: Shot at the 200mm end of the lens.
Left centre: At 18mm, from the same position.
Left bottom: Shot at 18mm, but moving closer to achieve a similar crop on the subject.

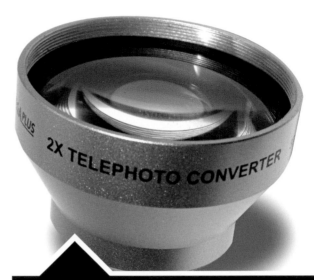

Options for fixed-lens cameras

What if your camera doesn't offer interchangeable lenses? If you own a bridge or enthusiast-level SLR your lens probably has a filter thread on the end. For many cameras you can buy supplementary lenses which screw on to your existing lens and offer additional telephoto or wide-angle options. You can also buy screw-on close-up lenses for macro shooting, which resemble clear filters and come in various dioptres.

LENS MOUNTS

It would be handy if every maker's lens fitted everyone else's cameras, but sadly this isn't the case, just as a Ford gearbox won't fit a Volkswagen. So when buying into a camera system take a good look at their lens range to make sure it contains the lenses you might want to buy in the future. Fortunately, there are several independent lens manufacturers, whose product lines supplement the proprietary offerings, so unless you're after something very specialised indeed you should find your required lens available from someone.

However, it isn't just the mounts that differ. Some manufacturers have developed special technology within the lenses themselves, which may be a deciding factor in your purchase. Optical image stabilisers, for example, help to keep telephoto lenses steady at relatively slow shutter speeds, thus greatly reducing the number of shots ruined by camera shake. Some lenses also contain ultra-fast or silent motors to facilitate faster, quieter focusing.

LENSES FOR PORTRAITS

The type of lens you choose for your portrait will have a dramatic effect on how the finished picture will look. A standard lens is the most neutral, and produces the least amount of perspective distortion. For many of the great photojournalists, such as Henri Cartier-Bresson, it's the only lens they ever used. Although you have to get quite close to a subject to do head-and-shoulders portraits they are ideal for half- and full-length shots, small groups, and observational street photography. Most cameras today come with what is called a standard zoom, which means that they go slightly wide-angle (but not very wide) and slightly telephoto (but not very telephoto) for those slightly closer or further away shots, without ever straying too far from the standard position. This not only describes virtually all lenses on fixed lens compacts, but the kit lenses supplied with DSLRs too.

ACCESSORIES

The first thing you should buy for your lens is a lens hood. This is because they reduce reflections coming into the lens from the sides, which cause flare and lower contrast. A UV or skylight filter to protect the front element from damage is also a prudent purchase. Some pros believe they diminish image quality, but even if this were so the effect is marginal, and if you'd rather buy a new filter than a new lens if the worst happened then the investment is well worth it.

Different lenses have different filter thread diameters so if you own several lenses, buying filters for them all can be costly. For filters other than those that remain permanently attached, consider investing in a square filter system which will fit all your lenses via the appropriate adaptor ring, so you only have to buy one of each type. Or buy the filter for your largest lens and use stepping rings to fit them to your smaller lenses.

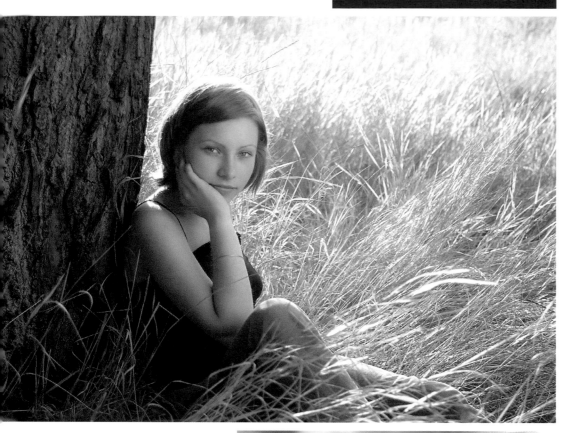

TELEPHOTO LENSES

Short telephoto lenses have always been the traditional choice. Lenses in the 85–135mm focal length range were often, in the days of 35mm, referred to as 'portrait' lenses. This was because they have several qualities which conspire to produce flattering pictures of people. Firstly, telephotos compress perspective, so rather than making ordinary noses look longer they can actually make big noses look shorter. Faces are flattened, so prominent features are played down.

Another side effect of telephotos is that, at a given aperture and distance, they produce shallower depth of field, so distracting backgrounds are much more easily thrown out of focus. A shallow depth of field has the effect of isolating your subject from its surroundings, rather than showing him or her as part of them. A telephoto can be used for picking out a single face in the crowd and leaving other faces a blur.

Short telephotos are ideal too because you're not so far away that you need a walkie talkie to communicate with your subject, and interaction is vitally important in most portraits. But when occasion demands it, very long lenses will produce dramatically shallow depth of field and greater compression. You can make distant scenes appear as though they're right behind the subject.

A potential pitfall of telephotos is camera shake. As the image in the viewfinder is magnified so are your shaky hands. A tripod is recommended, but this can inhibit your spontaneity. If you'd rather hand-hold, make sure the shutter speed stays higher than the focal length in use (for example: 1/250sec or above with 200mm lenses). Stand as steady as possible, tuck your arms in to your sides for stability and make use of any natural supports. If the light isn't good enough to maintain a fast-enough shutter speed you may have to raise the ISO setting or introduce flash. If your lens offers Image Stabilisation (called Vibration Reduction on some lenses) you can shoot two or three stops lower than you would otherwise.

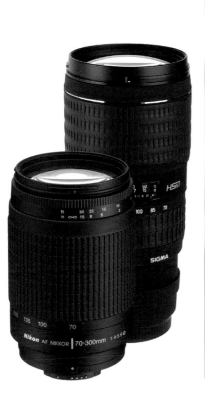

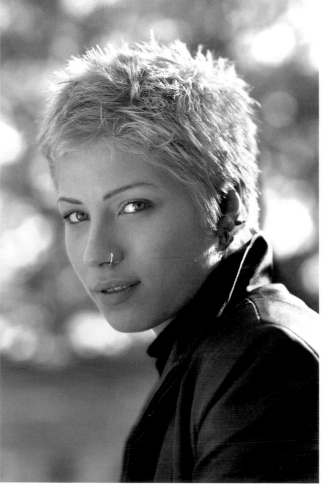

WIDE-ANGLE LENSES

Wide-angle lenses produce a wider than normal angle of view, and are ideal for those situations where you can't quite get everything in shot and can't step back any further. But they also distort the sense of perspective, making closer objects appear disproportionately larger than those further away. Lines converge more dramatically to some infinitely distant point.

In the context of portrait photography wide-angles are a mixed bag. The rule was that they should never be used because they aren't very flattering. That habit they have of making things close by appearing larger includes noses, chins and foreheads – and arms, legs, hands and feet, too, if they're closer to the lens than the face.

But they have their uses. For a start, portrait photography isn't always intended to flatter. Sometimes it's about reaching into the soul of your subject, and one way to do this is to get very close, to look right into the eyes. Wide-angles are also very useful for showing a subject in the context of his or her environment. Sometimes the surroundings are part of the story: a parish priest in front of his church, say. Or perhaps on holiday you may just want to photograph your beloved standing in front of the pyramids. With a wide-angle, large background views shrink in relation to your subject (as long as the subject remains close to the camera).

Wide-angles are favoured by photojournalists who want to not only show people in their environment, but to convey to the viewer a sense of being right in the middle of whatever is happening, rather than a distant observer. Portraits take on a confrontational, 'in-your-face' quality.

When stopped down to a mid-range aperture (for example, f/5.6 or f/8) and focused at about two or three metres, a typical wide-angle will get virtually everything in sharp focus from about one metre to infinity, making this ideal for pre-focused instantaneous grab shots of fleeting moments.

Wide-angles are also beloved of fashion and avant-garde photographers for the dramatic angles and unusual perspectives you can achieve if you push them to their limits.

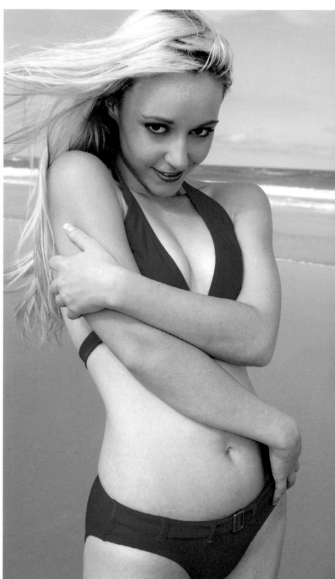

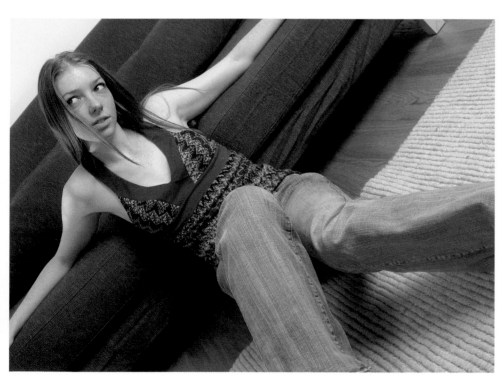

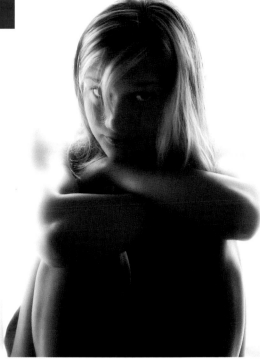

Left: Large, diffused lights from the front produce very soft lighting that's ideal for beauty subjects.
Above: Backlighting can produce a nice halo effect, but a frontal fill-light or reflector is essential to avoid a silhouette.

Lighting

If photography is 'painting with light', then the quality of that light plays a vital part in the success or failure of your pictures

CHECKLIST

The right type of light is crucial to the success of your shot.
The larger the light source, the softer the illumination.
Small light sources produce hard light and deep shadows.
Side lighting is ideal for revealing texture in skin.
Backlighting produces a rim-lit silhouette, if no frontal fill.
Daylight changes colour throughout the day and the year.
Reflectors are ideal for bouncing light back into shadows.

'ENOUGH' ISN'T ENOUGH

Most non-photographers waste little of their day thinking about light. There's either enough of it to see by or there isn't. They're often oblivious to the subtleties of the direction, contrast and colour of light, and how these qualities change the appearance of the world around them.

But as photographers we have to study and observe light, make it our friend. Light is the key ingredient of every photograph, and it is only by gaining some understanding of it that we can hope to use it to our advantage in our pursuit for great pictures.

Good images are not generally achievable in bad light, certainly with portraiture, because bad light is usually unflattering, and nobody likes unflattering portraits. But different types of subject and treatment demand different types of light, so our definition of bad light is illumination which is inappropriate to the subject, style, pose and mood that we're trying to create.

SIZE AND CONTRAST

A major factor determining the quality of illumination is the contrast of the light source. High-contrast lighting produces deep shadows with sharply defined edges. Low-contrast light produces soft illumination with more gentle shadows. The larger the light source, the softer the illumination will be. This concept is easy to grasp in a studio, when you can see how a large softbox creates a softer light than a small dish but, outdoors, surely the sun is the largest light source of all?

Well, yes, but at 93 million miles away it actually looks pretty small in the sky, so on a cloudless day it produces a hard light with strong shadows. So it's clear that the distance of the light source from the subject is key. The further away it is, the smaller it gets, and therefore the higher in contrast.

On cloudy, overcast days when the sun is hidden, the entire sky becomes a giant softbox, creating a virtually shadowless light source, which is great for outdoor portraiture.

Above: Soft outdoor lighting and lens diffusion have combined to create a very romantic, feminine feel.

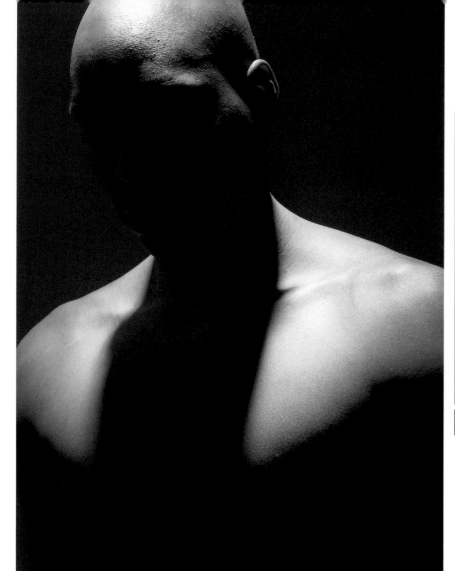

Left: A small, hard light source from above has produced a high-contrast image: burnt-out hightlights on the head and shoulders and deep shadows on the face.

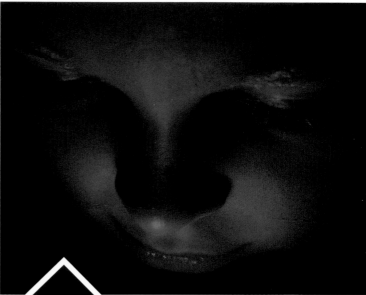

Using a single light source

Because most studio lights are sold in kits with two or more heads it's easy to get the mistaken impression that a multi-light set up is essential, but many top photographers get by happily with just one. This atmospheric shot was created by a single tungsten light from below – hence the orange colour and strong shadows on the upper sides of the nose.

DIRECTION AND ANGLE

The direction from which the light strikes the subject makes a vital contribution to the mood of the image. The most obvious place to put the light is directly in front of your subject. Depending on the type of light you're using the result can be harsh (for example, direct flash) or, if using a large diffused source, soft and flat. As the light is moved in an arc around to the face, the illumination becomes asymmetrical. One side of the face becomes more brightly lit, which introduces some shape and modelling to the subject's face. As you reach a 90-degree side view one half of the face is now lit and the other totally black – as famously seen on the cover of The Beatles' *A Hard Days Night* album. Continue the arc until the light is directly behind the subject and you have a silhouette, with a fine halo of bright light around the subject's edges (known as rim-lighting). This kind of lighting can look great if combined with a fill-light on the front of the model.

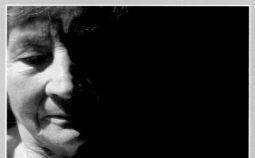

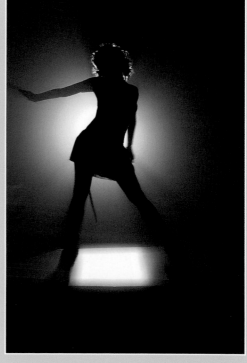

Above: Lit from the side. **Right:** Lit entirely from behind.

Moving the light source up and down also makes a big difference; the most flattering light usually coming from somewhere slightly north of the subject's nose.

All this assumes that there is no other light falling on the subject, but in the real world light bounces off every surface – ceilings, walls, the floor, etc. – so unless you take the trouble to eliminate it there will always be some light on the shadow side. Outdoors, of course, you can't move the light, so you must move the subject's position in relation to it.

COLOUR

Most non photographers are probably only vaguely aware that natural light changes in colour at different times of the day, at different times of the year and at different longtitudinal positions on the globe. They may have noticed how yellow-orange the sun is at the beginning and end of the day, and maybe, just maybe, they'll have observed how blue it appears at high altitudes, such as in the mountains.

In fact the colour of light, be it daylight or candlelight, varies dramatically, but our brain automatically adjusts for it so we rarely notice it. Cameras, however, do not. In the days of film, photographers had to choose film balanced either for daylight or artificial light, and use coloured filters for fine-tuning. Digital cameras feature a White Balance control, which adjusts the image at the processing stage to suit the light source.

The colour of light is described by its temperature, and measured according to the Kelvin scale. Typical daylight is around 5500K. At lower temperatures the light becomes more yellow-orange. Household lightbulbs may be just below 3000K, while candles are warmer still at about 2000K. Blue, cloudless skies can produce very blue light, in excess of 8000K.

Above: The light from a naked flame has a low colour temperature, resulting in a very orange light, which here contrasts beautifully with the blue of the dawn sky.

LOW LIGHT

Low light can be defined as light which is too dim to take a picture hand-held, at the normal ISO setting, without risk of camera shake. Low light in itself is no barrier to photography, and indeed can produce tremendously atmospheric images, but some compromises must be made to get them. For inanimate subjects the compromise may be to use a tripod, but with people it's unlikely to solve the problem, unless your subject is very still, or you want deliberate motion blur. Flash may be the answer, but it may kill off any ambient atmosphere in the scene. We've all seen pictures taken at parties where the subject is stark white, probably with red eyes, and the background is jet black. One strategy may be to combine flash with a slow shutter speed, so that the flash lights the subject and the slow shutter speed captures some of the surroundings. There will still be some blur using this technique, which is known as slow-sync flash, but that's part of its charm.

Often though, flash is either undesirable or impractical – the subject may be too far away, or is perhaps somewhere flash is not allowed. If so, the only answer is to increase the ISO. An ISO of 400 will permit a shutter speed four times faster than at ISO 100.

Unfortunately this causes some loss of image quality. Images become noisier (covered with fine speckles) and sharpness, colour and contrast deteriorate. The precise ISO performance varies depending on the camera and its particular sensor.

INDOOR LIGHTING

Photographing indoors can be a challenge. If there's a big window or source of natural light it may be a good idea to use that if you can. But you can of course press any form of lighting into service. An anglepoise or table lamp makes an effective light, though it's likely to be hard, contrasty and very yellow (make sure you use a tungsten White Balance setting). Candles and open fires make similarly warm lights, but aren't very bright, so a high ISO will be called for. As with outdoor photography, reflectors can be called into use to model, shape and bounce what light is available. You can also use natural reflectors to your advantage – white walls, cream carpets or upholstery – by placing your subject's face close to them.

If using flash try to bounce it from a wall or ceiling to diffuse it and reduce its harshness (as well as reduce the risk of red eye).

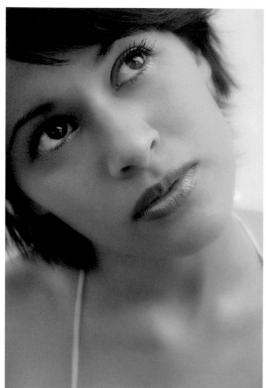

Above: In this image the light from the right of the frame is warmer than that from the left, resulting in an orange tinge to that side of the subject's face.

Right: The combination of harsh midday sun and fill-in flash (to eliminate some of the shadows on the face) has resulted in a stark, but very contemporary, portrait.

OUTDOOR LIGHTING

Daylight is great for portraits. It's infinitely varied in its colour, contrast, direction and intensity, allowing for a great variety of moods. But controlling it takes practice.

The time of day you shoot has a big influence. Early mornings and late afternoons the sun is warmer and lower in the sky, in winter it's lower at any given time of day than during the summer – if it isn't hidden by thick cloud. Overcast days provide soft, diffused light which can provide great results.

The choice of location is crucial. Under the shade of a tree or doorway is liable to be better than in the glare of the sun. Even in shade the light is often brighter from one direction than another – there may be a white wall, for example, bouncing light into the scene – so turn your subject to see how that changes the light falling on the face.

For more control, try adding a reflector – a sheet of white card or purpose-made folding type – placed to one side of your subject, to lighten the shadows.

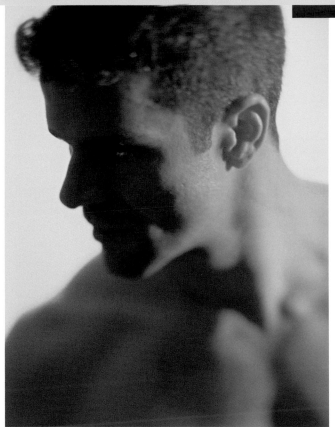

Above: Hard lighting adds a rugged feel to this outdoor shot. **Left:** Directional lighting works indoors too.

Men

You're far more likely to see a man behind the camera than in front
of it, but men make good subjects, as many of the greats have shown

CHECKLIST

Most men are photographed for what they do.
Study classical art for ideas on posing men.
Try character portraits, with hard side lighting.
Side lighting is good for revealing muscle tone.
Try shooting men engaged in their job or a hobby.
With formal portraits, choose a suitably dignified pose.
Take care if photographing male nudes outdoors.

PHOTOGRAPHING MEN

When we started writing this chapter we did some research to see how the subject of photographing the male had been written about in the past. You know what? We found virtually nothing out there. Women? There are thousands of books and articles. It seems men get a raw deal when it comes to attention from the camera. Look at the magazine racks of any newsagent and you'll see why. Men's magazines frequently have an attractive woman on the cover because that's what draws their reader's attention. Men want to look at beautiful women. So do women like to have hunky men on the covers of their magazines? No. They prefer women, too.

Of course men are probably photographed just as much as women, but they're usually doing something. They're sportsmen, businessmen, politicians... but the photograph is about what they do, not who they are. Men are seldom looked at from an

aesthetic point of view, unless they're celebrities or they're starring in a perfume ad.

It wasn't always so. The ancient Greeks put the male form on a higher pedestal than that of the woman, and artists and sculptors throughout history have depicted the well-toned male body – think of Michaelangelo's *David* and Rodin's *Thinker*, for example.

Many of the twentieth-century's greatest photographers have produced classic male figure studies too – among them Horst, Robert Mapplethorpe, Bruce Weber and Herb Ritts. They all happen to be gay, and it's the gay scene that still provides the only real market for images exploring the male aesthetic.

Here though, we're going to look at photographing the male in its widest context.

CHARACTER PORTRAITS

Character portraits are to men what beauty portraits are to women. Men are rarely lit with the same soft 'beauty' lighting used for women, but are instead more often photographed in a way that shows off their craggy skin, their wrinkles and their stubble. It's called character and, while it's considered a positive attribute in a male portrait, few women would thank you for photographing them in this way.

The key ingredients of a character portrait are a hard light, usually glancing across the surface of the skin from an oblique angle, a tight crop that goes right in close on the face, and a remorselessly sharp lens. Black and white is often the medium of choice, too. The subject's usually looking into the lens, and rarely smiling.

One technique that works very well with character portraits is to shoot at full aperture with a short telephoto lens to achieve very shallow depth of field in which only the eyes, and the area around them, are in focus.

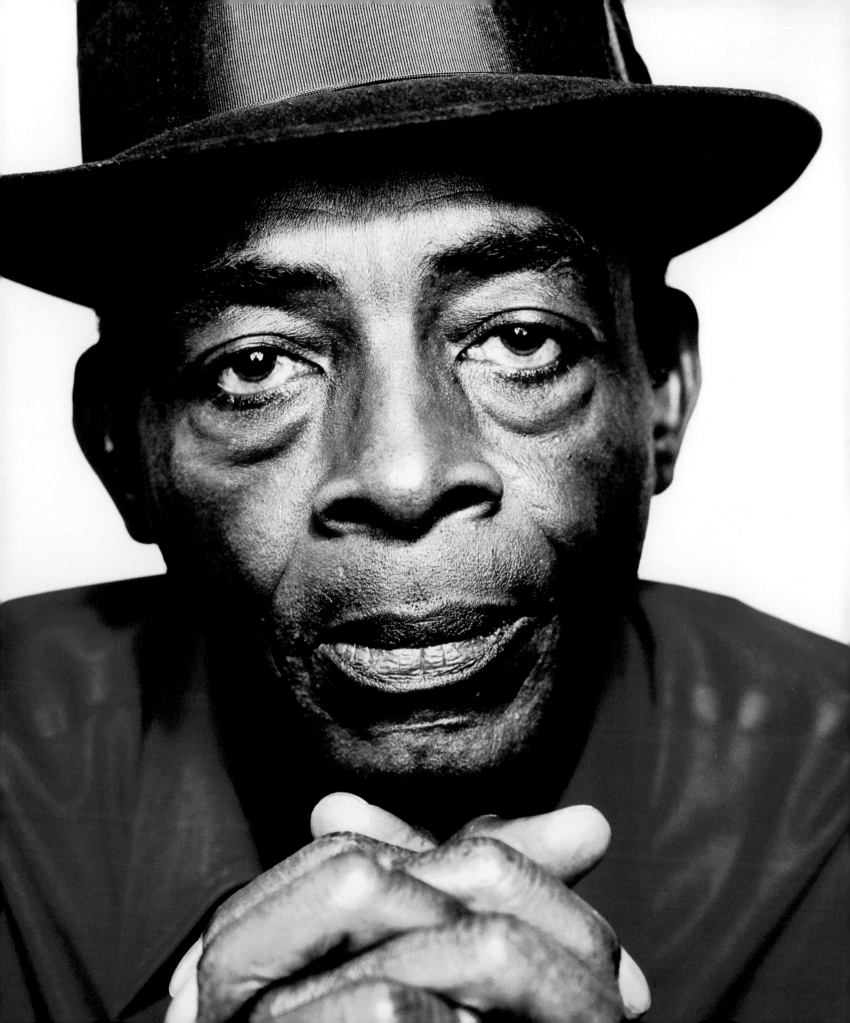

MEN IN ACTION

Another good way to approach photographing men is through a hobby or activity that they like to pursue. There's no shortage of pictures of men golfing, fishing, sailing, riding motorbikes and just generally enjoying themselves. Most men have a hobby of some description so if you're charged with the task of photographing one this is a good way in. If the activity is a fast-moving one you'll want to read our section on sports and action photography, but, generally, a fast shutter speed will freeze any movement while a slow one will introduce deliberate blur.

Where the setting is relevant, do try to show some of the setting in which the activity is taking place, to put it in context, rather than zooming right in and excluding all the clues which would identify to the viewer exactly what it is that your subject is doing.

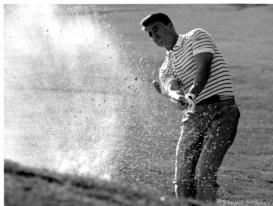

MEN AT WORK

Men are often defined by the work that they do. The first question anyone normally asks of a man, after their name, is what they do for a living, and we're often described in terms of our job. We're never simply 'John', we're John the architect, John the plumber, John the Baptist... (see, they even did it in biblical times!)

So, it's little wonder that men are often photographed in the context of their work, and men are often most comfortable when depicted this way rather than in the anonymity of the photo studio.

There are different approaches to photographing the working man. Many men wear a uniform of sorts, whether it's a police or military one, chef's whites, a hard hat and overalls or a business suit. The clothes we wear provide an idea of what we do, which means that, for many men, it's possible to shoot them against a plain white background and their jobs are still identifiable.

It may be more interesting though to show men in their work environment, whether that's a modern office, a building site, behind the wheel of a bus or on the deck of an aircraft carrier. The rules for such location photography are the same for any outdoor environmental photography, with the additional caveat that some work places can be hazardous, so take special care where you stand, and pose your model. For these and other reasons, most workplaces probably have a ban on taking photographs without the express permission of the management, so don't just stroll in and set up your camera.

Photographing the male nude

For anyone planning to shoot figure studies of the male nude (see also 'Nudes', page 100) there are a few ground rules. Firstly, if you're planning to shoot outdoors remember that society is less forgiving of male nudity in public than female, and there are strongly enforced laws governing what men can expose, so make sure you have privacy. A studio or private indoor location are preferable.

Male nudes tend to follow quite a different repertoire of poses than females, with a greater emphasis on postures that show off the biceps, triceps, abdominal and other muscles to best effect. More oblique lighting will bring out muscle tone by creating fine shadows around every contour.

THE FORMAL MAN

Ah, the stiff upper lip. There are still many men, especially older men, who feel that if they're going to have their picture taken, then a suit and freshly pressed shirt is the only appropriate attire. There is nothing wrong with this, and indeed many 'people at work' portraits are done this way, if the profession is a formal one (the legal profession is a good example). This style has its own repertoire of poses. Many involve standing, but some will allow for sitting on or in a chair (but never the floor). As with all portraits of men, but especially those lit by flash or studio lighting, care should be taken when the subject is wearing glasses. Strong reflections in the lenses will not only reveal your lighting set up (and perhaps even you, too), but will make it difficult to see the subject's eyes.

Military men are another group of people who are likely to favour a more formal style of portrait, especially if they're in dress or ceremonial uniform, when 'standing to attention' may be pretty much the entire repertoire available.

Left: Glamour models will have a repertoire of poses. **Above:** Good modelling is often about confidence.

Models

One vital ingredient for any portrait is a suitable subject, and many would-be portrait photographers come unstuck at this first hurdle

CHECKLIST

Start by asking friends and family to pose for you.
Don't expect too much of people who are new to it.
Don't be afraid to approach photogenic strangers.
Get a portfolio printed or a website to show them.
Look through newspaper ads for aspiring models.
For more ambitious ideas consider hiring a pro model.
Explain clearly what you want to achieve before startin

FAMILY

One of the biggest problems faced by aspiring portrait photographers is where to find models. A good portrait portfolio will include pictures of a variety of people, but asking them to pose can be more intimidating than taking the pictures. The most obvious place to start, especially if you're new to portraiture, is your own family. Most of us have wives, husbands, children, parents, grandparents, uncles or aunts, and asking them to pose for you is obviously going to be less of an issue than asking strangers.

Photographing family members on familiar territory, such as their home, should be a relatively relaxed affair, but don't take too much advantage of that blood-tie by turning your session into a long and painfully drawn-out affair, while you fiddle with the light and your settings, or any future request for an encore may not be met with as much enthusiasm. There's likely to be more opportunity for candids though, so take them.

FRIENDS

You've photographed everyone in your family what now? The next most obvious place to look is among your friends, neighbours, work colleagues and others among your social circle. Many photographers prefer to skip the family stage altogether and go straight to their friends for subjects. Sessions with your peers are perhaps more likely to be treated in a professional way by both parties and you may find there's less embarrassment factor. Of course it all depends on your relationships with your family and friends.

However, just because they're friends it doesn't mean they should be happy to pose for you. Many people hate having their picture taken, and if any of your friends fall into that camp, don't worry – there are plenty more subjects out there.

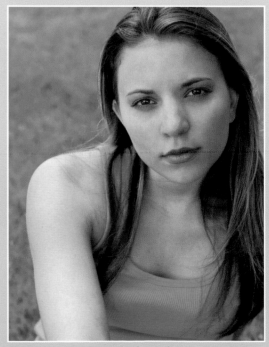

Above: Simple 'girl-next-door' portraits are easy to shoot.

PROFESSIONAL MODELS

There are many advantages to hiring professional models but also a few disadvantages. Firstly the good points: there's no embarrassment factor in asking them to pose – that's what they do. They may well have their own studio space, which solves another problem. They'll be comfortable in front of the camera and will have some understanding of the process (basic lighting, how the choice of lens and viewpoint will affect the result, etc.). They should quickly be able to grasp what you want to do, and should be able to easily slip into a range of poses and expressions to order.

But that's one of the disadvantages too – the risk of a posing by numbers approach. Some models tend to just go through a standard repertoire of clichéd poses. Glamour models, for example, may instinctively arch their backs, stick out their chests and pout at the camera. If this is not what you want, say so from the outset and don't let the model slip into auto-pilot.

The other main drawback of professional models is that you have to pay for them. This makes choosing the right model vital. There are dozens of agencies in big cities, but in the provinces your choice may be more limited. Look online at web-based agencies. Study the pictures carefully, ask questions, make sure your money will be well spent.

One cheaper alternative is to consider life models: young, aspiring models and enthusiastic amateur/semi-pro models who often advertise their services in local free ads papers. Again, ask to see some pictures and, if possible, meet them before booking something, to avoid potential disappointment.

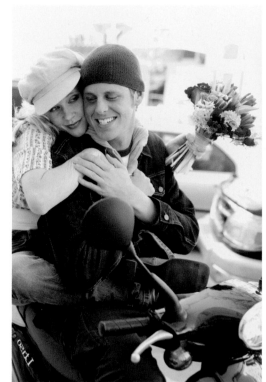

Above and right: Models are in some senses also actors, and are often called upon to portray a story or emotion, whether it be a happy or an unpleasant one.

STRANGERS

How often in the average week do you see a complete stranger who'd make a great model? That commuter sitting across from you on the train, the waitress in the coffee shop, the woman at the supermarket checkout, or standing at the bus stop.

Drumming up the nerve to ask a stranger to pose for you is daunting, there's no getting away from it, but there are ways to make it easier. Firstly, it helps if you have a business card with your name and contact details. This makes you look more professional. Having a website with some previous examples of your work, and printing the URL on your cards will enable your intended subject to check you out and see your pictures. Once he or she is satisfied you're above board you are more likely to get a positive response. If you don't have a website even a page on a photo-sharing site such as Flickr is worth having, even if you have to go into an Internet café to do it.

The traditional method is to offer to show the subject your portfolio. Make sure it's professionally presented and the picture quality is good. Arrange to bring it to a neutral public place (perhaps his or her place of work if that's where you met them) unless you've been forward thinking enough to already have it with you. Suggest your subject brings a chaperone, for peace of mind.

If your subject agrees to pose for you, make things as easy as possible. If he or she feels more comfortable bringing a friend, that's fine. An outdoor public place may be safer to start with, although your subject may feel more self-conscious if there are passers-by watching. If you want a private venue consider hiring a studio or third-party venue, rather than using your home.

Above: Potential models are everywhere – perhaps even working behind the bar at your local pub.

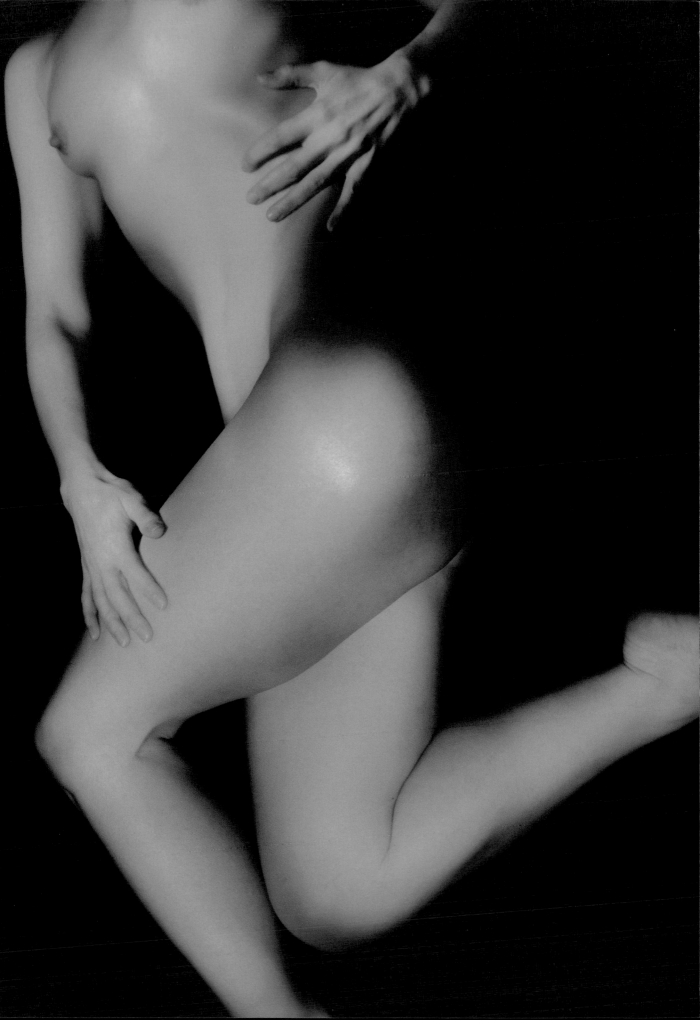

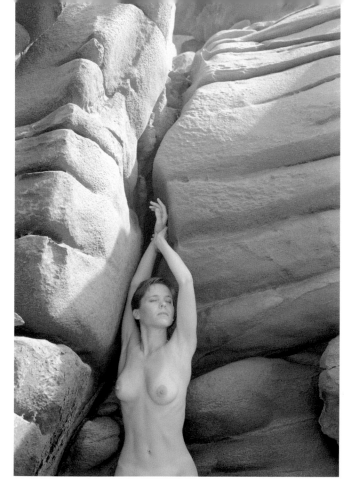

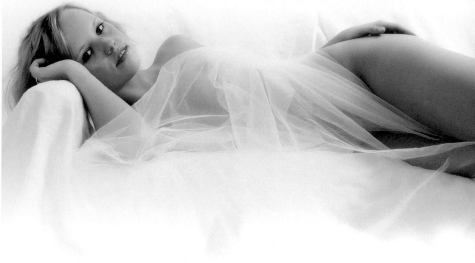

Above: Nudes can be subtle – use props to cover up parts of the model to retain a sense of mystery.
Left: With outdoor nudes, look for interesting geographical features and pose your model accordingly.

Nudes

One of the most popular subjects for artists since man first picked up a paintbrush, nudes are a challenging, but rewarding genre

CHECKLIST

Indoor settings provide more privacy for shoots.
If outdoors, shoot when it's deserted, such as dawn.
Keep a coat handy for quick cover-ups if necessary.
Professional models often have their own studios.
Look in local papers for keen amateur models.
Establish before you begin what you want to do.
If you plan to sell or publish, get a signed release.

THE NUDE

Few subjects have fascinated artists throughout the centuries as much as the naked human form, and photographers are no different. But there are as many different approaches to photographing the nude as there are body types. Although the erotic potential of the nude remains a key motivation for most photographers, quality nude photography (as opposed to glamour photography) is more an exercise in light, shape and form. The eroticism is in the subtlety.

The nude is an extremely difficult subject to photograph well, and there are so many potential pitfalls that getting results that are good enough to frame may take a lot of practise. Here are a few pointers to get you started.

MODELS

The first task of any aspiring photographer of the nude is to find a model willing to pose naked. This is a difficult one because friends may find the whole thing too embarrassing, yet strangers may understandably question your motives and credentials, especially if you've never done it before. The easiest way is to hire a professional model. This eliminates any embarrassment and may well solve your second problem too (finding somewhere to shoot them) as many have their own studios.

If a professional model is beyond your budget a cheaper approach is to advertise in your local newspaper or free ads paper. Likely respondees include exhibitionists, first-timers with modelling aspirations and those wanting pictures for them or their partner.

Whoever you use, discuss what you want and the potential future uses of your pictures. If you have any aspirations to publish the work make this clear and get clearance in writing, as this will avoid problems later on.

STUDIO NUDES

The easiest place to shoot nudes is in a proper studio. Not only are you guaranteed privacy, but you'll have a range of background and lighting to help you. Paper background rolls are perhaps best, as you can extend them across the floor to create a seamless background that the model can also sit or lie on. Plain black or white are the most popular colours. If using white be sure to light the background too, so it doesn't just record as a muddy grey.

Studios vary in size, but for full-length nudes you'll need a fairly long one so you can get back far enough, otherwise you'll find yourself limited to working with foetal-type poses or getting Bill Brandt-style wide-angle distortion.

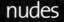

nudes

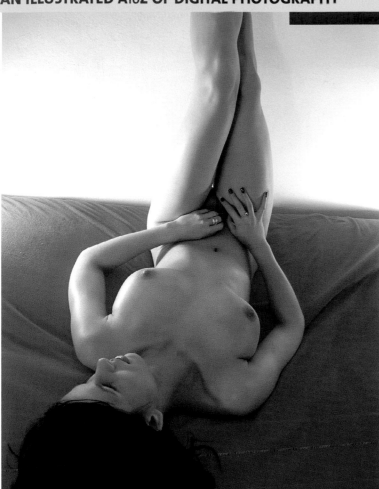

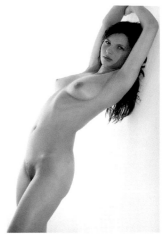

Left: Nudes can be shot in 'real' settings such as your own home. A sofa was used effectively in this image.

Right: For a clean simple background, and possibly more space in which to work, you can't beat a dedicated studio.

Below: Or go outdoors. There's a huge variety of settings available, though you'll need to find a time when no-one's around.

LOCATION NUDES

Some people find studio settings a little dehumanising, since they remove the subject from reality, and prefer to shoot in real locations. An empty house, or even your own home, can be ideal, as can public buildings (if you can get permission to shoot in them once they are closed – no easy task), offices and industrial settings. Derelict buildings work superbly as locations – it's something about the beauty of the subject contrasting with the ugliness of the surroundings. With some locations you may be able to take studio lights, but more likely you'll be working with the available light. This means seeking out windows or brightly lit areas, but check out the quality, not just the quantity. Dappled or uneven light, side light and soft, diffused light all have their benefits, but turn the model to see how the light changes before settling on a particular pose.

OUTDOOR NUDES

The great outdoors has long been used as a setting for nudes. Think of Edward Weston's desert nudes, or Bill Brandt's distorted nudes shot on the Sussex coast. You do have to be very careful though. Decency laws mean you can't get your model to peel off just anywhere. The first criteria is that it should be deserted. A private area such as a garden would fit the bill, if it's suitably landscaped. Try woodlands (though light can be scarce) beaches and fields of wheat or corn. If it's a public place try going early in the morning when there are fewer people, and have a coat in case someone comes along.

If shooting outdoors, look for shapes and backgrounds that be incorporated as elements in your picture. Try making the model part of the environment, by his or her attitude. Outdoor lighting can be tricky. Diffused light is preferable to hard sunlight for nude photography. Early mornings score here, too, as the lower light angle can be evocative.

LIGHT

Whether you're using natural light or flash, the lighting is one of the most important elements for a successful nude. Placing a diffused main light next to you, directed on to the front of the model, can produce a gentle, romantic image and lends itself well to a high-key treatment. When the main illumination is from the side strong shadows result, which can be used to enhance and emphasise different areas of the body, or different qualities of the model's form. But side lighting also highlights the texture of the skin, which may not always be good. Moving the main light behind the model will produce a silhouette, with a halo around the contours of the body that will emphasise the model's shape.

That's the theory, anyway. In reality the light will come from more than one direction, and will be bouncing off walls and furniture. Only in a studio situation can light be controlled so that it's coming from just a single point.

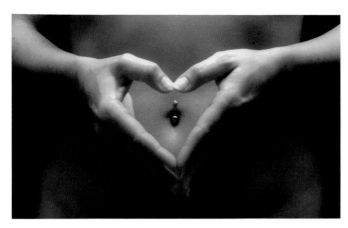

Left: You don't need to include the whole body. Look out for small details.

Right: Shooting two models together can produce great results—this tender image, for example.

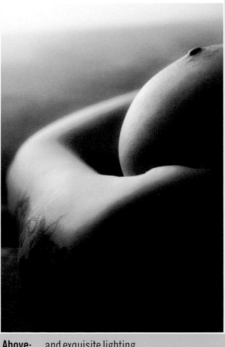

POSING AND COMPOSITION

There's a huge variety of different types of nude, from vast landscapes in which the nude forms a small component, to close-up details of a model's navel. Depending on the setting, environmental nudes can work well, setting a mood and perhaps even suggesting a story. Detail shots are more an exploration of shape, form and texture, but must be exquisitely lit to succeed. Then there's the question of whether you want the model to be looking into the camera or away. When the model is looking away from the camera the image's relationship with the viewer becomes voyeuristic, as though you just happened to peer in through the door and there was this completely naked person gazing out of the window. When a nude model looks into the lens the image generally becomes more sexual in tone, more of an invitation to the viewer to gaze upon his or her body.

Arranging the body is very important in successful nude photography. While you may want to find poses which create interesting shapes, beware of positions which stretch and distort the skin in unflattering ways, or which look uncomfortable. If your picture is supposed to look candid and natural you'll still need to find poses which flatter. Slouching, for example, should be avoided. Some poses are more sensuous than others, so should be chosen with regard to the level of sexuality you wish to create in your picture. (For more posing tips, see page 112.)

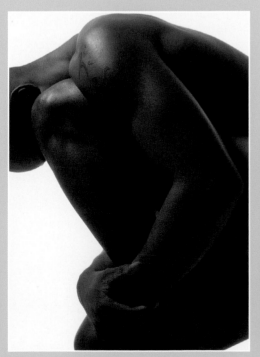

Above: Strive to create interesting poses...

Above: ... and exquisite lighting.

TOP *TIPS!*

1 BE INVENTIVE
Treat the body like a sculpture. Explore angles, shapes and interesting perspectives to see the body in a new and different way.

2 LIGHT IS VITAL
Take time over the lighting. Look at how it falls on the model, use reflectors to fill in shadows, or move the light and/or model to find the best light.

3 AN EYE FOR DETAILS
You don't have to include the whole body, or even the face, for a successful nude. Look for pictures in small details. Try shooting at wide apertures.

4 USE THE LOCATION
If on location indoors or out, make the most of any shapes and features in the setting, such as jagged rocks or spiral staircases.

5 LISTEN TO THE MODEL
A good model will suggest and contribute ideas of his or her own. Be collaborative.

professional profile

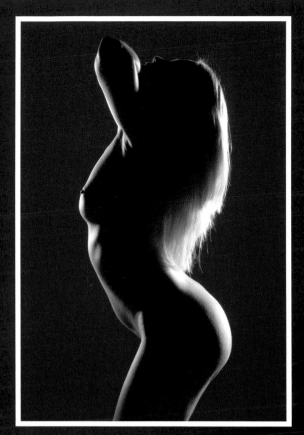

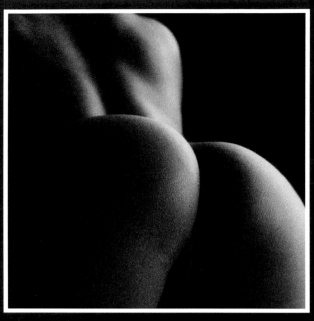

Far left: A backlit nude has created a perfect rim-light around her outline, emphasising her shapely figure.

Left: You don't need to include the entire body. Close-up details can be very effective if lit well.

Right: Outdoor locations, such as coastlines, can be great for nudes as long as you have privacy. John used a wide-angle lens here to show the model in her environment.

John Freeman

John has photographed the nude for various books, and passes on his tips and advice for those wanting to try it

You may recognise John Freeman's name as author of some of the world's bestselling photography manuals (he's sold over a million copies of them) but he also specialises in illustrating glossy books on various topics, from cookery to sex – with books such as the *Ultimate Lover's Guide* and *The Modern Kama Sutra*. John has also shot nudes for health and mind/body/spirit guides.

'There are several ways to approach the subject,' says John, who shot his first nudes as a photography student at art college. 'Personally, I've always preferred the fine-art approach to the glamour route.' This philosophy can be seen even in John's *Kama Sutra* pictures, which are beautifully lit and styled, and not very explicit. There's a romance to John's nudes, which is intentional.

For amateur photographers, finding models is one of the hardest tasks, and many would-be nude photographers never get past this stage. Luckily, John is often able to use professional models, but he also photographs women he meets in his day-to-day life.

'It isn't as difficult as you may think,' says John. 'A lot of women don't mind being photographed nude – it's a permanent record of how they looked when they were at their physical peak – but they need confidence in the photographer and their intentions. A portfolio of high-quality work will help.'

If you don't have any work to show, or don't have the nerve to ask people to pose for you, the best solution is to hire a professional model. While a more expensive option, they have several benefits.

'Professionals are, through experience, more likely to grasp what you're trying to achieve and work with you to get the best results. A good model will contribute ideas of her own and suggest poses that may not have occurred to you, making it a true collaborative effort. She will also know the practical things such as not wearing tight-fitting underwear which marks the body.'

You can photograph nudes either indoors or out but you need to be careful outdoors. 'Pick a time and location where you'll be almost guaranteed peace and quiet. I often look out for places with interesting geographic features such as rock formations

in which to place my nude, or shoot near water, which provides a reason for the nudity.'

Indoors is less hassle, and more private. Although studio flash is an option it isn't essential. 'I prefer natural light whenever possible,' admits John. 'It's much nicer.' Windows and doorways make great settings, and reflectors can be used to direct and model the light as required.

Before starting a shoot John advises having a good idea of what you're trying to do. 'Have a plan and discuss it with your model beforehand so she knows what you want and can work with you. But be prepared to be spontaneous and deviate from the plan if the shoot takes you in a different direction.'

While shooting check the background for distractions and choose a flattering viewpoint. 'For example, don't shoot from above with a short focal length lens as you'll give the model a big head and short body. A low viewpoint makes her look taller. I prefer using telephotos as their shallow depth of field isolates subject from background.'

You can find examples of John's work at www.johnfreeman-photographer.com.

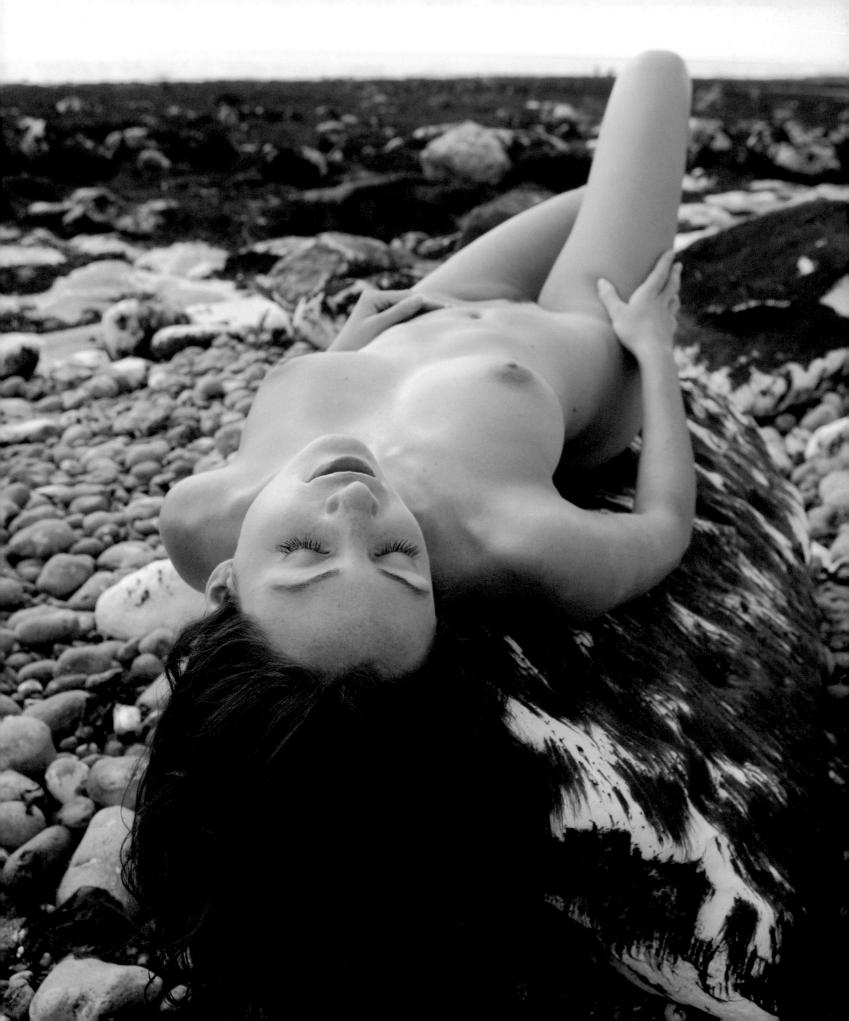

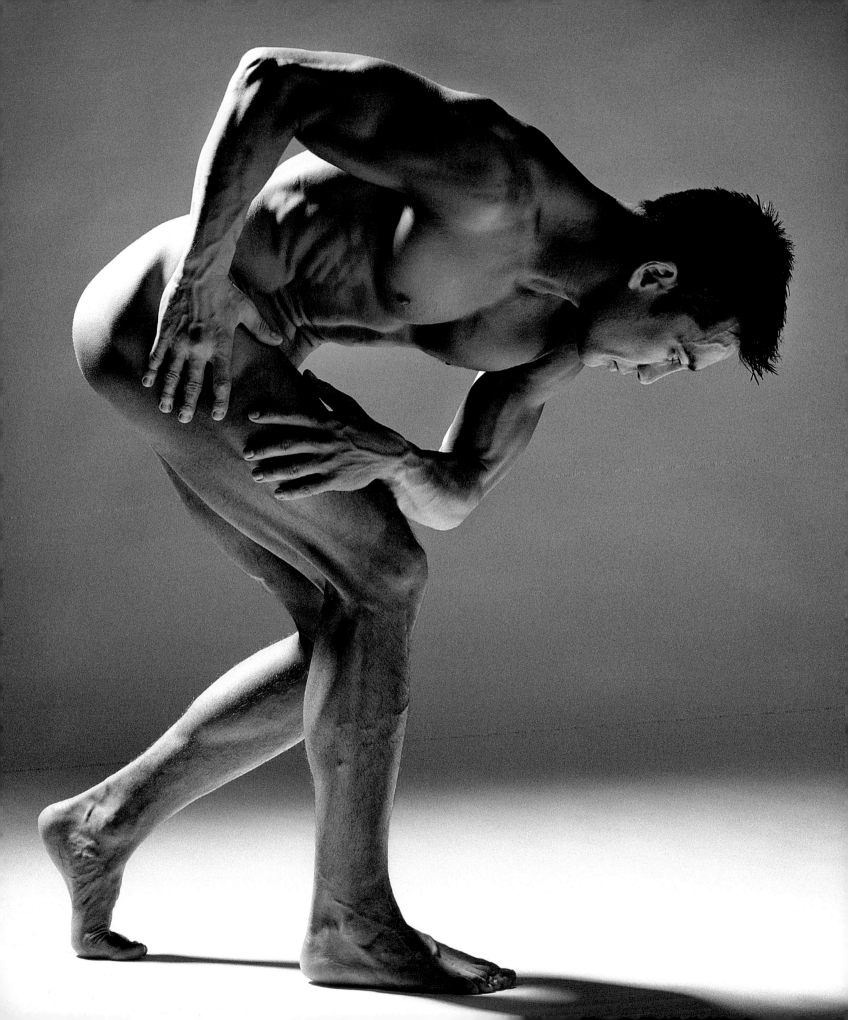

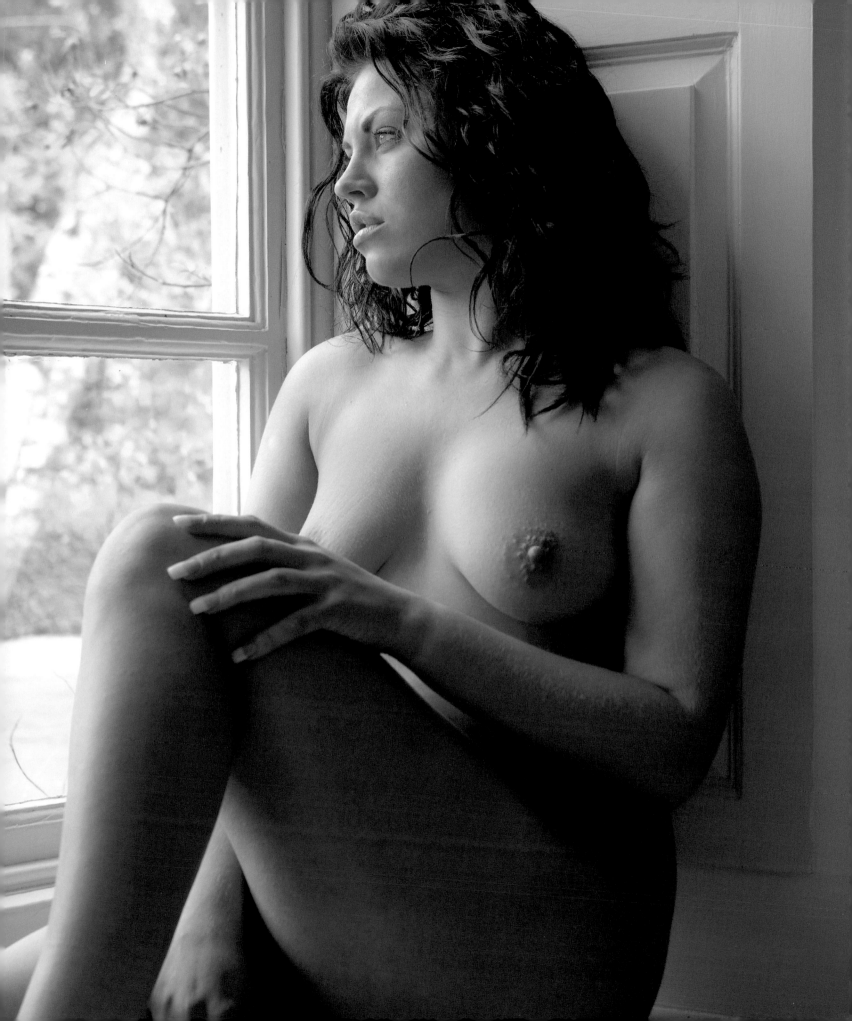

Left: CDs are a good way to archive your images.

Above: Card readers are an inexpensive way to transfer images from the camera to the PC.

Organise and Archive

If you don't look after your precious photos, digital technology
makes it easier than ever to lose them forever

CHECKLIST

Card readers are the easiest method of downloading.
Alternatively, plug the camera into the PC directly via USB.
Some cameras come with a docking cradle for downloading
On a PC download images to the My Pictures folder.
On a Mac download images to Apple's iPhoto software.
For powerbook users, better software is available to buy.
Make sure you archive your photos for safe-keeping.

ORGANISING AND ARCHIVING

In film days the cliché was that people kept their negatives in shoe boxes under the bed. This was probably never true, but it's fair to say that filing and organising was not high on most people's lists.

Digital photography, however, presents a few problems which require a more disciplined approach. For a start, unlike a print or negative you can't actually see a digital file. So, if you want to find a particular shot you can't do so by holding your media card up to the light. What you name that file and where you put it becomes vital if you want to be able to find it again.

The other drawback of digital images is that, because they aren't physically real until you print them, and because they're stored on media which has a high risk of going wrong at some point, there's a very real danger of the complete and irretrievable loss of all your pictures, unless you take steps to prevent it.

DOWNLOADING

There are several ways to download your images, but the most popular is to simply remove the card from the camera and insert it into a card reader attached to the PC via the USB port. These are inexpensive and many new PCs come with card slots built in.

An alternative method is to connect the camera via the supplied USB lead, although this consumes the camera's battery power. Some cameras come with a USB cradle or dock which automates the process.

When a camera or card is connected to a PC using Windows XP, a dialogue box will provide a list of options as to whether you wish to simply view the images or copy them.

The My Pictures folder is the obvious home for your images, but you can create many sub-folders within that for, say, different events.

Macs usually provide organising software called iPhoto, which does an admirable job of keeping tabs on your digital photos.

ORGANISING

The first thing that must happen once images are downloaded is to edit them and sort them. It's best to do your editing on the PC rather than on the back of the camera because you can't really judge a picture's worth when it's only two inches wide on the screen. On your monitor you can tell if a picture is sharp and well exposed, and get a better idea of its aesthetic value. You need to be a little ruthless in your editing if you don't want to rapidly fill your hard drive or CD racks with worthless images. Some people keep their rejects, perhaps in a separate folder called 'rejects' so they can cannibalise bits of them, such as skies, for Photoshop montages.

Once you've weeded out the rejects you must sort them. Rename your pictures with something more recognisable than the standard three-letters-plus-number applied by most cameras (for example, DSC_1234). This could be the name of the place or the name of the subject – whatever you like.

BROWSER SOFTWARE

Organising and finding pictures on your computer is a lot easier when you install dedicated software designed for the job. This type of software may be called album or image-management software or one of several other names, but most do a similar job. You can sort your photos into named albums or chronologically along a timeline, rename them, add searchable tags or keywords (for example, the names of your family members, places you've been to, or descriptive adjectives) so you can find specific images when you search on that word.

Most offer a variety of output functions, such as letting you create slideshows with music and fancy fades and wipes between shots, or arranging your photos into pre-designed templates for printing as photo albums. Some also offer editing and enhancement features, and most provide some archiving aids, such as CD/DVD burning, and reminders when you've added enough new photos to burn a new CD. Popular applications include Adobe's Photoshop Elements, and Photoshop Album, PaintShop Album, ACDSee, iView Media and Roxio Easy Media Creator.

Right: Portable storage devices enable users to download images from their cards in the field. Some also offer a colour screen for viewing/editing.

Far right: A laptop is an extremely useful accessory for the mobile digital photographer, enabling downloading and editing on the fly.

ARCHIVING

Leaving your photos on your PC, with no back up, is like playing Russian roulette with your memories. Sooner or later your PC is likely to go wrong and if you don't save your images elsewhere you could lose them. There are a couple of options. The first is to attach an external hard disc drive to your PC on to which you can back up your pictures. A good-sized model with, say, a 200GB capacity should last a while unless you're a very active photographer with a high-resolution camera.

But even external hard disc drives can fail, so the second option is to burn your pictures on to a CD or DVD. The advantage of DVDs is that they hold over 4GB of data, as opposed to less than 700MB for a CD, but only relatively recent or high-spec PCs tend to have a DVD writer, whereas almost all currently usable computers will have a CD burner.

For the greatest security of all it's best to use both methods of archiving: an external hard drive and a secondary back up to disc, with the discs stored at another location, in case of fire. This may sound extreme, but if you value your images it's a small inconvenience.

TOP *TIPS!*

1 EDIT AS YOU GO
Delete obviously bad shots immediately, to avoid filling up your hard drive and CDs with rejects.

2 KEEP SOME REJECTS FOR SPARES
If you're a Photoshop enthusiast, keep a folder of rejects to cannibalise for parts in future montages.

3 ALL IN THE NAME
Rename your files with a meaningful name to make it easier to find images later, and identify what images the folder contains.

4 PORTABLE STORAGE
A portable hard disc drive or iPod will let you download your cards in the field, eliminating the need for so many cards.

5 BUY DECENT SOFTWARE
Free organising software is pretty good, but for serious use you should invest in a dedicated program.

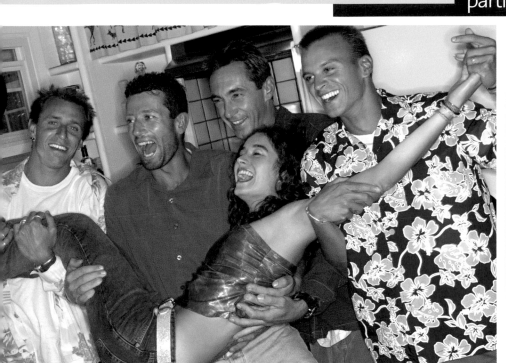

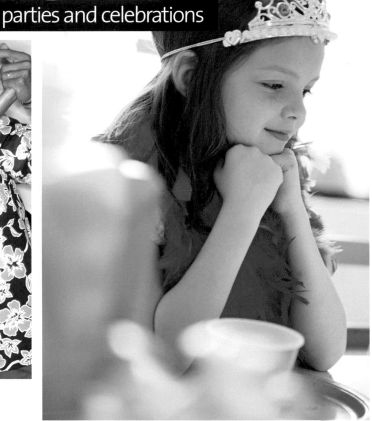

Above: Keep a camera ready for spontaneous moments.
Right: Keep an eye out for individual moments.

CHECKLIST

Indoor parties are the most challenging of subjects.
Set a high ISO to reduce flash dependence.
Use an external flashgun, bounced off a wall, if you can.
Don't get too close to subjects – the flash will blast them.
Use a slow shutter speed to record some ambient light.
Get some shots of the special birthday girl, boy, etc.
Keep the camera primed and ready to shoot quickly.

Parties and Celebrations

More bad photos are taken of parties than of any other subject, but there are a few techniques that can improve the success rate

A DIFFICULT SITUATION

Few shooting situations are more challenging for the photographer, and less likely to produce high-quality results, than parties. The combination of low light and often excitable subjects means that the best you can often hope for is a reasonable record of the event without too many people blinking.

Children's parties are difficult because the kids are running around like lunatics. Tracking them with the camera so that they remain in the frame *and* getting them in focus requires concentration and quick reflexes. Adults are a challenge for quite different reasons, many of which are related to alcohol!

SAY NO TO FLASH

Most parties take place indoors in low light, and these are the worst conditions possible. The absence of ambient light means flash is required. With close-range subjects it blasts the subject's face with such force that his or her skin is often turned pale and ghostlike, with almost no tone or detail. The background, meanwhile, is as black as midnight, leaving the viewer with no clues as to where the event took place. With faraway subjects, the flash usually doesn't reach at all, so events are barely visible in the gloom.

If you can, the best strategy is to switch the flash off and use ambient light, but this will inevitably mean raising the camera's ISO to at least ISO400, and more likely 800 or 1600, if your camera even offers such sensitivity settings. The downside of this is that pictures will suffer badly from 'noise', which resembles film grain. However, many would argue that this is the lesser of two evils, and there are at least noise-reduction

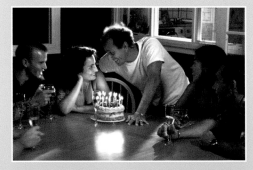

systems available on many cameras and as filters in some post-editing software, which can reduce the problem, if only a little.

Depending on the sophistication of your camera, one solution is to use a combination of flash and ambient light by setting a slow shutter speed. This records the ambient light, while the flash lights the subject. You'll need to set a speed of between about 1/4sec and 1/15sec (enough to record some ambient light, but not enough for the background to be unrecognisably blurred) and hold the camera as steadily as possible.

OUTDOOR PARTIES

If you're lucky enough for your party to be outdoors, say at a barbecue, then your chances of getting good pictures are much greater. Go for discreet candids of individuals, and small groups chatting, laughing and enjoying themselves, as well as perhaps a few posed groups. In bright sun, it may be worth switching the flash on to fill in any harsh shadows. If there are any children present keep an eye on them because they often offer golden moments if you're quick enough to catch them.

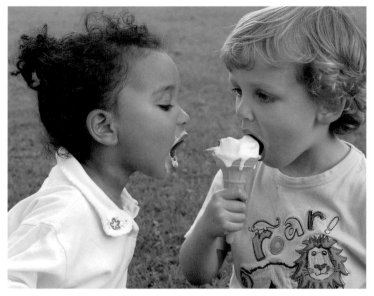

Above: Children and food are a great combination.

READY FOR THE MOMENT

At parties good pictures tend to happen quite spontaneously and without any warning, so if you're not ready with the camera you'll miss the action. Keep your camera with you, rather than in a bag somewhere, and if possible keep it switched on and with all the correct settings applied, so that if a good shot materialises you can just lift the camera to your eye and shoot. Most cameras go into a sleep mode if they haven't been used for a few minutes, and will continue to consume battery power while doing so, but they reactivate more quickly than if they were switched off. Try to avoid using too wide-angled a setting. You need to get quite close to your subjects to fill the frame, then the flash blasts them from close range. Also, switch off the red-eye reduction feature (surely one of the most useless photographic inventions). The delay it causes before the shot is taken ruins any chance of getting a good expression, and it doesn't often work anyway.

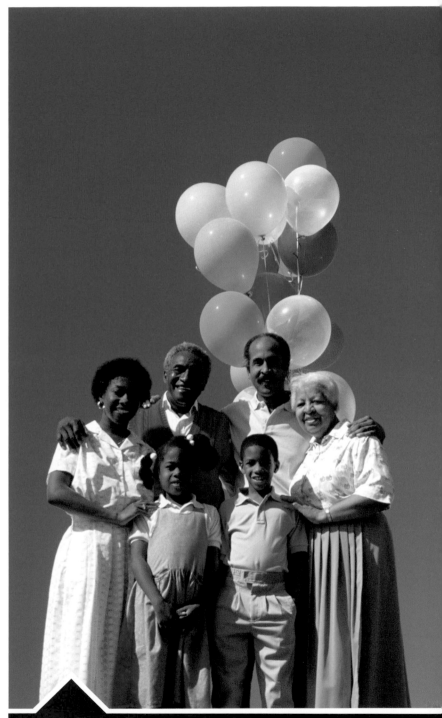

Keeping it simple

Outdoor events are much easier for photography than indoor ones, if for no other reason that there's plenty of light and you don't need flash. Summer barbecues and garden parties offer great photographic potential, but you still need to be ready to shoot quickly should a good opportunity occur. If the occasion is centred around an individual or couple (say, a birthday or anniversary), make sure you get some nice shots of the VIPs, even if this means posing them.

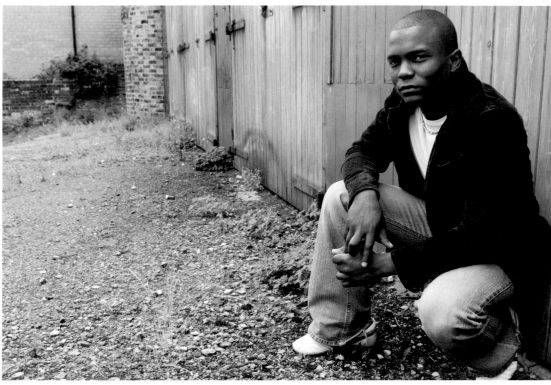

Left: Let your subject find a pose that's natural. **Above:** A crouching pose and three-quarter angle works well here.

Posing

Don't just position your subjects any old how. If you want them to look good you need to be aware of a few simple guidelines

CHECKLIST

For best results find a pose that's natural for the subject.
Find poses for your subject that enhance his or her personality.
Learn, but don't always follow, the traditional rules of posing.
Shoot a variety of poses and angles during a shoot.
It's easier to show a pose you want than explain it.
Don't over-pose subjects so they become self-conscious.
Choose poses that disguise any imperfections.

STRIKE A POSE

There are many elements to consider when shooting a portrait: the light, the location, the camera settings. But the two that most directly involve the subjects themselves are the expression and the pose, because the ultimate success of both is in the hands of the model, not the photographer.

A successful pose is one that works, visually. It doesn't look awkward or untidy, and indeed it will provide lines and curves that enhance the composition. For many styles of portraiture a successful pose is one that looks comfortable and natural, and flatters the subject, but in other genres, such as fashion, it may be quite the opposite. Models are often expected to strike theatrical poses that are neither comfortable nor natural, in the name of art.

While fashion and fine-art photographers are happy to follow the maxim that 'the only rule is: there are no rules', the world of social portraiture — the genre which concerns

itself with capturing flattering pictures of ordinary people — is choked with rules about posing, many of which are borrowed from the world of classical art. There are rules about the angle of the shoulders, how the head should be tilted, where the hands should be placed and about the positioning of every part of the body. The justification is that these rules will, if followed, produce a flattering, tidily composed image.

There are those, however, who scorn such rules and delight in breaking them. They argue that such rules produce the kind of clichéd pictures that mire so many provincial portrait studios in mediocrity. Few could argue, however, that's it's useful to know what the rules are and what the logic is behind them so that they can be followed — or broken — in a knowing, informed way.

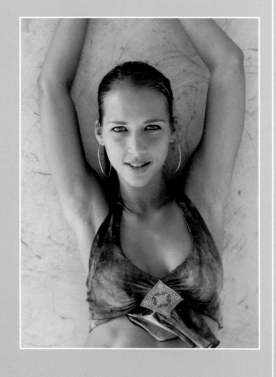

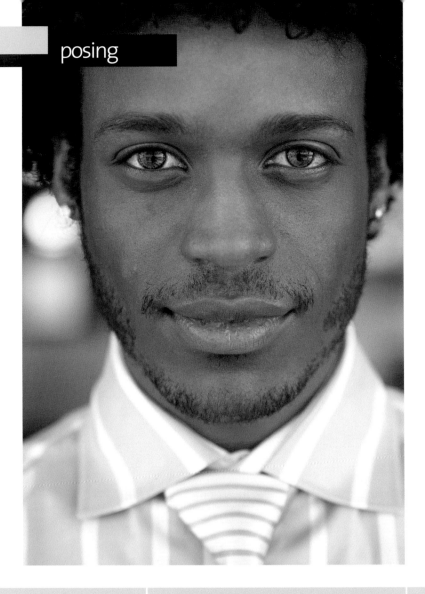

THE EYES

As the 'windows to the soul', the eyes are the most important part of any portrait. It's crucial that they are not only in sharp focus, but convey the right message. Boredom, pain, anger, joy and desire are among the many emotions that can all be seen in the eyes, so the right kind of interaction is essential. Eyes should look bright and lively too, and the easiest way to achieve this is by ensuring they have a catchlight – a small reflection of the light source. Catchlights add so much life to the eyes that many photographers consider them a 'make or break' element in a portrait. The best way to achieve them is to make sure the subject is facing a strong light source, whether it be a studio light or a window.

Whether the subject looks into the camera or not is a matter of choice. Most people prefer looking into the camera – it's more personal, more intimate, friendlier. Looking away tends to give off a more dreamy, thoughtful vibe. The positioning of the eyes is important too. Having the subject turn his or her eyes, to look slightly askance rather than straight ahead, is a common trick used to make the eyes look bigger and more attractive, and is a consequence of having more of the whites of the eyes showing. The easiest way to achieve this is to have the subject turn his or her head slightly away from the camera, but to look into the lens. Or vice versa. This technique works whether the eyes are looking to the side or looking up, though rarely by having the subject look down.

THE HEAD

An old posing rule still persists that the head should be tilted slightly to one side, according to the subject's gender. Woman should tilt towards their higher shoulder, and men should tilt to the lower one. This is a hang-over from the days of studio portraiture and you don't need to follow these conventions. Tilting to the lower shoulder *can* seem masculine, but gender roles are less defined now, and if you're shooting a woman with long hair it makes sense to tilt the head. Of course, the head doesn't have to be tilted at all.

THE NECK

The neck is one area that shows up age and weight. Older people's necks can look more wrinkled, while the overweight can suffer from visual afflictions such as double chins or 'turkey neck'. Finding a pose in which the subject has to extend their necks slightly will stretch the skin and minimise such problems, though poses which stretch the tendons in the neck so they stand proud should obviously be avoided. In some cases the easiest way to deal with a problem neck is to hide it with clothing or a well-positioned arm.

THE SHOULDERS

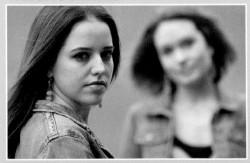

As you may have gathered, shooting the subject square on makes people look wide, and is not generally a flattering look. It can work, but usually only if the pose makes one shoulder higher than the other, so they aren't parallel to the top and bottom of the picture. Turning the subject so that one shoulder is slightly closer to the camera than the other is usually a better way to go. By creating more of a profile you present a thinner aspect to the camera, and this also makes one shoulder look slightly higher.

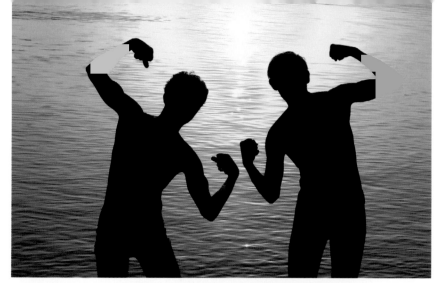

Above left: Silhouettes lend themselves to exaggerated poses.

Left: A great pose which, incidentally, lifts the eyes to a flattering angle and hides both neck and arms.

Right: The classic 'arms-resting-on-the-back-of-a-chair' pose, as used by Christine Keeler and others. It's gender-neutral, relaxed and looks good in shots.

THE ARMS

Few people have perfect arms, and the camera can be unforgiving, seemingly emphasising bony, flabby, hairy, veiny or blotchy arms, and patches of rough skin around elbows.

The safe bet is to have your subject wear long sleeves. In any event, make sure the arms aren't just hanging by the subject's sides. Move them away from the body (it makes them look larger) and bend the elbows. Folding them across the chest, however, makes people seem hostile or indifferent.

THE HANDS

People often struggle to know what to do with their hands, and there are lots of positions which should be avoided.

Interlocking fingers ('banana fingers') look unpleasant in pictures, as do clenched fists where knuckles are showing. When people are self-conscious they become more aware of their hands and suddenly no position seems natural. One solution is to have them hold something. Avoid having hands much closer to the camera than the face – this makes them appear huge.

TOP *TIPS!*

1 TILTING HEADS
Tilting the head to one side or turning it at an angle to the camera can add a more interesting angle to a face, but isn't essential.

2 STICKING YOUR NECK OUT
Avoid poses that stretch the neck so the tendons are taut, or that emphasise hanging jowls or double chins.

3 SHOULDER THE BURDEN
Turning the shoulders at an angle makes people look less wide and introduces diagonal lines to the composition.

4 NO ARM IN THAT
Don't leave arms hanging at the side. Arms can be used to hide features such as the neck, but covering them with sleeves is a safe bet.

5 A SAFE PAIR OF HANDS
Avoid banana fingers and, with nervous subjects, give them something to hold.

Printing your Photos

Don't just leave all your best pictures sitting on your computer's hard disc drive – print 'em up and show 'em to the world

CHECKLIST

Share your photos with the world by printing them.
The easiest way is to take them to a high-street lab.
Lab prints are printed on traditional photo paper.
Some shops offer a self-service kiosk for printing.
You can also upload photos to numerous online labs.
For more control or bigger prints try home-printing.
The latest inkjets are as archival as silver-based prints.

WHY PRINT?

Film users have no choice but to get prints of their pictures (unless they're using slide film). But with digital cameras, users can see their shots straight away, and can download them on to their PCs.

Unfortunately, that's where most of them stay. Of the millions of digital photos taken every year relatively few get printed. This means that they languish, unseen and unloved, on our PCs, always at risk of being lost forever though accidental deletion or computer failure.

Social historians have already expressed concern that the rich visual record that exists of the last few generations, through family snaps, may not exist for our and future generations.

You can of course print all your shots on your home inkjet, but it would be costly and time-consuming. Many people don't even know how easy it is to take your card or camera into a photo shop and get a set of prints made as though it were film, and it needn't cost any more either.

SELF-SERVICE KIOSKS

Some outlets even provide a self-service console that allows you to display, adjust, crop and make other minor enhancements before selecting a print size and pressing the 'print' button. These self-service machines are ideal for those who either don't have a PC or may be away from home. If you are uncertain how to use the consoles staff are always on hand to help.

Even people who do their own enhancements and manipulations at home can enjoy this service. By burning a CD of images and taking it to the lab you can get a set of true photographic prints that not only look better but may last longer than some home-made inkjets. Why not scan all your old prints and get a set of enlarged prints or blow-ups made from them all?

Above: Get your prints made at your local shop with a self-service kiosk.

ONLINE SERVICES

These days you don't have to leave the house to get prints made of your digital photos. If you have Internet access you can do it all online. There are numerous web-based photo labs (Photobox, Snapfish and Kodak being well-known examples) and all work in a similar way.

Using them is very simple. In most cases you'll have to register. Once inside you'll be presented with a list of options. With some labs you'll need to download some software from their website to use their service, with others you simply click on the Upload button, having selected the shots you want printed and put them in an album.

Apart from the usual printing size and surface options, most online labs offer other services too, such as printing on to other media, or a free web gallery where you can display the uploaded images for friends to view. Once ordered and paid for, your goods are mailed back to you within days.

HOME PRINTING

When you can get prints made in shops or online, why bother printing at home? Well, for the same reasons photographers have always had darkrooms at home. By printing yourself you can get exactly the result you want, at the size you want it. If your first print isn't exactly what you wanted you can tweak the settings and try again.

Friends round for Sunday lunch? Taken a couple of good shots of them? You can knock out a couple of prints in minutes and give them to them to take home. Got a birthday coming up? Forgot to buy a present? Send an A4 print of a family photo instead.

There are many reasons why photographers would choose to invest in a printer, but perhaps the most important is that it's their hobby and they enjoy the process of image-making as much as the results.

PRINT SIZES

Buying a printer isn't as simple as it once was. The first task is to decide what size of print is required. While the obvious answer may be 'the bigger, the better' there are many reasons why this isn't always the practical answer.

Although professional and SoHo printers go larger, the biggest practicable desktop home printers make prints up to A3, which is about 40x30cm. They can make smaller ones too, but if most of your prints are small an A3 model would not be a good choice. They're big (they take up virtually a whole desk), and are expensive to buy and fill with ink.

Most people opt for A4 printers, which enable 30x20cm enlargements to be made, but keeping the printer size and media costs within reasonable boundaries.

One of the fastest growing sectors is for small 6x4in (15x10cm) printers. Although limited in some ways, they're cheap to run, take up little space and are portable (some run off batteries).

INKJET VERSUS DYE SUB

The decision-making doesn't end there. There are two types of printer: inkjet (which sprays millions of microscopic dots of ink close enough together to create the illusion of continuous tone) and dye sub (in which successive ribbons of cyan, magenta and yellow ink are transferred by heat to the paper in separate passes).

Until recently dye subs were better quality and more archival, but inkjets have caught up with – and arguably overtaken – dye subs on both counts, though there isn't much in it.

Within the realm of inkjets there are two types of ink: dye and pigment. The latter has better archival permanence, but is less easily absorbed into the paper for a smooth finish. A few high-end printers use hybrid inks that combine the benefits of both types.

If you'd like a printer and a scanner but don't have space consider a multi-functional device or 'all-in-one', which combines a printer, scanner and copier in a single unit.

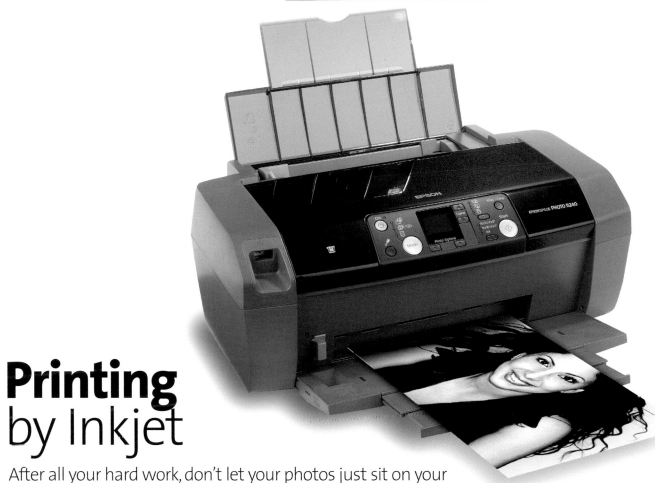

Printing by Inkjet

After all your hard work, don't let your photos just sit on your
PC or CD, print them out. Follow these simple steps to produce great-looking prints

MORE CONTROL

With printing your own images, it is essential that that you take extra time to make sure that you get the most from your printer and image. It is also important that you understand the differences between types of papers so you get the best output.

Unless you have had your monitor calibrated (colours adjusted for your environment and printer output), you may not always get exactly the same colour and tone you see on your screen as you will see on your print. It's wise to produce test prints first so that you don't waste expensive paper.

Make sure that you have followed the instructions in the printer's dialogue box when sending to print, checking you have selected the correct paper size, media type (glossy, matt, etc.). You can choose the auto functions, but doing it manually will give you more control.

STEP ONE

CHOOSE THE RIGHT MEDIA

When choosing print media, always try to buy the best paper that you can afford as it will pay dividends. Glossy photo papers have a shiny surface which reproduce vivid colours and a wide tonal range. They print richer blacks than matte papers, and will allow you to use your printer's finest-quality settings.

STEP TWO

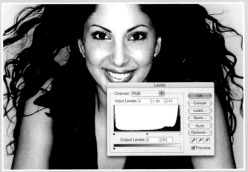

CORRECT IMAGE BRIGHTNESS

Open your image and bring up the Levels dialogue box. Inside are all the tools you'll need to use for adjusting the brightness of your digital image. Inkjet printers are not good at reproducing darker tones and tend to increase the amount of black shadows already present. It's a good idea to make your image look slightly brighter onscreen by moving your Levels midtone slider to the left as shown.

STEP THREE

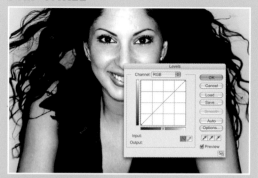

CORRECTING COLOUR

Next, it's essential to correct any colour imbalance that may have been caused by your lighting. Photos shot with flash can look cold and devoid of atmosphere, but this can easily be put back using the Curves dialogue.

If you've been using the wrong White Balance setting, this can also be corrected by applying a correction to both Highlights and Midtones in the Curves dialogue.

STEP FOUR

ADJUST RESOLUTION AND SIZE

Once you've made your image look good on screen, the next stage is to prepare it at the right size and resolution for print out. Open the Image Size dialogue and first uncheck the Resample option. Choose Image >Image Size. Next, change the Resolution to 200 pixels per inch, then this will set the maximum print size available as shown in the Document size readouts. It's not essential to prepare your images to match the 1440 or 2880 ppi output resolution of your printer, as you won't see any increase in quality above 200.

STEP FIVE

CHECK PRINT PREVIEW

Next, confirm your print size and orientation by using the Print with Preview command. Choose File > Print with Preview. At this stage, if your image is too big for your print paper, you can easily reduce its size by typing in a value less than 100 per cent until it fits within your currently selected paper size. If your image is lying in the wrong orientation, you need to change this in your Page Setup dialogue, rather than rotate your original image file. Finally, select the Centre Image option for a perfect, centrally positioned print.

STEP SIX

SET-UP PRINTER SOFTWARE

After choosing the Print command, pick the closest match to your print media from the Media drop-down menu. Next, set your print quality to its highest available option, sometimes referred to as High, Photo or 2880 dpi. Turn off all auto contrast, colour and sharpening controls as these might undo your work between steps 1 and 3.

STEP SEVEN

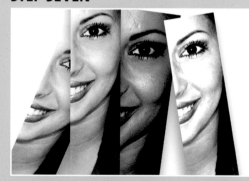

MAKE A TEST PRINT

Return to your image, pick the rectangular Marquee tool and make a selection around the area you want to test. This should contain highlight, midtone and shadow areas. Choose File > Print and select the Print Selected Area option. This will place your rectangular test selection exactly in the centre of your chosen paper size.

STEP EIGHT

JUDGE YOUR RESULTS

Once printed out, write a comment on your test strip to help you remember your printer settings and paper type. If you need to make any changes, return to your image file, take off the selection and adjust in Levels or Color Balance as before. Once ready, make another test print with your new settings before committing to a full-size sheet of paper.

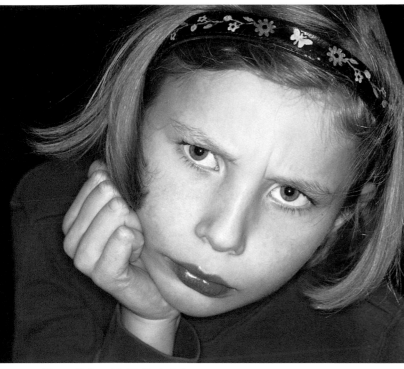

Above: Red eye blights flash photos.

Above: It's easy to remove afterwards on a PC.

Red Eye

Some purist photographers consider flash to be the devil's work.
The proof is in the satanic red eyes it inflicts on people in low light

CHECKLIST
- Flash occurs in low light when the pupils are wide open.
- It is caused by flash bouncing off the blood-red retina.
- On-camera red-eye reduction features rarely work.
- To reduce the risk, move the flash further from the lens.
- Diffuse the risk by bouncing it off a wall or ceiling.
- Some cameras offer post-shot red-eye retouching.
- Red eye can be corrected easily on the computer.

THE CAUSES

Red eye is the scourge of photographers the world over, and is one of the main reasons why flash often makes such a hash of people's snapshots.

Red eye is not a sign that your subject is a vampire or that he or she has been drinking heavily. It occurs most frequently in dim light. The pupils in the human eye expand in low light and contract in bright sun, much like the aperture in a lens. When a flashgun is fired from close to the lens axis in dim light, when the pupil is fully dilated, the flash enters the eye and illuminates the blood vessels at the back of the retina, and the reflection bounces back through the lens.

Some people are more susceptible: blue-eyed people, whose eyes are lighter, and children, whose eyes are proportionally bigger. And yes, people who are tired or drunk, because their body reactions are slower. But in certain conditions, it happens to us all.

THE CURE

There are only two ways to cure red eye at the shooting stage. The first is to force your subject's pupils to close down. This is best achieved by raising the light level — switching on any ambient lights that are around. Camera manufacturers use this technique in their red-eye reduction systems by firing a pre-flash, pre-exposure strobe or shining a beam into the eye, but they never really work, and when they do they invariably produce a forced or unnatural expression in the poor victim.

A better solution is to move the flash further away from the lens axis. Since the angle at which a reflection leaves the eye will be the same as that at which the flash enters, the red eye will not be picked up by the lens. Another method is to bounce the flash off a wall or ceiling. This spreads the light over a large area and enters the subject's eyes obliquely, preventing red eye from occurring.

Above: External flashguns reduce the risk of red eye by moving the flash further away from the lens axis.

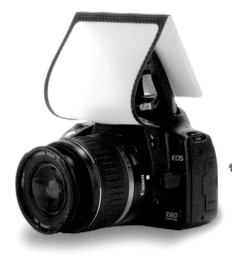

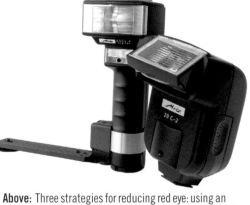

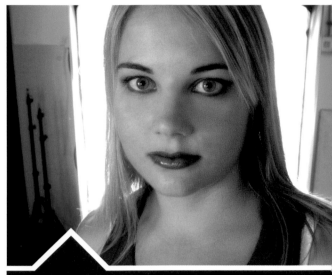

Above: Three strategies for reducing red eye: using an accessory diffuser over the flash such as this LumiQuest Soft Screen; taking the flash off the camera; or bouncing it off the ceiling (if your flash has a bounce head).

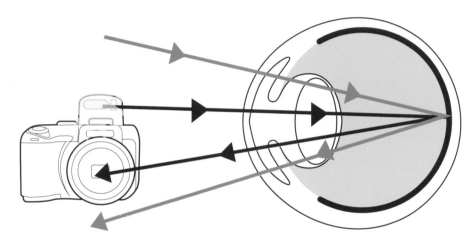

Above: When the flash is close to the camera the reflection from the retina enters the lens. By moving the flash further away the reflection will not be picked up by the lens.

The size of the light source

Although this model was standing directly in front of a powerful studio flash, fitted with a one-metre wide softbox (like the one behind her), when it went off, she did not get red eye (even with those big blue eyes). This is because the light source was large. For red eye to occur the pupils must be penetrated by a small point light source. Diffusing the flash is therefore a good anti-red eye option.

REMOVING IT AFTERWARDS

Some of the latest compact cameras offer the ability to remove red eye in-camera after you've taken the shot. This is better than red-eye reduction, because a) it works, and b) it doesn't cause a delay when taking the shot. However, most of us have to remove the red eye on the PC later. Most image-editing software provides the option to remove red eye in a couple of easy steps. Based on a brush tool, this function replaces the red colour with a more natural hue.

In Photoshop Elements, the tool is found directly in the toolbar. In Photoshop 7 and CS you can find the tool nested in with the Healing and Patch tools.

Remember that when using any brush tools, you must select the size and softness from the Brush palette. Make sure that the size selected is smaller than the offending area in the eye.

STEP ONE

With the red-eye removal tool selected and the brush size and softness set, choose the colour you will replace the red with. Usually this will be black. Make sure the colour black is in the foreground of the swatches.

STEP TWO

Click once on the colour you want to replace in the image – in this case, the red colour.

Drag over the red with the brush to repair the image. You can increase the Tolerance level in the Options bar to help you get better coverage.

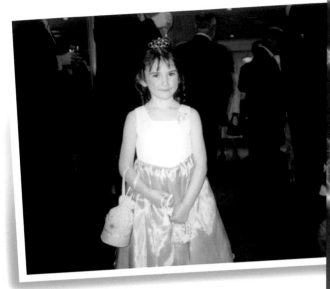

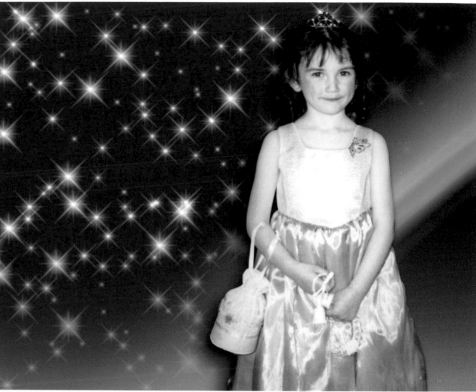

Replace a Background

Some backgrounds can be dissapointing and distracting.
Learn how to use Layer masks to replace it entirely

Left: The portrait of the little girl is almost ruined beacuse of the busy, cluttered environment.

Above: The background has been replaced with an artistic image. The final result was not to achieve a sense of realism, but to produce a 'fairytale' picture that was suitable for the subject.

IT'S UP TO YOU

We can't control the weather and we certainly can't make allowances for it with our photography. If the sky is overcast or dull, then that is what will end up on the photograph. But, thankfully, with a crafty bit of editing, we can replace the dull sky with a new, more interesting one.

It may seem like 'cheating' to put a false sky in, but really it's entirely up to you, if you feel that your image would benefit.

The debate for what constitutes a 'real' photograph has been raging for years. The art of image-manipulation and enhancement has been with us since the invention of photography: from painting inks on to negatives, to specialist darkroom techniques, 'fake' images are all around us.

The great thing about Photoshop is that it allows us to produce the kind of image that we wish, without having to have the specialist skills of an artist. This time round, we don't have to achieve a realistic finish.

GREAT BENEFITS

Once you've mastered the art of cutting out using layer masks, you can apply the skill to just about any background.

It can be of great benefit to be able to isolate your background, leaving you to manipulate it anyway you choose.

For instance, you could apply a blur filter to a cluttered background, drawing attention to your focal point. Or you could replace it altogether, placing your subject on a plain background or an entirely different location. Either way, it's up to you; follow these next steps and learn how to isolate a subject and change its background.

STEP ONE

With your image open, select the Layers palette and double-click on the background layer. In the text field, name the layer. Doing this, you will be converting the fixed background layer into a layer that supports masking.

STEP TWO

Open your new background image. Click and drag it over on to your layer image. The new background should now appear as a second layer in your layer stack.

Click on the layer in the Layers palette and drag it down to the bottom of the layers.

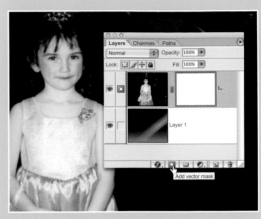

STEP THREE

From the bottom row of icons on the Layers palette, select the Add Vector Mask icon to make a new mask. The image thumbnail will display a mask thumbnail next to it. The chain link between them indicates that the mask is connected to the image.

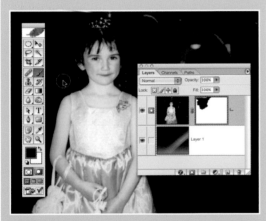

STEP FOUR

Make sure that there is a thin, black border around the mask thumbnail. If it is not, then click on it to select it.

Your swatch palette should now be the default black and white. When applying masks, use the black to paint on the mask and the white to remove it.

STEP FIVE

Select a suitable brush size that will be easy for you to apply the mask. Choose a soft-edge brush to help blend in the edges of your subject. With the black swatch selected, apply the new mask by painting over the top of your original background.

You should now see the new background coming through from underneath.

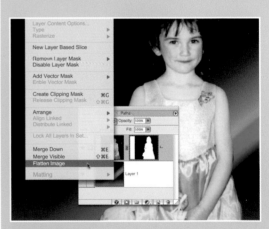

STEP SIX

If you make a mistake, don't worry, just select the white swatch in the tool bar and reapply over the top of the mask. The original pixels will then reappear.

Remember to change the size of the brush to suit as you get close to the edges of the main subject.

When you have finished applying the mask, you can then continue with normal enhancements or flatten it into one image. Choose Layer > Flatten Image.

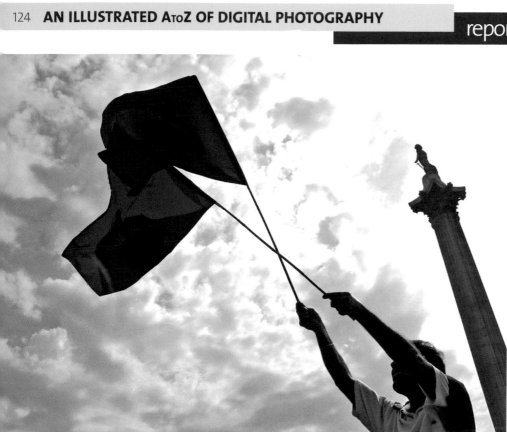

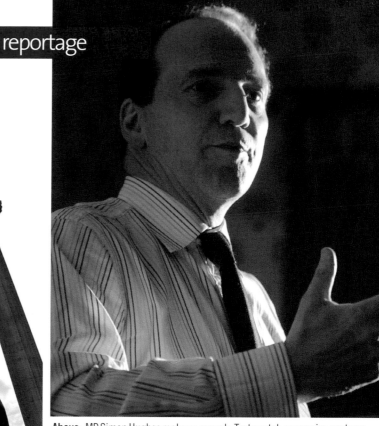

Above: MP Simon Hughes makes a speech. Try to catch expressive gestures.
Left: The inclusion of Nelson's Column reveals the setting of this protest.

Reportage

Also known as documentary photography or photojournalism, reportage is all about making a visual record of world events

CHECKLIST

- Reportage is about recording real-life events.
- You don't need to shoot wars, famines and disasters.
- Local events are just as pertinent as international ones.
- You may sometimes be treated with suspicion or hostility.
- Using a wide-angle lens creates a sense of being there.
- Be unobtrusive so you record the moment, not influence it.
- Be polite and courteous to get your subjects 'on side'.

A RECORD FOR POSTERITY

Reportage goes under many names, including documentary, street photography and photojournalism. Essentially it's a genre concerned with recording life, culture and the world around us as it is, rather than creating or contriving our own vision. Many of the greatest photographers in history have worked in this genre. Think of Dorothea Lange and her images of Depression-era America, Sebastiao Salgado's epic tribute to the world's workers, and many others whose work has become etched on the public consciousness.

Not everyone has the time, means or inclination to tackle the epic subjects, but you don't need to find global catastrophes to pursue this genre. Wherever you live there are great subjects right on your doorstep. Many successful photojournalists have made a career out of low-key, but perceptive local scenes. And Martin Parr is famous for his images of quite banal and humdrum subjects, such as the food on his plate!

THE CHALLENGE

Our view of what life was like for our parents and grandparents is formed largely by the archive photos we've seen that were taken for legendary publications such as *Life* and *Picture Post*. But the great photographers who worked for those journals would find their working lives very different today. A culture of suspicion, paranoia and media cynicism means that a photographer taking pictures of anything other than his family or the obvious tourist traps is often immediately marked as a potential terrorist, would-be burglar, spy or tabloid muckraker (depending on the situation) by many sections of the public, including the police, and is considered fair game for harassment.

Nevertheless, dedicated photographers persist with the genre because our culture is worth recording for future generations. If you're going to take it up you must be prepared for the hassle, but if you deal with the inevitable problems in a mature way you will go a long way.

Left: Unusual angles add impact. This one shows a bungee jumper's terror.
Bottom left: Unusual events can make good stories. This shot depicts candles being lit at a 'gothic Eucharist' in Cambridge, a service designed for goths.

Find an unusual angle

Look for unusual viewpoints to provide immediate graphic impact to a shot. This image, showing the counting of votes at Cambridge Guildhall during the 2005 UK general election, was taken looking down from above, while for the bungee jumper (top left), the opposite was the case. (All images on these pages and overleaf by Jamie Marland).

WHAT YOU NEED

Most documentary photographers seek to blend into the background and observe life, so the ability to be unobtrusive is important. That's one reason why many photographers in this genre favour small Leica rangefinder cameras over huge SLRs with big lenses. However, being unobtrusive doesn't necessarily mean hiding in the bushes with a super-telephoto lens. Most documentary photographers work at relatively close range with a wide-angle or standard lens. The subject often knows the photographer is there and has consented to the pictures, but after a while has forgotten about the photographer's presence and has got on with whatever he or she was doing.

Some photographers shoot candids though, and have developed strategies to get them, such as shooting discreetly with the camera hanging from the chest strap, pre-setting the focus and exposure, and learning to bring the camera up to the eye, shoot and drop it down again in a single split-second action.

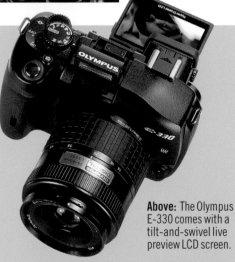

Above: The Olympus E-330 comes with a tilt-and-swivel live preview LCD screen.

A few digital cameras have a tilt-and-swivel LCD screen, which makes waist-level shooting easier anyway, and if not, at least you can review the shot you've just taken and redo it if need be.

TOP *TIPS!*

1 TELLING A STORY
Try telling a picture story about your town, your job or a leisure activity.

2 LONG-TERM PLANS
Embark on a long-term photo project over a number of years, which will record the passing of time.

3 GET INVOLVED
Don't just go for unobserved candids. Involve your subject in your stories and enlist his or her co-operation.

4 THINK ONCE, THINK TWICE
Safety first. Think twice before taking your camera out in potentially dangerous situations such as riots, or in socially contentious locations such as children's playgrounds.

5 SHARE AND SHARE ALIKE
Don't keep your pictures to yourself: show them. Build a website for them or organise an exhibition at a local venue.

TELLING A STORY

Photojournalism is not just about the single picture. Most photojournalists seek to tell a story through a series of pictures. Although some of the individual photos in a set may be outstanding in their own right, and may summarise the entire story you're trying to tell, the aim is not to make every shot great. Such a task would be almost impossible to achieve with an in-depth project. Rather, each picture must play a part in the story, whether it is setting the scene, providing a colourful vignette or capturing a critical moment in the story. Think of it in terms of a narrative – much is about the events leading up to the key moments, and the time in between, but they're just as important to the overall story.

There is no limit to the length of time a project should take, or set number of pictures. It could be a set of a half-dozen shots taken in an afternoon. On the other hand, some photographers dedicate their entire lives to a single story. A few photographers have ongoing projects that they return to again and again, between other jobs. Elliot Erwitt's dog portraits are a great example.

All the pictures on these two pages were taken by photojournalist Jamie Marland as part of a story on the riots at the 2005 G8 summit in Edinburgh.
Right: Riot police march past bags of waste that were thrown at them during the riots.

Above: A protestor sits on top of the Exchange Building in Edinburgh's financial district during the riots.

Left: Police battle with rioters.

Left: A masked protestor holds up a flag during the Edinburgh riots at the G8 summit.

Below and bottom: Protestors rally in Edinburgh for the 'Make Poverty History' march, prior to the G8 summit at Gleneagles.

Left: The vaults under Brighton Station are now a model railway museum. The curator, Chris Littledale, fine- tunes his layout.

Right: Dancer and choreographer Rajyashree Ramamerthi performs 'Vestige' in the Victorian brick tunnels of Brighton Sewers with clarinettist Colin Waurzynik as part of Architecture Week and Dance Screen Brighton.

Roger Bamber

The award-winning documentary photographer has a talent for storytelling and attention-grabbing

Roger Bamber is not just a photographer. He's a storyteller. His pictures are more than just a record of what the subject looks like, they provide clues about them and what they do. But he also photographs them in a way that grabs the viewers' attention, which is why he has enjoyed such a successful career.

'I like to tell stories in my pictures,' says Roger. 'It makes them more interesting to look at.' Some of his pictures are the result of assignments, but many are his own ideas, inspired perhaps by something in the news or a local issue which then sparked an idea for a particular visual treatment. But Roger also has an innate ability to think on his feet and to arrive at a shoot and spot, immediately, the visual potential of his surroundings.

A classic example is the portrait of Luke Cresswell, the founder of Stomp (overleaf) for which he borrowed a cherry-picker to get an aerial shot of the dustbins which the group so famously uses as musical instruments.

It's the strong graphic nature of Roger's images that make them so successful.

Newspapers need to grab people's attention instantly and draw them in for a closer look, and Roger has demonstrated an ability to deliver pictures like that time after time.

'I like nice shapes,' he says, simply. 'I try to create pictures that will be interesting to look at, and try to avoid just going for the obvious shot. Sometimes the pictures aren't planned at all, however. For the Holiday on Ice shot (overleaf), I was just driving down the road behind the Brighton Centre and the stage doors were open at the back while they were rehearsing. I just got a glimpse of these silhouettes projected onto the stage backdrop, so I stopped the car and went to shoot it.'

Roger makes it seem so simple, so obvious, but that's only because the ideas come so easily to him. Who else, when sent on an assignment for SightSavers International, would think to photograph not the subject himself, but his multiple reflections in a scattering of the intraocular lenses that are used to save his sight, and that of thousands like him in the developing world who go blind through want of a cataract operation.

Roger shoots entirely on location – never in a studio – and more often than not uses

just available light, though he does carry with him an Elinchrom flash kit and a set of tungsten halogen lights, which he sometimes uses to bounce light off walls and so forth. An example of this is his shot of the artists performing in one of Brighton's (disused) Victorian sewer tunnels where, without his portable lighting, a picture would have been impossible.

Roger went digital with the introduction of the Nikon D1X and now uses its successor the D2X. 'I find the quality better than film,' he argues. 'I was once asked to make two three-foot wide enlargements for the wall of a local hotel,' he recalls. 'One was from a negative and one was digital, and the digital one was so much better.'

Roger carries a range of lenses from the 12–24mm to the 500mm, and uses them all, exploiting fully the visual characteristics of each lens to create impact. Although he now spends more time at the computer, printing, that he did in the days of film, he has no regrets about the increasing digitisation of photography. 'That's progress,' he says.

View more of Roger's award-winning work at www.rogerbamber.co.uk.

Left: Luke Cresswell sorts some of the 1,110 dustbins shipped per year to the five international touring companies of the musical *Stomp*.

Left: Czech Olympic skater Lenka Kulovana rehearses with the Holiday on Ice company at the Brighton Centre for their *Ice Dance* show.

Right: Comedy street artist Helen Kane rehearses her Marilyn Monroe act in a giant luminarium designed by artist Alan Parkinson. The inflatable tunnel was erected as part of the 2002 Brighton Festival.

Right: Six-year-old Amin Mahmood is reflected in the tiny intraocular lenses being used by SightSavers International to restore the sight of thousands of children born with cataracts in Bangladesh.

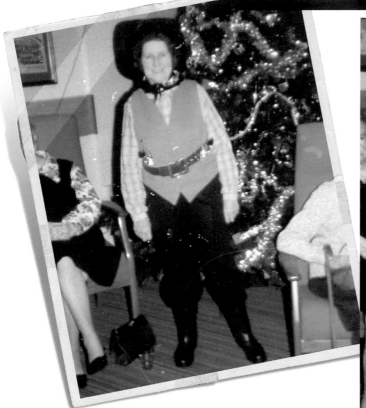

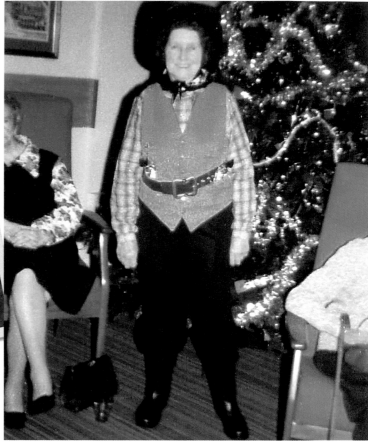

Restoring Photos

Restoring old photos isn't all about saving ancient black-and-white prints: even colour ones need attention

Above and left: The original photo on the left has been badly damaged over the years, but with a little patience you can restore it to its former glory.

FRESH NEW COLOUR

Photographs from the 1960s and 1970s are now ageing badly. Early automated photographic laboratory technology led to poor fixing and washing of prints. Emulsions don't stand the test of time particularly well under adverse conditions, especially when kept in 'sticky' albums or hung on a wall near the sun. Over the years, the colours begin to fade to yellow and gradually disappear. In this tutorial we will help you to bring those colours back to life and renew any damage to the image.

But it's not always easy to remember the original colours of an old photo, the clothes being long since discarded, and of course hair changes colour as we get older, too. So a sense of 'artistic licence' is required for some of your badly damaged prints.

SCAN THE IMAGE

First, clean your flatbed scanner, removing all dust and hairs from the glass. This should always be done as a matter of course, but it is essential with scanning old photos – after all, why make more work for yourself?

After giving the print a dust-off too, scan the image at a high-enough resolution to give you enough pixel information when zooming in. In this example, we scanned in at 300ppi: this would give us enough information to print at least twice the size of the original.

You may feel that you want to adjust the scan using the scanner's auto functions, but it is probably better to have more control and do all your refinements in Photoshop.

SAFTEY FIRST!

First, as a standard of safety, it is always advisable to save a copy of the untouched image. If all else goes wrong, you can always go back and start again! Choose Save As > Copy. Select the Crop tool and draw a marquee around the image, keeping it to the inside edge of the white border, as we will discard it. Rotate the crop marquee slightly to match that of the scan and accept the crop.

Now drag the background layer to the New Layer icon on the Layers palette. This will enable us to work without affecting the original image. We can toggle on and off the background as we proceed to evaluate our progress. Leave the background invisible for now.

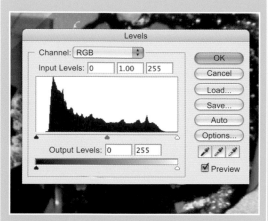

STEP ONE

Choose Image > Adjust > Levels and make sure the preview option is selected. Slide the shadow and highlight triangles to suit the tonal level

Select a new adjustment layer from the bottom of the Layers palette, choosing Curves. Adjust each curve to remove the underlying colour cast.

STEP TWO

Now select the Clone tool and start to remove all the dust spots around the image. alt-click (option-click for Mac) as close to the offending spot as possible for a convincing repair. Remember not to have your brush size much larger than the spot you are removing, and always remember to 'dab'.

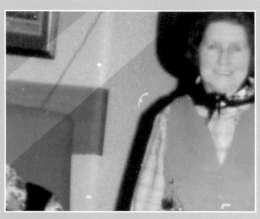

STEP THREE

If there are areas of sticky tape or glue on top of the image, use a selection tool, such as the Polygon Lasso tool or the Pen tool and carefully select the affected area. Adjust the levels and curves to bring it inline with the rest of the image. Use the Clone tool to remove any obvious edges.

STEP FOUR

The image may look slightly soft in certain areas – if this is the case, duplicate the layer and apply an Unsharp Mask filter to the layer. Filter > Sharpen > Unsharp Mask. If some areas of the image now look too sharp Select Layer > Add Layer Mask > Reveal All. With a suitable brush size, paint over the over-sharp areas to reveal the normal detail underneath.

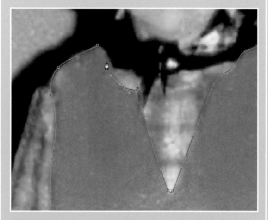

STEP FIVE

Now we need to improve on individual areas of colour, such as clothing. With the Pen tool, draw around a piece of clothing – in this example I drew round the waistcoat. Double-click on the path and save it. Now make the path a selection by choosing Make Selection from the path options. Feather a few pixels to soften the edges. Select > Feather.

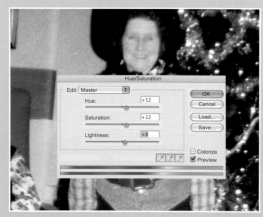

STEP SIX

Select the Hue/Saturation command, Image > Adjustments > Hue/Saturation. Start to use the sliders to enhance the individual colour, changing from highlights to midtones and shadows. Repeat this Path, Selection, Adjustment process on all the areas of the image that you feel need special attention. Remember to save each path for future use.

Retouching Techniques

Even the most glamorous of models are usually retouched before they hit the printed page. Learn how it's done and how you can do it too

Left: The portrait of the young girl could benefit from some light retouching around the eyes and removing freckles.

Above: The retouched portrait gives the girl a little lift, making her look fresher and brighter.

WHAT DOES IT ALL MEAN?

Retouching is an age-old skill that has been around almost as long as photography itself. In the time before computers, retouching was carried out by trained artists using special inks and paintbrushes or airbrushes.

Early Hollywood employed many artists to retouch their stars' publicity shots by hand. It was not uncommon for an actor or actress to have their spots painted over or their sagging chin airbrushed out. But in those days the shots were black and white and were easier to disguise than colour versions.

The term 'airbrush out' has continued to stay with us even today with the use of the 'airbrush' mode in Photoshop. The mode allows you to spray virtual paint over your image using applied pressure on the mouse. But the sophistication of today's modern editing software means that the airbrush is not the only tool used in image-retouching.

TOOLS OF THE TRADE

There are many ways to retouch an image in Photoshop. Most of them are brush-based so the edges are soft and can easily be blended into the original image, making the art of retouching easier.

CLONE TOOL

One of the most popular retouching tools is the Clone tool. Found in Photoshop's toolbox, it works by copying a section of the image and then applying the copied pixels over the desired area. This is great when you have simple 'cloning' to do such as removing spots on a face. You can easily change to just about any brush shape or size, allowing for maximum effect. Opacity and flow settings can also be manually adjusted for greater control.

PATCH TOOL

This tool allows you to draw a marquee selection around an area that you wish to duplicate and then drag it over to the area that you wish alter. Alternatively, you can also do the opposite and draw a selection around the area you wish to alter and drag it to an area you wish it to sample from.

The pixels are then blended together to make a seamless join. This tool is really designed for areas of flat colour that has little details, such as sky, sea, etc.

HEALING BRUSH

The Healing brush works in similar way to the Clone tool, selecting a sampled area and then applying it over the desired area. Only this tool blends the tone, texture, shading and transparency with the underlying characteristics. Again, this blends like the Patch tool and is perfect for areas of flat colour.

USING THE CLONE TOOL

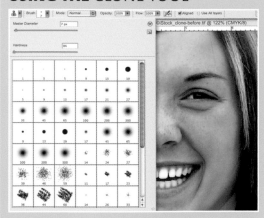

STEP ONE

Select the Clone tool from the tool bar. Click on the arrow next to the Brush Shapes button to view a selection of preset brushes which can be selected to suit the detail of work you want to do. Select a small-sized, soft-edged brush ideal for this kind of work. You can adjust the size of it using the size control on the tool palette.

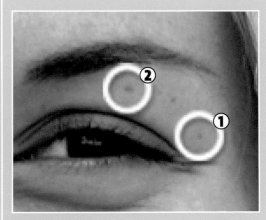

STEP TWO

Zoom in on the object you want to delete. Carefully select an area that has the same shade and alt-click (option-click on the Mac) on it to set the pick-up area (area no. 1), then click on the area to cover over (area no. 2). Use lots of short clicks rather than one long stroke, since this is easier to delete if you make a mistake.

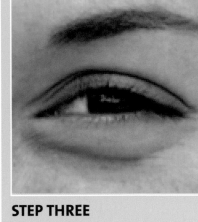

STEP THREE

The pick-up point follows the brush at the same distance and angle as the first stroke, so try to avoid accidentally picking up other objects in the picture, particularly the edge of the frame. Change your pick-up point regularly to disguise your work, but take care to match both colour and texture.

USING THE HEALING BRUSH

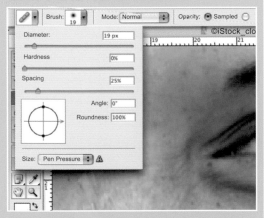

STEP ONE

Select the Healing brush from the tool bar. Click on the brushes palette up in the menu bar and select the options.

Use the sliders to adjust the size of the brush, along with the softness and spacing. Choose a suitable-sized brush with the softest edge, to help with blending.

Try not to choose a brush bigger than the area you wish to retouch, as it will become difficult to control.

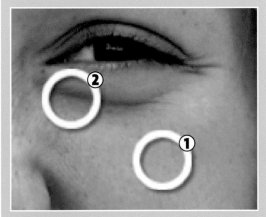

STEP TWO

In a similar way to the Clone tool above, select an area that you would like to clone from. Alt-click (option-click) on the clean area and then click and drag over the area you wish to remove. In this example, I wanted to remove the eye bags, so I selected an area on the cheek that was clean and similar in colour and tone.

Dragging over the area in one sweep to begin with gives you an idea if your cloned area was the best place to pick. If it doesn't work, then hit Undo and try another area to sample from.

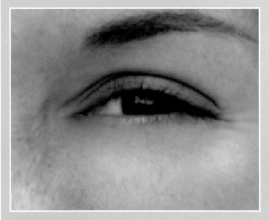

STEP THREE

The Healing brush will blend the colour and tone of the sampled pixels over the new area. This does not always work first time and may need a little experimenting first to get the most suitable area.

When you have finished, you may have to tweak the area further with the Dodge tool to lighten the area if it still seems a little dark.

Select the Dodge tool and set the options to mid-tones. Bring the strength right down to about 20 per cent. Dab around the chosen area to lighten the pixels.

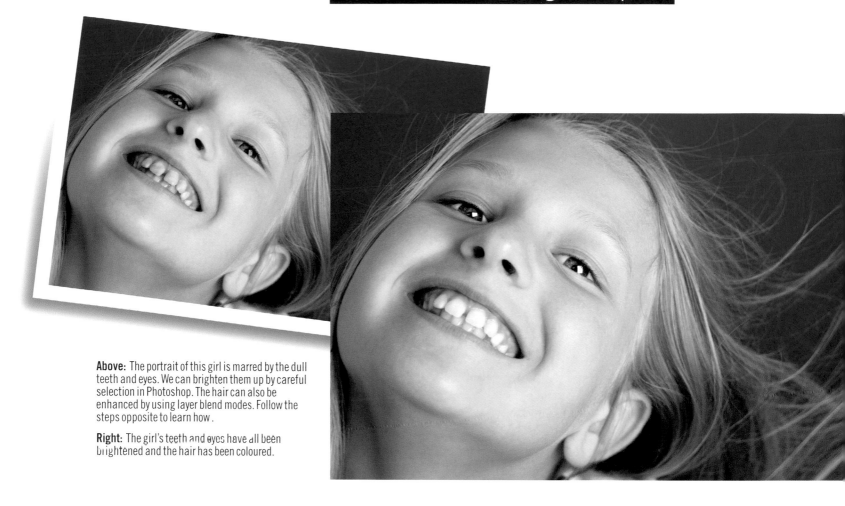

Above: The portrait of this girl is marred by the dull teeth and eyes. We can brighten them up by careful selection in Photoshop. The hair can also be enhanced by using layer blend modes. Follow the steps opposite to learn how.

Right: The girl's teeth and eyes have all been brightened and the hair has been coloured.

AND THERE'S MORE

The Clone tool, Patch tool and Healing brush are the basic and most useful set of tools for any retouching job, but there are still lots more tools, filters and commands that Photoshop can offer to help you achieve a professional look. Also found in the toolbar is the Smudge tool, which treats the pixels as if they were wet paint – literally smudging an area of pixels into another.

With the Blur tool, which gives the pixels a blurred effect, the longer you hold down the mouse over the area, the greater the effect.

The Dodge and Burn tools work like traditional darkroom techniques, allowing you to either darken selected areas or lighten them. This can be effective when increasing or decreasing a shadow area.

Liquify mode is a stand-alone filter that displays its own controls and interface. This is the 'daddy' of image-distortion and allows you to manipulate large areas of pixels.

KEEPING IT REAL

The essential idea with any retouching is to keep it real. If you can see it, it hasn't worked. There is absolutely no point in spending hours on your PC, only for the end result to be obviously fake. Remember that no skin is completely flawless and very few have a 'perfect' body.

It's worth sitting down and studying your image beforehand to decide what's achievable and what's not. If your subject is in his or her sixties, for example, then don't to remove every single wrinkle and furrow. It just won't end up looking realistic.

Similarly, if the subject is very overweight, then trying to slim him or her down too much will only end with disappointment.

By all means have a go, try it, and see the results for yourself. It's good to experiment, but just remember that this kind of manipulation can lead to hours in front of your PC screen, so use your time wisely.

IT'S NOT ALL ABOUT BEAUTY

Retouching isn't all about the modelling industry: all these tools and skills can be applied to just about any image you wish. The Clone tool is excellent at removing dust spots, creases and tears from scanned images of old photos, for instance and can remove people or objects from an image entirely.

The odd stray element that draws the eye away from your focal subject is better off removed. Depending on your background, try each retouching tool in turn to see which one gives you the best results.

If you are new to retouching, it's a good idea to duplicate your image into two layers: that way you can work on the top layer and then toggle between the two to see how you are progressing.

BRIGHTENING TEETH & EYES

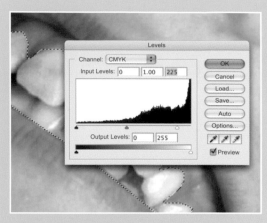

STEP ONE

Smiling is the most natural reaction when having a photo taken. But unfortunately some smiles can show less-than-white teeth that can look distracting. This can also be true for the eyes. They may be slightly bloodshot or just dull. To whiten teeth and eyes quickly and simply, open your image and zoom right in to the mouth area.

STEP TWO

Select the Lasso tool from the toolbar. Draw carefully around the teeth area, making sure that you do not stray over into the lips. If you need to delete a section of the marquee, select the Subtract icon in the Options menu bar and continue over the chosen area.

Feather the edges by a few pixels to soften the marquee. Select > Feather, and enter the number of pixels.

STEP THREE

Now select the Levels command from the image menu. Choose Image > Adjustments > Levels. Select the right-hand slider and move it up towards the left. You will notice that teeth will start to brighten up immediately.

Repeat the steps for the eyes, making sure you subtract the pupils from the marquee so that they are left unaffected.

Zoom out to get a better idea of how the image looks overall.

ENHANCING HAIR

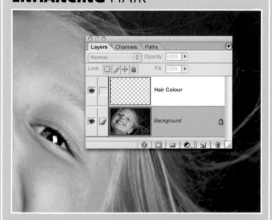

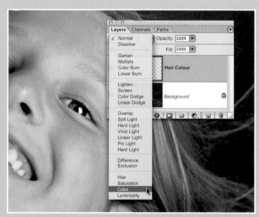

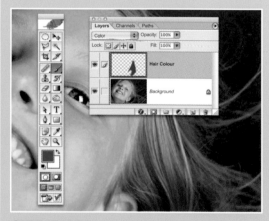

STEP ONE

Just about everything can be retouched and enhanced with image-editing software, including hair.

In this mini tutorial you will learn how to change the colour of the hair using layer blend modes.

With your image open, select the Layers palette and create a new layer. Click on the layer name and rename it 'Hair Colour'.

STEP TWO

On the upper left of the Layers palette, select the layer blend mode drop-down menu. Choose Color towards the bottom of the list. By choosing this blend mode, any colour you paint on that layer will blend with the pixels of the original image underneath.

STEP THREE

Select a suitable-sized brush from the brush palette. Now select a chosen colour from the swatch palette.

Start to paint over the original hair, making sure that you don't stray over into the background or on to the face.

This method works best with light hair, but dark hair can also be enhanced with a subtle use of dark colours, such as red or copper.

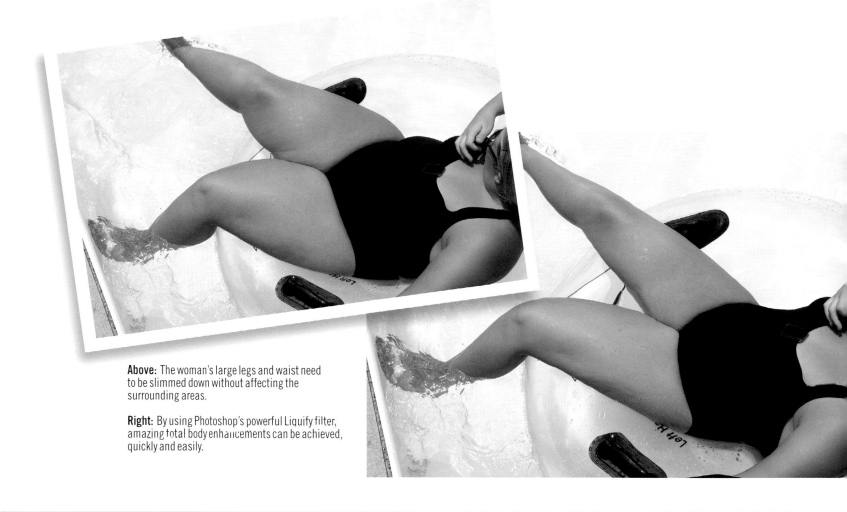

Above: The woman's large legs and waist need to be slimmed down without affecting the surrounding areas.

Right: By using Photoshop's powerful Liquify filter, amazing total body enhancements can be achieved, quickly and easily.

BODY RETOUCHING

One of the newest forms of image-retouching is manipulating the entire body. This has been pretty hard to achieve with realistic results up until now, as altering edges of clothes and skin is uniquely difficult because of the way the light and texture combine with each other.

In the past, if you wanted to make someone a little thinner, you would paint (with inks) more of the background over the edges of the waist area. Though this worked to a degree, it was still hard to achieve with a sense of realism.

Since the advent of digital manipulation, editing software has become so advanced now that any part of the body can be altered quickly and easily without losing any of the original details, textures and lighting.

LIQUIFY

In Adobe Photoshop, there lies a hidden gem called Liquify. This filter is a very powerful manipulation tool that can push, bloat, shrink and twist any part of your image with only a few simple steps.

Found in the filter menu, Filter > Liquify, the Liquify filter is displayed within its own application window. The main tools are positioned down the left-hand side of the window, with all the options and settings down the right-hand side and the preview of the image is displayed in the middle.

The Forward Warp tool pushes pixels forwards as you drag across the image.

The Reconstruct tool allows you to return the pixels back to their original state.

The Twirl Clockwise tool rotates pixels clockwise as you hold down the mouse button or drag.

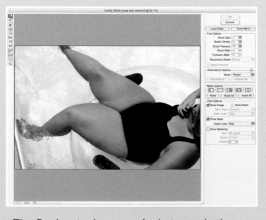

The Pucker tool moves pixels towards the centre of the brush area as you hold down the mouse button or drag.

The Bloat tool moves pixels away from the centre of the brush area as you hold down the mouse button or drag.

LIQUIFY COMMAND

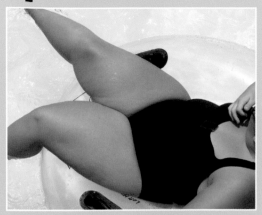

STEP ONE

With your image open, select Filter > Liquify from the image menu bar. The main display will change to accommodate the Liquify screen. In this example, the lady in the boat has large legs and a large waist. We will use the Liquify tools to slim down the legs and reduce the waist size.

STEP TWO

From the tool bar, select the Forward Warp tool. Now select a suitable brush size from the top left of the Options menu, using the slider to increase or decrease the size of the brush. From here you can also set the brush's density and pressure, etc. It's a good idea to experiment first with the different settings.

STEP THREE

When you are happy with your brush settings, click and hold down the mouse a little away from the edge of the subject and drag in towards the area you want to be affected. In this example, the leg needs to be thinner, so I clicked and 'pushed' the pixels in towards the leg.

STEP FOUR

Continue the 'pixel pushing' all the way along the subject's edge. Try to keep the enhancements realistic: don't go over the top as it will look fake.

The larger the brush, the easier it is to keep the main edge smooth. You can resize the brush to a smaller size when you need to tackle localised areas such as the knees or the calf.

STEP FIVE

In this example I then proceeded to slim down the second leg using the same techniques. Where the inside of the thighs touched, I pushed this area up towards the groin to minimise the amount of flabby skin. This also helped with the lower stomach area as this was elevated at the same time.

Remember that when using the Liquify filter, the background pixels stay intact, but will also move along with the area you are applying to. Watch out for any obvious distortion.

STEP SIX

The next step in this example was to slim down the waist and hips. To do this, select the Pucker tool and choose a suitable brush size. Again, it's worth a little experimentation first. Click directly on top of the area you wish to alter and hold down the mouse. The longer you hold the mouse down, the more the filter will be applied to the area.

Click and hold the filter all along the areas that need the enhancements. If you make a mistake, you can select the Reconstruct brush to paint back the original state of the pixels.

Above: Flatbed scanners.

Above: Multi-function devices offer both printing and scanning in one unit.

Scanning

Scanners enable you to bring all your old prints, negatives and slides
into the digital realm. Print them, restore them or simply archive them

CHECKLIST

Scan your old photos to protect and preserve them
There are two types of scanner: flatbed and film.
Film scanners offer higher-resolution scans of film.
Many flatbeds also offer adequate film scanning.
Choose a flatbed offering at least 2400ppi resolutic
Film scanners should offer 3600ppi or more.
To save time and space, scan to the size you need.

FLATBED SCANNERS

Of the two main types of consumer scanner,
flatbeds are by far the most common. Most
flatbed scaners consist of a horizontal glass
plate with a moving sensor and a light below it.
In many ways they look and act just like a
photocopier, except that they produce high-
resolution scans of your photos. Some flatbeds
can also scan film (slides or negatives) thanks
to a mini lightbox built into the lid. On other
models this is an optional extra.

In addition to the normal CCD scanners,
there are also super-slim CIS scanners which
can be powered from the PC via the USB port.

Scanners come in various levels of quality,
with the more expensive models offering
higher resolution, but you should consider
2400ppi a minimum for high-quality scans.
Some scanners also come with software which
includes sophisticated dust- and scratch-removal
features – a great time-saver and worth having.

SCANNING FILM

Film scanners work in much
the same way as flatbeds,
with some minor differences.
The image must first be
placed in a carrier to hold it
flat and aid insertion. You'll
have a choice of holders: one
for strips of film, one for
mounted transparencies.

Having selected the right
holder and placed your image
into it, the holder is then
inserted into a slit in the
front. It will be drawn into
the scanner and from here on the process
is much the same as for flatbed scanners.

Remember to select 'Transmissive' (for
film) rather than 'Reflective' (for prints), and
set the resolution to a minimum of 2000ppi,
and preferably over 3000ppi.

If scanning film on a flatbed scanner, you'll
still have a holder, but will have to lay it
on the glass plate in the right place to
correspond to the location of the lightbox
built into the lid. The rest of the procedure
is as described.

WHY SCAN?

So you've bought a digital camera, you're creating masterpieces in Photoshop and printing out super-glossy A4 prints on your inkjet. But what about all those thousands of prints from your hazy, pre-digital past? Don't they deserve some care and attention lavished on them too?

If you look back through your old prints (and those faded old photos passed down through the generations) you'll find many great shots that deserve to be digitised and archived. You'll also find many other failed shots that, with a bit of help from Photoshop, could be turned into winners.

There are lots of reasons for buying scanner and digitising these pictures. You can improve them, add them to your digital albums, burn them to CD for archiving, create DVD slide shows from them, send them to friends and relatives (as emails, CDs or prints). Very old, damaged pictures can be restored. The list goes on.

Scanning software

The scanner software offers variety of controls and options which must be set correctly to obtain the best results. Advanced options are accessed via additional buttons. Some scanners feature shortcut buttons on the front for one-touch scanning to pre-set default settings, averting the need to open the software.

SETTING UP

To anyone who's used a photocopier, scanning a photograph will have an element of déjà vu about it. You lay the print to be scanned face-down in the corner of the glass plate, close the lid and press the button. With most scanners, though, the button is a virtual one in the software interface.

The software is usually accessed through your editing application. Once selected, a dialogue box will appear offering various controls. One of these is called 'preview'. Pressing this button allows to you see how your scan will look. If your print is crooked you'll be able to see this.

The image will have a box of marching ants over it indicating the area that will be scanned. Drag the box to the outside edges of the photo or, if cropping, to your preferred crop area.

Before you scan, you must also indicate your preferred scan resolution, in pixels per inch. For print-quality scans select at least 300ppi, for websites or emailing 72ppi is sufficient.

MAKING THE SCAN

If your scanner can also scan transparencies too then you need to tell it which kind of media you're scanning (print or slide), using the drop-down menu. The other question you'll be asked is what scale you wish to scan at. Normally this should be no more than 100 per cent. If you only need a small scan then select a lower value. If you'll be enlarging the image to more than its original size select a larger one, but be aware that the scanner will use interpolation to achieve this, which will diminish the quality somewhat.

As you become more experienced, you may wish to explore some of the advanced manual options that many scanners offer, but features such as Color Balance, while desirable to be in the right ball park, are best left to your editing software for fine-tuning.

When everything is ready, press the scan button and wait. The scan time will depend on the size and resolution selected.

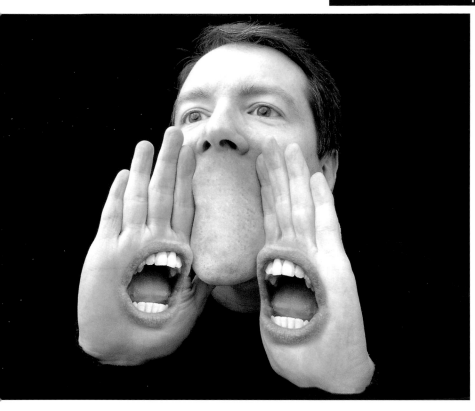

Special Effects

Photoshop and image-editing is not just about applying
your skills to serious enhancements, it's also about having fun

CHILDISH CREATIONS

There are many powerful tools and filters in Photoshop that allow you to perform some amazing enhancements. Most of these are used by the professional photographer or the expert hobbyist to apply controlled alterations.

But image-manipulation doesn't always have to be serious: far from it. A great deal of fun can be had with even the most popular of tools and commands. For instance, you can create wacky special effects on a portrait, such as ageing a young person by over-laying old skin and wrinkles to his or her face, or making a caricature by enlarging parts of the body to comic proportions. You could even cut out your pet's head and paste it onto your own body!

IT'S GOT TO BE FUN, FUN, FUN!

Though it is important to have some fun with your images, there is the underlying aspect that you are putting into practice most of the skills that you have learnt over the past tutorials. It can only be beneficial to you the more experience you have with the software.

Creative fun may not be taken seriously, but, in reality, the more times you perform basic functions in Photoshop the more you will retain later for more 'grown-up' editing.

And besides, you may start off with basic functions, but as you grow with confidence, you will start to push your knowledge and become more adventurous, testing out new functions, filters and commands. And that can only be a good thing!

FUN CARICATURES

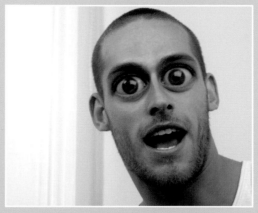

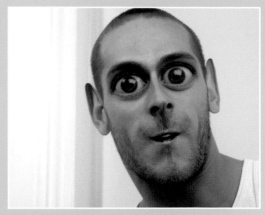

STEP ONE

Turning a portrait into a caricature is very easy to do. Making good use of the Liquify filter, you can bloat, shrink, stretch, smudge and twist virtually any face or body part. These next steps are only ideas on how to make funny portraits.

STEP TWO

With your image open, select the Liquify filter from the Image menu bar. Filter > Liquify. (For more on using the Liquify filter, see page 138.)

Select the Bloat tool and a brush size slightly larger than an eye. Apply the Bloat tool, enlarging each eye individually to produce 'bug eyes'.

STEP THREE

Select the Pucker tool and a brush size just larger than the mouth. Apply the Pucker tool over the mouth to make a tiny, pinched mouth.

Finally, select the Forward Warp tool and a brush size smaller than the ears. Smudge the ears up away from the head to create big pointy ears.

IMAGE MORPHING

STEP ONE

You can apply some of the tricks you have learnt from the previous Liquify filter tutorials, to create a more realistic morphed result. In this example we make someone into a muscle-bound bodybuilder.

Again, it is important not to go over the top if you want realistic results. But of course this is all about fun, so don't let me tell you what is realistic – if it looks funny then that's what it's all about!

STEP TWO

With your image open, select the Liquify filter from the image menu. Filter > Liquify.

Select the Bloat tool and a suitable brush size that is about the same area as the chest.

Gently click and hold down over one side of the chest until it bloats up to a decent size.

Repeat to the other side of the chest. Use the Forward Warp tool with the same-sized brush to move the chest up and slightly out at the sides.

STEP THREE

Repeat the last step over the arms and neck, bloating them out until they look large.

Select the Pucker tool and a large brush size that is about the half the size of the body. Click and hold down over each side of the waist until it starts to look like the body has that muscular V shape.

Finally, accept the Liquify window by clicking OK.

SURREAL PORTRAIT

STEP ONE

To separate the hair from its backgound, use the Background Eraser from the toolbar. Choose a suitable small brush size and softness. Select a tolerance of about 10 per cent if the hair is of a similar colour to the background. Zoom right in and start to erase in small strokes. Use the Eraser tool to clean up any stray background.

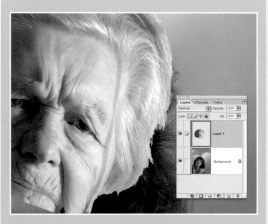

STEP TWO

Click and drag the 'hair' layer on to your master image. Use the Transform tool to adjust the hair so it sits correctly on the master portrait. Go to Edit > Transform > Distort. You may need to rotate it slightly and push the edges inwards to make it narrower. You may be left with some of the original image's hair poking out from underneath.

STEP THREE

In the Layers palette, turn the 'grey hair' off by clicking on the 'eye' icon. Using the Clone tool, start to clone out the original portrait's hair. Switch the 'grey hair' layer on and off as you go to check that no original hair is showing. As you will be covering over the top of the original, it's not important to clone all the hair out completely.

STEP FOUR

Seamlessly blend in the edges of the skin by selecting the 'grey hair' layer and add a layer mask. Go to Layer > Add Layer Mask > Reveal All.

Use a medium-sized soft brush and a opacity of about 20 per cent. Brush out the edges of hairline, up to the grey hair. Adjust the opacity as you go. Don't let the original hair show through.

STEP FIVE

Use the Pen tool and draw around the old face, including the hand and wrist. Make sure you don't include any of the hairline. Draw the face section with a 'mask' shape, following the contours of the head. Select the Options from the Paths palette and make the path a selection.

Copy and paste the 'old lady face' on to the composite document. Use the Transform tool to rotate the mask. Line up the hand with the wrist of the original. Zoom in close to line the edges correctly.

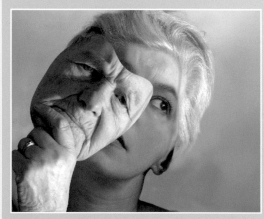

STEP SIX

Create a new layer and position it under the mask layer. Use the Pen tool to draw around the face once more; this time we are creating the edges of the mask and inside the eyes. This will give the mask the illusion of depth. Make the paths a selection, and, with a dark skin colour, paint inside the selection. Use varying highlight colours for the outer edges.

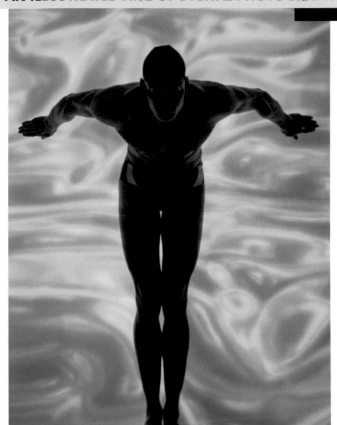

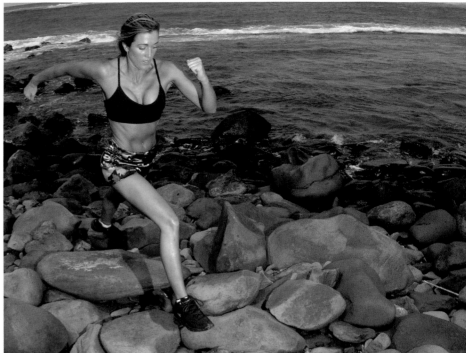

Left: A static shot relying on shape and colour for impact.
Above: This athlete's posture indicates that she's running, without the need for motion blur.

Sports and action

Capturing your fellow human beings in motion is a challenge,
but the results can be worth the effort, with a bit of planning

CHECKLIST
Use a fast shutter speed to freeze action in people and animals.
Use slow speeds to convey movement with motion blur.
A long lens at a wide aperture makes the subject stand out.
Small apertures offer a greater sharp zone for moving subjects.
If light levels don't enable fast-enough speeds raise the ISO.
Set the drive mode to continuous and the lens to servo AF.
Try creative techniques such as slow-sync flash and zoom burst.

PREPARATION

Sports photography is a difficult and challenging genre to master, but for sport lovers it's surely the most rewarding. If you have a specialist knowledge of a particular game you'll have an immediate advantage because you'll find it much easier to anticipate what will happen next and be prepared for it.

Away from the sports field, general day-to-day action, such as the kids playing in the park, calls for the use of similar techniques – though you're not generally forced to sit 50 metres away behind a fence or jostle for a spot with lots of spectators, as you are with sports.

Preparation is crucial in sports photography, starting with knowing where to stand to get the best shots. With motor racing, for example, it may be on a sharp corner, where you know the cars will slow down. At a football match it may be on the halfway line or behind the goal. Wherever you choose you may not be able to relocate, so choose well!

ANTICIPATING THE MOMENT

Moving subjects are difficult to photograph at the best of times, but some cameras make it easier than others. The ideal camera is an SLR, but with a little practice even budget compacts can produce great action shots.

The biggest factor determining the success of an action shot is the ability of the photographer to anticipate the moment and to be able to predict what will happen in the next couple of minutes. Armed with this knowledge, the next task is to be totally prepared, choosing your camera settings and keeping your finger on the shutter button.

Some cameras experience a delay of up to a second before firing. With these cameras it's a good idea to lock on to your subject by pressing the shutter halfway down and then keeping it there. This will preset the focus and exposure on whatever you're pointing the camera at so that when you're ready to shoot the camera will fire almost instantly.

SHUTTER SPEEDS TO STOP MOTION

There are two kinds of action shot: those where a fast-moving subject is 'frozen' in time (such as a child in mid-leap) and those where the subject (or background) is blurred due to its movement across the frame. Both kinds have their merits, depending on the subject. The frozen movement technique is ideal for photographs of people or animals, where the subject can be captured in mid-air or with legs outstretched, for example.

To stop fast motion in its tracks you'll need to set a high shutter speed of at least 1/250 sec and probably faster, depending on the subject. It's best to set your camera to shutter priority or manual exposure mode for this.

Far Left: Telephoto lenses allow you to pick out individuals in a scene without being right up close to them.

Left: A study in concentration.

Below: Is this motorbike moving or stationary? It's hard to tell. But if it was moving, and a slow shutter speed had been used, the resultant motion blur would have answered the question.

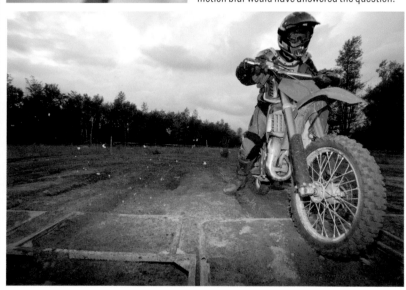

SHUTTER SPEEDS FOR BLUR

With mechanical subjects such as cars, motorbikes, etc., a fast shutter speed can easily make them appear stationary. A Formula One car stopped dead on the track could just as easily be parked there, for example.

In cases such as these a degree of blur will give a better impression of movement. You'll need to set a slower shutter speed of, say, 1/30 sec or maybe even slower, in order for some of the subject's movement to record as a streak across the sensor, as though smeared.

You'll need to experiment with the precise speed because there are various factors influencing the result, including subject speed, distance from the subject, the lens in use and so forth. Do a few shots at a selection of apertures and review them on the LCD screen to decide which one works best on that occasion.

PANNING

If you don't want the subject to look blurred there is an alternative, which works well with subjects travelling across the frame. This is called panning.

With panning, you select the same slow shutter speed, but you follow the subject's movement with the camera, keeping it in roughly the same part of monitor or viewfinder. When you're ready to shoot, press the shutter, but keep turning the camera. The result will be a sharply recorded subject and a horizontally streaked background. This has the advantage of not only conveying the movement, but reducing any distracting elements in the background. A tripod or monopod is useful for this technique, making it easier to move the camera in just the plane of motion.

USING FLASH

A highly effective way to enhance a panned photograph is to add a burst of fill-in flash to the mix. Using flash at slow shutter speeds is called 'slow-sync flash' and it's done in the same way as straight panning, but with a flash attached or with the camera set to its slow-sync flash mode. When you press the shutter the long speed records the background as a blur and the flash 'freezes' the subject, making it stand out more. If you choose not to pan your subject can be recorded as both blurred (the ambient exposure) and sharp (the flash), which can also look great.

Some cameras and flashguns offer a second (or 'rear') curtain sync option, which fires the flash at the end of the exposure, rather than the beginning. This is better for action shots since the sharp image precedes rather than follows the blur, creating a more natural look.

Obviously these techniques only work when your subject is within the flash range.

Use a long telephoto lens

A long telephoto or zoom lens makes action photography easier as subjects appear to move more slowly when they are further away. You can, however, shoot action without one – you'll just have to get closer and react more quickly. For more on telephoto lenses, turn to page 124.

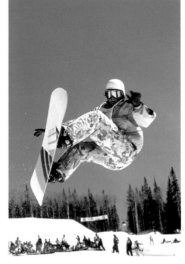

Above: The finish line is a good place to stand for the best photographs of races.

Left: A small aperture ensures enough depth of field for fast-moving and unpredictable subjects to remain in focus.

Right: A low angle gives emphasis to the ball and the player's foot.

ZOOM BURST

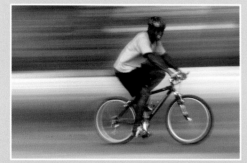

Panning works well with subjects moving across the frame, but not travelling towards the camera. There's a technique for this too, though it can only be done with cameras that have a manually operated zoom, not a motorised one. As with panning, a slow shutter speed should be set. Release the shutter while the subject is still some distance away and simultaneously zoom in while the shutter is open. As with panning, a tripod is advisable. Zoom bursts can also be simulated on a PC using the Radial blur filter.

APERTURE

While the main focus of your exposure control is on the shutter speed, the choice of aperture is also important. The aperture determines how much of the scene is in focus.

At wide apertures the zone of focus ('depth of field') is very shallow. This helps to make your subject stand out from the background, but you need to be much more precise with focusing to get a sharp subject, and it only has to move a small amount to fall outside this zone.

By choosing a smaller aperture the depth of field is extended, providing a greater zone of sharp focus from foreground to background. This can be distracting, but can also be useful when shooting unpredictable subjects such as children playing in a park, where it allows more room for movement without the subject leaving the zone of sharpness.

OTHER SETTINGS

If it isn't bright enough to set the shutter speed and aperture combination you'd like then you'll either have to compromise on one or other setting or consider increasing the ISO rating, although this may reduce image quality if you go too far.

As for other camera settings, it goes without saying that you will want to set the drive mode to continuous for rapid shooting (at least 3 fps is preferable) and the lens to servo AF (so it keeps refocusing on the subject as it moves) rather than single focus (which doesn't).

Shooting in RAW mode can be problematic as this may fill the buffer more quickly, resulting in the camera being unable to take any more shots until the images have cleared the buffer and been copied safely on to the media card.

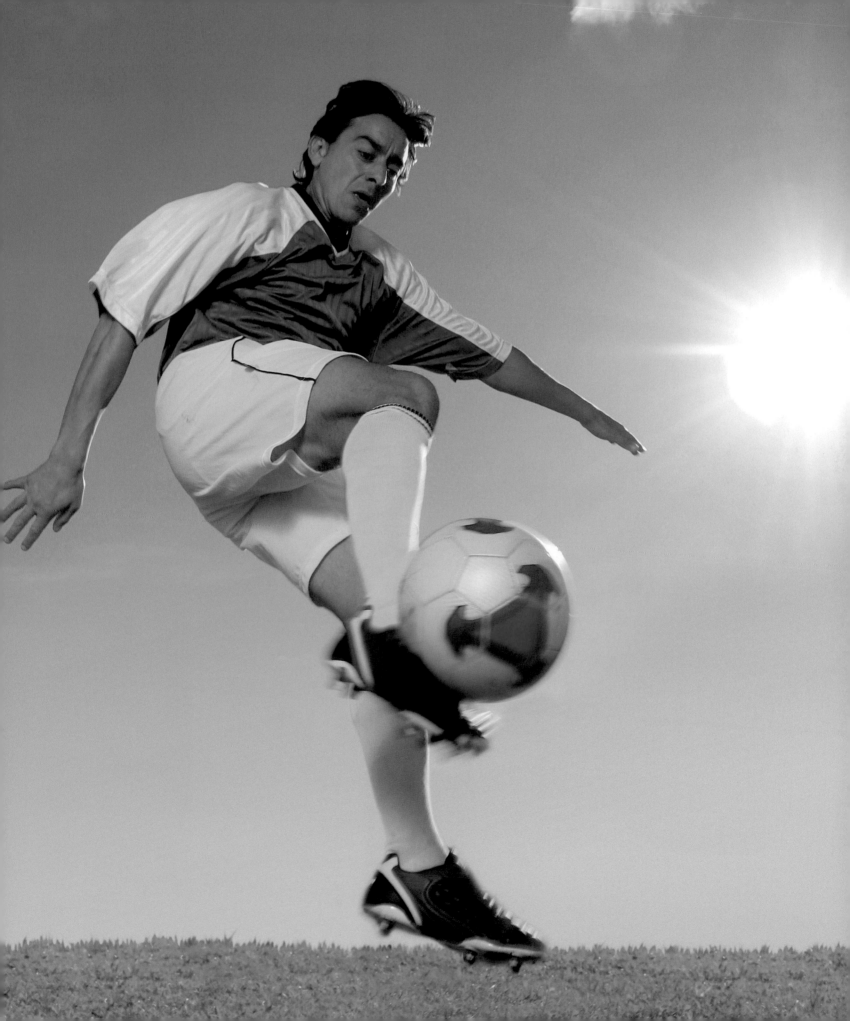

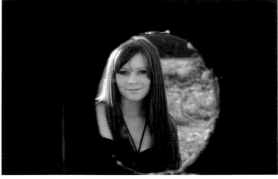

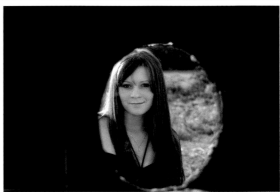

Left: Sepia tone is subtle and elegant.
Above and top: Duotone and tritone can create some atmospheric results.

Toning and Tinting

Black-and-white photos can be warmed or cooled with the use of tones.
Follow these simple steps to create atmospheric images

MORE ATMOSPHERE

Black-and-white images can be atmospheric and dramatic. But with some images, they are just screaming out to be given a little warmth and colour.

Toning can add warmth or coolness and a little more atmosphere to a portrait by adding selective colours back into the image. The process of toning is very subjective: what you may like, someone else may not, so for this reason, remember to experiment and produce a set of different tones and colours.

Try to avoid using primary colours unless you wish to gain a more stark effect.

In these short tutorials we will make a sepia tone, a duotone and a tritone.

When you have finished creating your toned image, it's a great idea to choose a fine-art paper to get fantastic results from your printing.

SEPIATONE

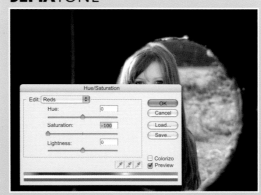

STEP ONE

With your image open, select the Hue/Saturation command from the image menu. Select Image > Adjustments > Hue/Saturation. Slide the saturation slider to the left as far as it can go. This will remove all the colour from your image.

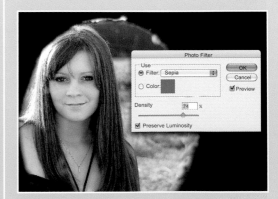

STEP TWO

Select Image > Adjustments > Photo Filter. From the drop-down menu in the dialogue window, select Sepia.

Use the slider in the dialogue window to determine the strength of preset sepia tone.

Hit OK to accept the settings.

DUOTONE

STEP ONE

With your image open, select the Hue/ Saturation command from the image menu. Select Image > Adjustments > Hue/ Saturation. Slide the saturation slider to the left as far as it can go. This will remove all the colour from your image.

From the image menu, select Image > Mode > Greyscale.

STEP TWO

Now choose Image > Mode> Duotone. The dialogue box that appears will have duotone as the default, but the drop-down menu will give you the other options. Click on the blank right square to bring up the Color Picker window.

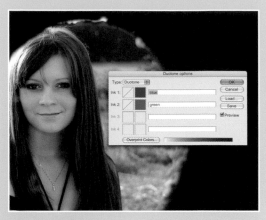

STEP THREE

With the Color Picker window open, choose your first colour, preferably the dark one first. Click OK. In the duotone dialogue box name the colour. Now click on the square underneath and pick your complementary colour. As you pick the colours you will notice your image change colour automatically.

Click OK and save the image.

TRITONE

STEP ONE

With your image open, select the Hue and Saturation command from the image menu. Select Image > Adjustments > Hue/ Saturation. Slide the saturation slider to the left as far as it can go. This will remove all the colour from your image.

From the image menu, select Image > Mode > Greyscale.

STEP TWO

Now choose Image > Mode > Tritone. The dialogue box that appears will have duotone as the default, but the drop-down menu will give you the option to select the Tritone. Click on the blank right square to bring up the Color Picker window.

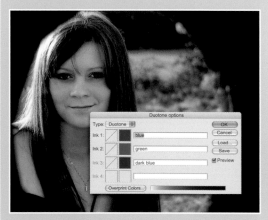

STEP THREE

With the Color Picker window open, choose your first colour, preferably the darker one first. Click OK. In the tritone dialogue box name the colour. Click on the square beneath and pick your complementary colour.

Repeat again to select the third colour. Try to make sure that the colours work together; don't choose random colours.

Click OK and save the image.

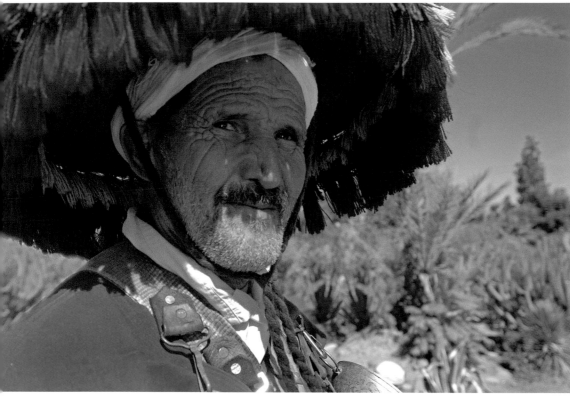

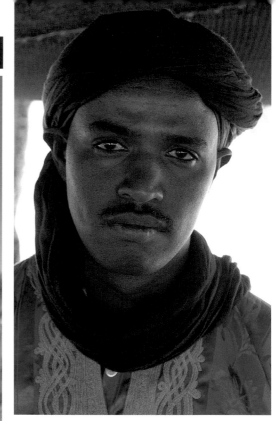

Above and left: Two contrasting portraits taken in Morocco. An unposed grab shot (left) and posed portrait (above).

Travel

If you're off on your travels, don't forget to capture interesting portraits of the locals as well as the views and architecture

CHECKLIST
- Choose locations other than typical landmarks.
- Try to use the subject to tell a story.
- Visit local markets and meeting places.
- Seek out small details.
- Pack spare memory cards.
- Ask permission from the locals first.
- Invest in good-quality camera bags.

PLACES ARE ABOUT PEOPLE TOO

Few genres are as rich in subject matter as other people's countries, but don't focus solely on the famous views – remember that a country is as much about its people as its landmarks, so make sure you dedicate plenty of attention to the human element in your travel portfolio.

Of course one man's travel destination is another's doorstep, but as tourists we're often more able to see potential pictures in things that locals may have long since failed to notice. It could be a particular style of dress, a type of job that doesn't really exist back home (tea-picking, for example) or perhaps just a different way of doing familiar things (for example, the floating markets of Bangkok).

In any event, adding people to your shots often makes them more interesting.

INTERACT WITH YOUR SUBJECTS

There are several ways to shoot travel portraits. The least confrontational is to fit a long zoom and stick to candids. A few shots like this are fine and you can capture some natural expressions. But too many will make your travel portfolio look voyeuristic and emotionally disengaged.

Getting up close can be intimidating for some photographers, but photographing people without their consent is a contentious issue. Some people don't mind being photographed, others dislike it, and a third group sees it as a source of income and expect to be paid. Try engaging your subject in a few moments of chat before reaching for the camera. If he or she seems hostile, move on – there are lots of other people out there who may not mind so much.

Some photographers object to paying for photos on principle, but it's usually only a few pence and for poor people this can mean a lot.

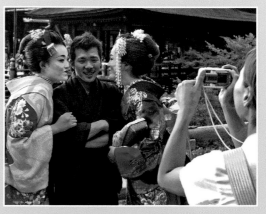

On the other hand, the resulting photos are often poor, as your subject, once paid, often stares blankly at you or strikes a well-rehearsed pose. Just take a shot, move on – and mark it down as an occupational hazard.

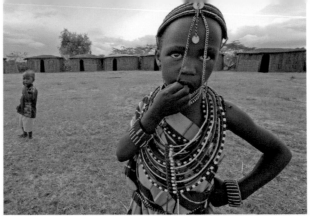

Left: Shooting on a 10mm wide-angle lens has both emphasised the girl and shown more of her village.

Below: This very low-light shot was achieved by the use of a high ISO of 1600 and balanced fill-flash, which has retained the atmosphere created by the ambient illumination.

Keep it varied

These three pictures were all taken at Masai villages in Kenya, but are all very different. There's a traditional portrait (above), a close-range wide-angle shot (top right) which shows something of the subject's environment, and an atmospheric night shot (right), shot at ISO 1600 with fill-in flash.

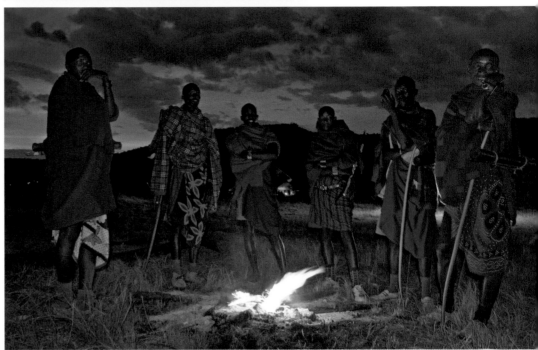

GADGET BAG

Choose a camera bag that you can carry on your flight as hand luggage – never check your cameras in the hold. Pack plenty of spare media cards and batteries. Take a tripod, even if only a pocket one, so you can get sunsets and night shots of spectacular views. If you have a lot of kit, pack a smaller day bag so you can leave some of the heavy stuff at your hotel. And don't flash your gear around, but keep it discreetly in your bag or under a jacket when not in use.

TOP *TIPS!*

1 TAKE A SPARE
Pack spare cards and batteries and take your gear on as hand luggage.

2 DIFFERENT APPROACH
Try to find new and original approaches to familiar icons.

3 TELL A STORY
Work to tell a story of the place, in pictures, convey its spirit and culture.

4 DETAILS
Look for small details as well as general views.

5 PEOPLE
Photograph the people, if they don't mind, but desist if they object.

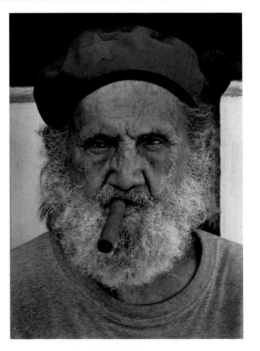

Right: The Che Guevara beard and beret, the Cuban cigar – this street portrait could only have been taken in Havana, Cuba.

WWW.FLICKR.COM

Now owned by Yahoo, Flickr has been a runaway success in the photo-sharing business and claims its members upload 60,000 new photos per day. It's strictly a place for sharing and commenting upon each others' work, though they have introduced a printing service for US customers only. The key to its success is its great interface, the ability to add searchable tabs to pictures and to create your own albums of favourite pictures. There are blogs, too, and 'photostreams' on a range of niche subjects.

Websites

Digital photography and the Internet were made for each other. The world wide web in particular is an invaluable source

CHECKLIST

Use the Internet for:
Emailing photos to friends and relatives.
Sharing your pictures with others on photo-hosting sites.
Getting all your printing done.
Catching up on the latest photography news.
Reading reviews of new products – and buying them.
Brushing up on your skills and learning new techniques.

NET GAIN

As with any genre of photography, the Internet is an enormously useful tool for the portrait specialist, and an unparalleled resource. It is a place to gain inspiration through the work of others, to get technique and equipment advice, and to share your work with the wider photographic community. You can also find models, discover the location of your nearest studio for hire, and even get your photos printed. Here's a selection of websites worth bookmarking:

WWW.EPHOTOZINE.COM

A UK-centric online magazine covering all the main bases. Some news and reviews, and a reasonable amount of technique, but especially strong in its gallery section. Ephotozine has some gifted photographers among its members and some of the portfolios are stunning. Although landscapes and nature dominate, there is some portraiture too.

WWW.PHOTO.NET

A general photography portal based in the US, but with an international membership from a real United Nations of countries. At its core is a comprehensive gallery section where members' work can be viewed and commented upon. A tab-based interface enables viewers to click between comments, technical details and other information. Photo.net also has a selection of technique features and articles.

WWW.PBASE.COM

Photo-sharing website aimed at enthusiast photographers as a place to show their portfolios of work. Pbase charges a modest annual membership fee for the web space.

WWW.SHUTTERFLY.COM

A photo-sharing and printing website that's huge in the US, though has yet to make a big mark on the rest of the world. It's a high-quality site with a range of good-quality printing services. Its bound albums, for example, are among the best available, and they ship internationally.

WWW.SNAPFISH.COM

Snapfish is an online printing and photo-sharing website owned by HP. Sharing is a key part of the Snapfish experience, but there's also a greater emphasis on printing than with some similar sites, and a wide range of printing services are offered, such as the ability to make bound albums.

WWW.ISTOCKPHOTO.COM

If you think that your portraiture has reached a high-enough standard that you can sell it, and you've got the permission of your subject via a model release form, iStock is a good place to start trying. Most picture libraries are like exclusive clubs. You have to show your work, they decide whether they want you or not. With iStock you upload your own images and get a cut of whatever they sell for. The asking price is ridiculously cheap (from $1 per picture) so you need a large volume of sales to make any money, but it's a good starting point.

WWW.WHATDIGITALCAMERA.COM

What Digital Camera is the UK's original digital photography magazine, having been established in 1997. The website offers a mix of daily news stories, equipment reviews (along with 360-degree product photos and test images), technique tutorials (including Photoshop movies), forums, readers' photos and a variety of other resources, including a shop. It also runs a home study course for those wanting to hone their skills.

WWW.PHOTOBOX.CO.UK

While some similar photo-sharing sites offer printing services, Photobox comes from the opposite direction and could be described as a printing service that offers space for photo-sharing. Its interface is less slick and more businesslike than, say, Flickr but the ace up its sleeve is the quality of its printing, which has consistently been shown to be the best on the web – at least for its strongly UK-biased audience.

WWW.DPNOW.COM

A news-based photography website servicing a predominantly British- and American-based audience, with a variety of product reviews and a busy forum section too.

WWW.PHOTOLIBRA.COM

An online picture library where you don't need anyone's permission to sell your work, you upload whatever you like. You do have to pay a modest fee for the privilege, so it's up to you not to waste your money uploading shots that won't sell. PhotoLibra takes a cut of what you sell.

WWW.DPREVIEW.COM

The blue whale in the online photography ocean. DPReview offers the web's busiest photography forums, daily news and what must be the most exhaustive tests of selected cameras you'll find anywhere. If the model you're interested in has been reviewed by DPReview, it's well worth a read. Just clear your diary first.

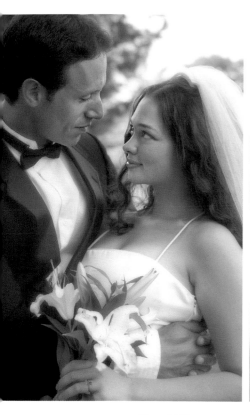

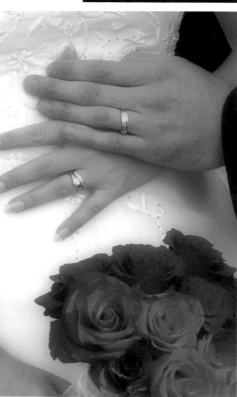

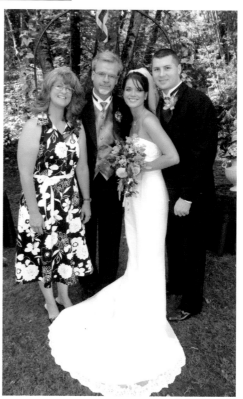

Far left: The happy couple gazing into each other's eyes – a cliché, but a popular one.

Middle: Make sure you get a shot showing the wedding rings.

Left: Weddings are an important day for the family too. Make sure you include them.

Right: No wedding set would be complete without some posed shots of the bride.

Weddings

The happy day may only happen once, so it's essential to get it right on the day. Here are a few pointers

CHECKLIST

Don't forget to talk to the bride and groom.
Be organised for quick set-ups.
Don't be shy.
Scout for venues.
Look for pretty locations.
Make sure the bride and groom are close togethe
Don't forget the family.

TALK TO THE HAPPY COUPLE

Taking on a wedding is a huge responsibility. To your clients it's the most important day of their lives, so it's vital that you get it right on the day. This can be very intimidating, but with some careful planning and organisation it will run smoothly.

Firstly, talk to the couple to find out what they want. Where is it, and how many guests will there be? Discuss the timings, and the logistics of the day. Some couples now prefer an informal fly-on-the-wall approach to the traditional posed shots, but a good wedding shoot should be a mix of both. The posed shots present the only opportunities to make sure everyone looks good in the shots, and the groups guarantee a record of everyone who was there – it's easy to miss people using the reportage approach.

LOCATIONS

If you can, visit the venue in advance to check out potential locations for the posed shots, either outside the wedding venue or the reception. Seek out places away from direct sun and with plain (but not ugly) backgrounds. Make a list of the shots you need to take (exchanging rings, cutting the cake, etc.) and refer to it on the day. Find out if there are any restrictions on taking pictures during the ceremony. If you're allowed to shoot, be discreet, and don't use flash.

Don't keep guests waiting too long while you do the posed shots – keep them brief. Be loud, clear and decisive in your instructions so that people know when they're needed – weddings are as much about crowd control as photography.

ON THE DAY

You should already have checked your equipment before the day to make sure everything is working, that batteries are all fully charged and that you have a spare camera, plus additional spare batteries as a back up. Check all your camera settings before shooting, to make sure you aren't inadvertently set to ISO 1600 or something. Do a couple of test shots and check them carefully on the LCD screen. Refer to the histogram to ensure the exposures are good. You'll need to be especially careful with white wedding dresses in sunshine, which can burn out and lose detail, especially when the groom is wearing a dark suit, so examine the highlights. Most digital SLRs have an overexposure warning in which blown highlights flash on the LCD, and it's a good idea to set the display to this mode if you're shooting in bright conditions.

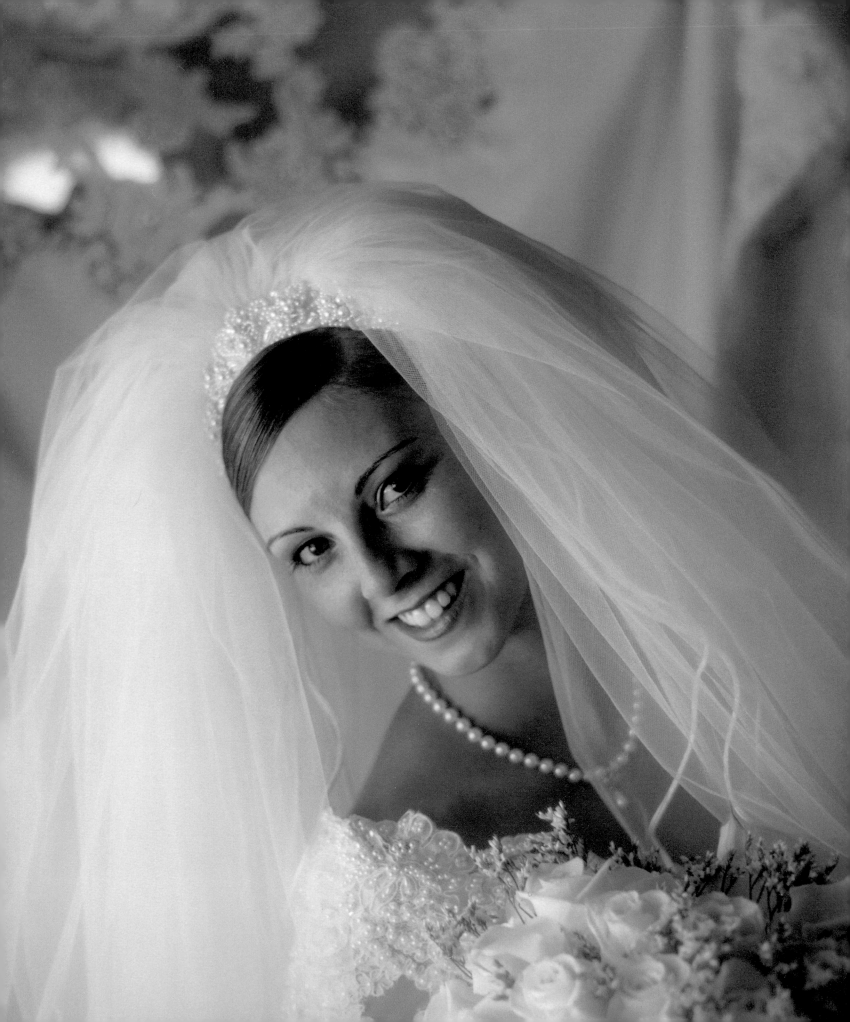

weddings

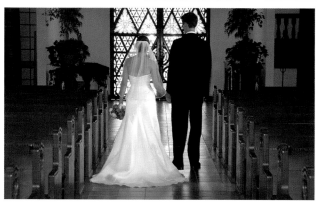

Above: The best man — a central character in every wedding.

Far left: Some photographers like to do a studio portrait session of the bride and groom before the big day.

Middle top: Getting ready.

Left: Walking out of the church.

A SHOOTING CHECKLIST

There are so many things to think about and so much to photograph at a wedding that it's easy to forget some of them.

Although there are no fixed rules about what you should photograph, there are certain moments that it would be remiss of the wedding photographer to leave unrecorded — moments which the bride and groom (the clients) would notice if they weren't there. Here's a list of some of the shots that should be covered.

THE VENUE

While not essential, if you have the chance to take a photo of the church or venue where the wedding and reception are taking place it will enable the couple to say '… and this is the church where we got married' in years to come. If it's local why not shoot it before the event, in good light, from its best viewpoint.

GETTING READY

Some photographers go to the bride's home or hotel to photograph her getting ready, perhaps putting on her wedding dress or applying finishing touches in the mirror.

ARRIVING AT THE CHURCH

The bride getting out of the car on arriving at the church or standing at the entrance, composing herself before the big entrance, convey the sense of anticipation of the event.

THE DETAILS

Don't forget a close-up of the rings, and, if possible, the bride's bouquet. A lot of thought goes into every detail of most weddings, from the flowers to the menus. A relative may have taken a personal interest in some aspect of the day and it's good to record his or her efforts.

THE CEREMONY

An obvious one, but check that you have permission and don't intrude on the ceremony — it isn't a photo opportunity. Get a shot of the couple at the altar from the back, perhaps showing the whole church. A shot of the ceremony from above is great if there is a balcony available. Never use flash.

THE RINGS AND THE REGISTER

The iconic moments — exchanging the rings, being pronounced man and wife, and signing the register which makes the marriage legally binding — are must-haves if you've been allowed to photograph the ceremony.

Right Putting on the rings — a crucial moment.

Below far left: Get some shots cutting the cake.

Below left: The bride with her bridesmaids is an essential shot.

Below: Don't just shoot posed shots. Candids give a better sense of the emotion and joy of the day, but getting good expressions requires quick reactions.

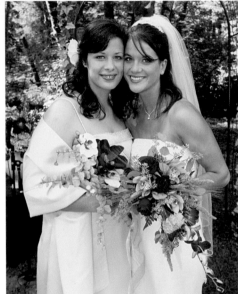

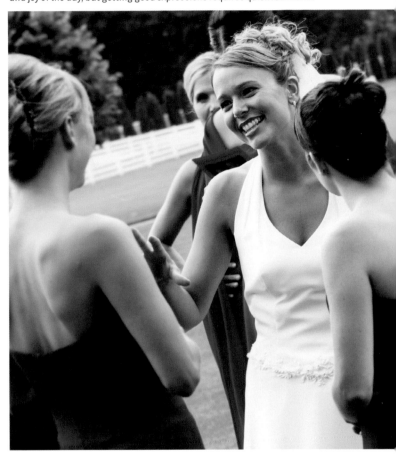

POSED SHOTS

Without taking too long about it, get a few posed shots of the bride and groom together outside the church, ideally at a preselected spot with good, diffused light. Also shoot the bride and her bridesmaid(s), the groom and his best man, the bride alone, some group shots with each family, and everyone together.

CANDIDS

The wedding will seem a very staged, formal affair if you only take posed, static shots. Keep your camera trained on the key players and the guests, for relaxed chat, spontaneous funny moments and other pictures which convey the warmth, love and joy of the day.

THE RECEPTION

Most hired photographers finish the job when the reception starts. Sometimes they stay for the cake-cutting. If you're a guest as well as the photographer, or can stay for the whole evening, you'll get some good shots of people dancing, chatting and having a good time.

TOP *TIPS!*

1 BE CONFIDENT
Don't attempt to shoot a wedding unless you're confident of the technical aspects. The long-term consequences of messing it up are huge, not only for the distraught couple but for you too, if you're a friend or part of the family. If in any doubt, say no.

2 BACK UP
Make sure you have a back-up camera, plus spares of everything you need. Anticipate what can go wrong and prepare for it.

3 BE DECISIVE
Shoot quickly, give clear commands on what you want to do and who you need for each shot, and don't fiddle with the camera while people are waiting.

4 GET AN ASSISTANT
If you can, employ an assistant (perhaps your partner). As well as helping to organise groups and round people up, they can pass lenses and fresh media cards, and look out for faults in the shot, such as twisted clothing, etc.

5 POST YOUR IMAGES ONLINE
Put the pictures online, on a custom website or a site such as Photobox. All the guests may want to see the pictures, and many will want to order prints.

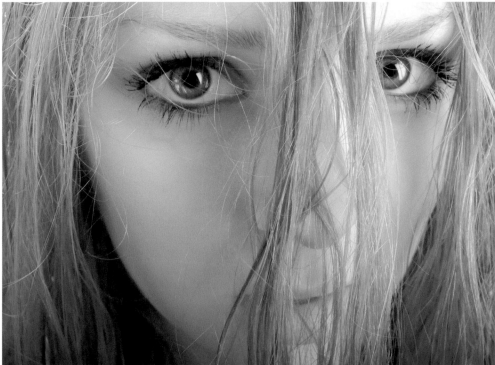

Above: The photographer was drawn to the subject's eyes and made them his main focus.
Left: Candid, off-guard moments often produce more relaxed images.

Women

They account for about half of the world's population, but much more than half of the world's portrait photos. Here's why ...

CHECKLIST

Almost all women can be made to look beautiful.
Identify the model's best attributes to focus on.
Developing a rapport is essential for good shots.
Soft diffused light is the most flattering.
Women have many roles in society that you can represent.
Photograph older women with grandchildren.
Pregnancy is a great time for photography.

PHOTOGRAPHING WOMEN

There is a whole history of debate surrounding the representation of women. But there is no denying the visual appeal of an image of a beautiful woman. Just look at films and TV shows, magazines (men's and women's), newspapers, billboards.... Images of women sell, because our gaze instinctively zooms in on them, however small they may be in our peripheral vision. And it doesn't even have to be the entire person. It can be just the face, the eyes, an exposed midriff, an expanse of thigh – even a single ankle.

This is great for photographers because it gives us a limitless variety of pictures within a single subject. Not that you're likely to find an original angle, because the female form has been immortalised so many times in so many ways, that the best you can really hope for is to produce images that stand out for the quality of their execution rather than their originality.

FINDING THE INNER BEAUTY

Although it's by no means essential, the aim in photographing women, especially young women, is to make them look attractive. This is not always easy. While a small minority of women are so beautiful and flawless that taking a bad picture of them is more difficult than getting a good one, most women have imperfections, both real and imagined, which need to be addressed by the photographer if a successful portrait is to be achieved. It's been said that all women are beautiful in their own way, and that's true of everyone. Most women have certain assets that they're more proud of than others. It may be nice eyes, a full mouth or prominent cheekbones. Perhaps it's some aspect of their figure, such as very long legs or a slender neck.

It may not be a body part at all, but an expression: a certain smile, a laugh, perhaps an endearing facial habit such as raising an eyebrow when surprised or sceptical. The best portrait photographers are those who like people and are observant. They pick up very quickly those traits and attributes which are attractive and set about trying to immortalise them in an image.

They achieve this by the decisions they make in setting up the picture: a high viewpoint or a low one, a profile or head-on shot, a short or long focal length lens, soft or hard light, etc. Once the set-up, camera position and pose have been determined, the photographer's job is then to coax from the subject that special look or expression. This is more likely to be achieved by casual banter and conversation that relaxes the subject and makes her forget about the camera than by pedantic direction, although some direction (where to look, etc.) is obviously necessary.

WOMEN AS MOTHERS

We have already covered topics such as fashion, glamour and nude photography elsewhere in this book, but those aren't the only approaches to photographing women. Women are not simply objects of desire: they're workers, mothers, community leaders. Their roles are as diverse as those of men. We have discussed photographing people at work in the chapter on men, and most of the same rules apply to photographing the working woman. There is one role that is exclusive to women though – that of being a mother. Women are often photographed during their various stages of pregnancy, both fully clothed and as tender nude studies (with an emphasis on the 'bump'). There's something romantic and touching about such pictures, and the mother is likely to treasure these images as the bump becomes a baby and grows up.

Even more emotionally charged are portraits of a mother with her baby. For these shots it's best if the mum holds the baby in her arms at a slightly higher position than perhaps feels natural to enable the photographer to go in close for a tightly cropped shot of mum and baby together. Another popular pose is for the mother to sit with the baby in her lap, both facing forwards, with her arms around the infant, though this works better when the child is old enough to hold its head up by itself.

Above Left: Mother and child.
Left: The pregnancy bump – an iconic image.

REALISING THE VISION

Sometimes women are photographed not to flatter or to satisfy their aesthetic needs, but to realise a vision dreamed up by the photographer or an art director. This would describe most advertising and commercial photography of women, and is usually done with the assistance of professional models who are trained to convey a mood, feeling or attitude on command. Getting amateur models to work in this way is very difficult unless the subject is uninhibited and confident in front of the camera. But if you can find a willing subject it can be fun to work together to create a picture which illustrates a pre-visualised concept.

It could be, for example, that you want to create a tribute to an iconic image such as Botticelli's *Venus*. Perhaps you're going for a contemporary stereotype, such as the power-dressing executive, or you're trying to convey a specific emotion such as fear or surprise.

In any situation where the aim is something more specific than just a nice portrait you should sit down with the model beforehand and discuss the goal, and how you plan to achieve it, so that you can work together collaboratively. This will ensure a greater chance of success than just barking instructions. With digital cameras it's easy to stop for a break and, together, review the shots you've taken so that you can make any necessary adjustments. Although they can be difficult to view accurately on a small screen the image can be magnified so that expression, sharpness and other qualities can be carefully examined. Alternatively, if you have a laptop computer you can download the images and view them at a much greater size.

THE OLDER WOMAN

As women get older they're less likely to be enthusiastic about having their pictures taken. As wrinkles and gravity take their toll women may well feel their days of modelling are over, but this need not be so. Beauty is as much a state of mind as a physical state.

Above: A powerful shot of a working woman, accentuated by the use of a low shooting angle.

Female sensuality

The ultimate aim of most photographs of young women is to make them look beautiful, sexy and desirable, not just in media aimed at men, but at women too. With attractive, confident women this is a relatively easy job, but for the 98 per cent of women who are not happy with their self-image (according to a recent study) the photographer may have to work a bit harder on the posing, styling and expression to bring the beauty out. Concentrating on the positive attributes, and being free with compliments when you're getting some good shots, will boost her confidence.

Just look at beautiful middle-aged celebrities such as Goldie Hawn, Catherine Deneuve and Twiggy, all of whom have aged gracefully.

That said, it would probably be inappropriate to go for a close-up with a hard light source on a mature woman. Soft light, perhaps even soft focus, will downplay any visible signs of ageing, and careful posing will ensure the subject is shown in the best light.

One incentive for the older woman is to be photographed with children or grandchildren. Cross-generational portraits such as these (perhaps with three generations of women, from grandmother to grandchild) can only be taken during a relatively short window in your subjects' lives, and make great gifts and keepsakes.

TOP *TIPS!*

1 RAPPORT
We've said it many times already, but it's worth repeating – a good rapport with the model is essential for good pictures.

2 GO WIDE
You don't want anything to distract from the subject's beauty. A wide aperture will blur the background and keep attention on her.

3 EXPRESSION
Pay particular attention to the subject's expression. Take lots of shots to increase your chances of getting a great one (and it doesn't have to be a smile).

4 POSE
With experienced models let the subject find poses that are natural and comfortable, and just fine-tune them to 'tidy' them up. More experienced models can be more experimental.

5 LIGHT
For the most flattering light go for soft, diffused illumination. Backlight is great for hair.

professional profile

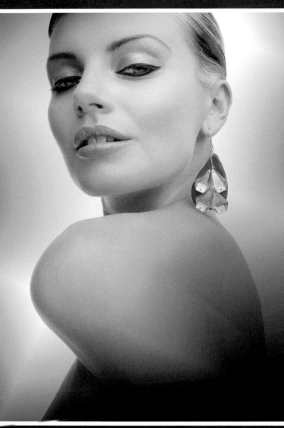

For more of Martin's great beauty and fashion photography visit www.martinevening.com.

Martin
Evening

The top beauty and fashion photographer finds the studio a great place to shoot

For many photographers Martin Evening's name is synonymous with the international best-selling Photoshop manuals, but Martin is also one of the UK's most respected beauty and fashion photographers.

Based in North London, Martin has a particular reputation for hair photography, and he shoots for a various high-profile international clients and celebrity hairdressers, who fly in from all over Europe to benefit from his expertise.

'Beauty and fashion photography is often about creating iconic images, especially with the more avant-garde catwalk styles, which are often flights of fancy. Some commercial shoots are grounded more in reality; the aim is for people to see the pictures and think, "I love that hairstyle, I wonder if it would suit me?"'.

Whatever the style, Martin works almost entirely in the studio. 'Logistically it's easier, because I can have up to 20 people on a big shoot,' he explains, 'including models, hairdressers, clothes stylists, make-up artists, art directors and ad agency people, plus a photographic assistant and a chef. It's good

to have changing facilities and make-up areas on hand too. And I have much more control over the lighting, which is crucial, especially for hair. Taking all that on location would be problematic and I'd be less prolific. I can get more pictures, with greater variety, in the studio.'

It's also the case that photographers are hired for their particular skill set, and with Martin that would be exquisitely lit studio shots.

'I actually prefer to keep my lighting fairly simple, and often use just one light on the model,' Martin confesses. 'This would usually be a one-metre square softbox, which I position in front of the model from above, pointing down. I may add a second light directly above and slightly behind, fitted with a grid spot to light the hair.' In addition, but not always, Martin may place lights behind the model to light the background.

'I don't want too much in the way of lighting between myself and the model because it creates a barrier – photographer on one side, model on the other – and that would impede the communication and rapport, which is very important. I don't even like to use a tripod.'

Sometimes, however, the client calls for more complex lighting, and Martin is able to deliver just what's required. 'If a client wants a shine on a specific part of the hair, I can get that. Lighting is a bit like snooker: you have to get the angles just right to get the reflections just where you want them.

Martin uses a Canon EOS 1DS MkII SLR, and his most frequently used lens is a 24–70mm f/2.8. 'I tend to shoot at 35mm most of the time,' he says. 'People talk about distortion, but if you keep the camera level this isn't so much of a problem. I also use the 70–200mm but shorter lenses provide a greater sense of intimacy, which I prefer.'

Although Martin's style is beyond the reach of most hobbyists, he has a few tips for those starting out on the fashion and beauty route.

'Start with location shooting and natural light,' he advises. 'Get used to working with people, build up your inter-personal skills before you start worrying about being clever with lighting. Inexperienced studio photographers get distracted by the lighting, but in the end it's about the model and her pose and expression. Take lots of pictures to increase your chances of getting that right.'

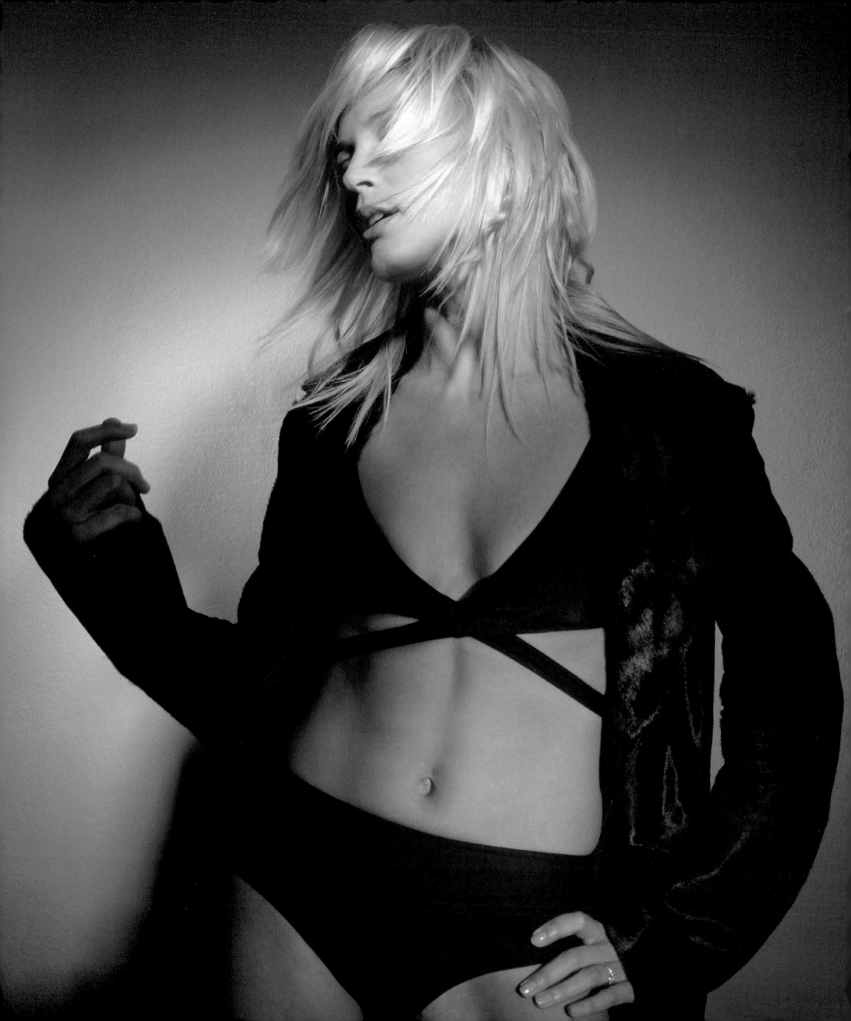

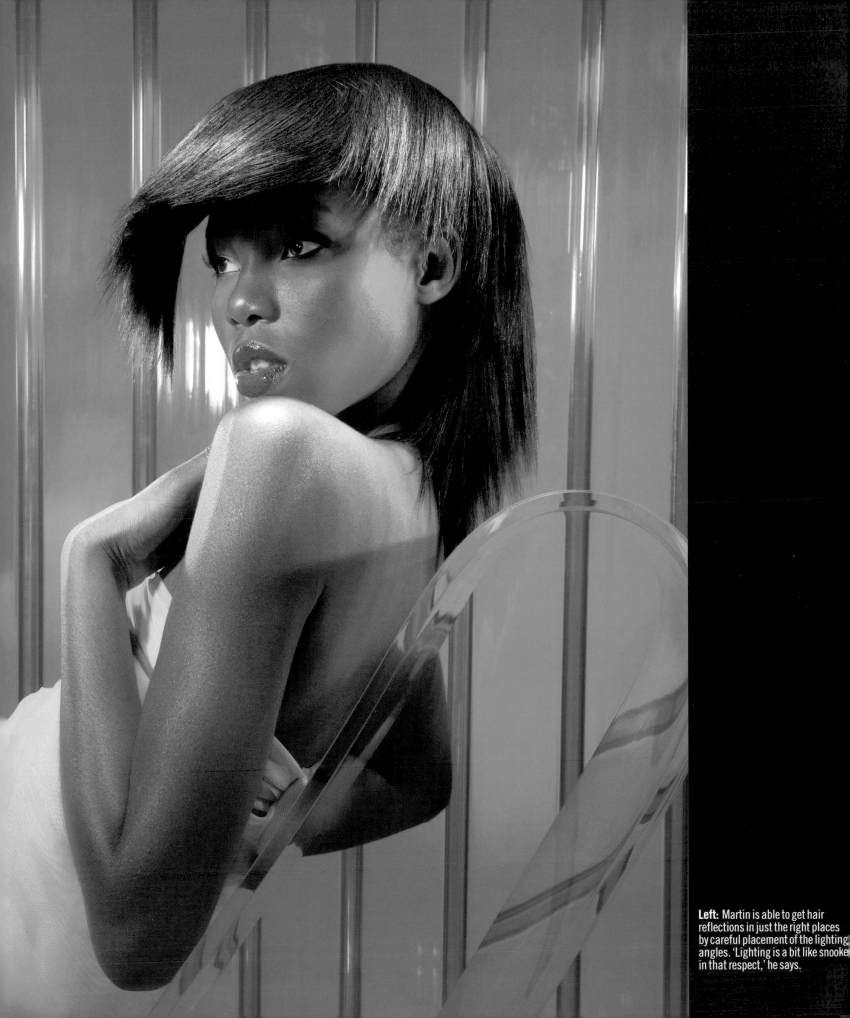

Left: Martin is able to get hair reflections in just the right places by careful placement of the lighting angles. 'Lighting is a bit like snooker in that respect,' he says.

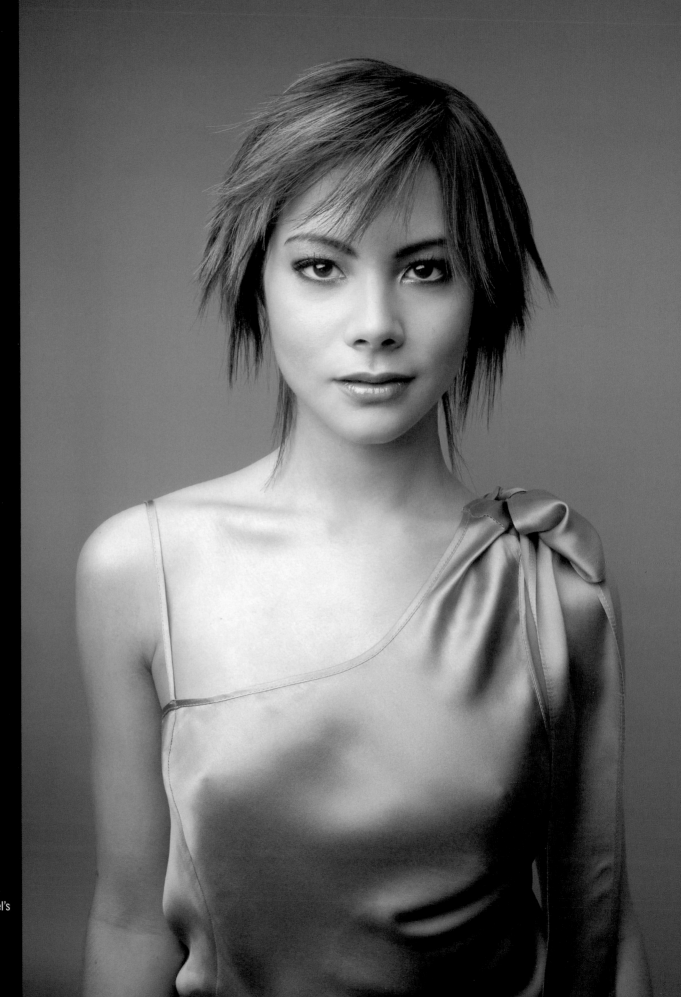

Right: 'Concentrate on the model's face and expression, and keep the lighting simple,' Martin advises novices.

JARGON BUSTER

Baffled by the technical terminology? Don't worry: this essential glossary is all you need to understand what it all means

Aperture
Variable opening that controls the amount of light passing through the lens, measured in f-stops. Wide apertures (such as f2.8) let in lots of light and give limited depth of field, whereas narrow apertures (such as f22) give greater depth of field, but let much less light through.

Analogue
Continuously variable.

Anti-aliasing
Smoothing the jaggy edges (aliasing) of selection or paint tools in digital imaging applications.

Backlight Control
An exposure compensation introduced when the subject of a picture is lit from behind (which can fool a camera's metering system, creating a silhouette effect).

Bit
A binary digit, basic digital quantity representing either 1 or 0. The smallest unit of computer information.

BMP
File format for bitmapped files used on Windows.

Buffer RAM
Fast memory chip in a digital camera. Buffer RAM is used for temporary storage while they are being written to the memory card.

Byte
Standard computer file size measurement: contains eight bits. Other common units include kilobyte (KB: 1024 bytes), megabyte (MB: 1024K) and gigabyte (GB: 1024 MB).

Calibration
The process of adjusting a device, for example: a scanner, so that it captures, displays or outputs colour in an accurate and consistent way. The same applies to monitors and printers.

CCD
A Charged Coupled Device converts light into electrical current. The digital camera equivalent of film.

CD-R
Recordable CD, useful archiving system. CD-Rs can be written once and not erased. There are also rewritable disks/drives (CD-RW), which are more expensive, but can be erased and reused.

CD ROM
A non-rewritable digital storage compact disc used to provide software.

Cloning
A feature of many image-editing software programmes where part of an image can be duplicated over another part. Used to seamlessly 'paint out' blemishes.

CMYK
(Cyan, Magenta, Yellow.) Colour printing model used by dye-sub and low-end inkjet printers. CMYK adds black (Key) and is used for most professional printing.

Colour Bit Depth
The number of bits used to represent each pixel in an image; the higher the bit depth, the more colours appear in the image: 1-bit colour provides a black-and-white image with no greys or colours; 24-bit colour gives 16.7 million colours ('photorealistic' colour).

Compact Flash
Type of removable memory card.

Compression
The 'squashing' of data to reduce file size for storage or to reduce transmission time. Compression can be 'lossy' (for example, JPEG) or 'lossless' (for example, TIFF LZW). There is greater reduction with lossy compression than with lossless schemes.

Contrast
Range of tones in an image between the highlights and the shadows.

CPU
(Central Processing Unit.) Carries out all the instructions and calculations needed for the computer to work.

Data
The generic name for any information used by a computer.

Default
The standard setting for a software tool or command, used if the settings are not changed by the user.

Depth of field
The area in front of and behind the focused point that is sharp. A shallow depth of field is used in portraits to provide a soft backdrop, while a greater depth of field is useful for landscapes to ensure everything is in focus. Shorter (wide-angle) lenses and smaller apertures increase depth of field.

Dialogue Box
A window in a computer application where the user can enter options or change settings.

Digital Zoom
Camera feature that involves enlarging the central part of an image to give a similar effect to a telephoto lens. Basically an in-camera crop, it usually results in a degradation of image quality.

Download
The transfer of files or other information from one piece of computer equipment to another (such as transferring pictures from camera to computer screen).

Dpi

(Dots per inch). A measurement of the resolution of a printer or video monitor (see also ppi).

DPOF

(Digital Print Order Format). A system which lets digital camera users select images and quantities for printing in-camera.

Driver

A software utility which tells a computer how to operate an external device (a printer).

Electronic Viewfinder (EVF)

Recent addition to high-end digital cameras. A tiny, colour LCD monitor placed inside a viewfinder which does not suffer from the glare problems of standard LCD monitors.

Exposure

The amount of light falling on to a digital camera's CCD. Exposure is determined by the combination of shutter speed (duration) and aperture (intensity).

Exposure Compensation

The ability to increase or decrease the exposure set automatically by the camera. Measured as + or - 'EV'.

F Stop/F Number

See Aperture.

Feathered Edge

Found in an image-editing software, this is a soft edge to a mask or selection. It allows you to make seamless montage effects.

File

Used in computers to describe a single document (for example, a digital photograph) stored on a disc.

File Format

The way information in a file is stored. Common file formats include JPEG, TIFF, FlashPix and GIF.

Filter

Photo-editing software function that alters the appearance of the image being worked on, such as filters for SLR camera lenses.

Fixed (non-zoom/prime) Lens

A lens with a fixed focal length.

Focal Length

Determines a lens's magnification and field of view.

Focus

Adjusting a lens so the subject is recorded as a sharp image on the CCD. There are three types of focus system used in digital cameras: fixed focus (focus-free), autofocus and manual focus.

Flash Memory

A type of fast memory chip that remembers all its data even when the power is turned off. See Removable Media.

Fringe

A (usually) unwanted border of extra pixels around a selection caused by lack of a hard edge. Can also describe an unwanted artefact in digital images, caused by lens defects or CCD problems.

GIF

A graphic file format developed for exchange of image files (only supports 256 colours).

Greyscale

What photographers would call a black-and-white image.

Guides and Grids

Function in the camera LCD monitor that helps you achieve straight compositions. Also found in software to do much the same thing.

Hard Disk (aka Hard Drive)

A fast and cheap form of digital storage (usually referring to a computer's internal disk).

Hue/Saturation

An RGB image can also be defined by Hue, Saturation and Brightness, where Hue is the colour and Saturation the 'strength'. Hue/Saturation controls are useful for altering colours without affecting overall brightness or contrast.

Image Manipulation

Once a digital image has been transferred to a computer, image-manipulation software allows the pixels to be altered. Colour corrections, sharpening, montage and distortions are all forms of manipulation.

Infinity

The farthest possible distance at which a lens can be focused.

Internal Storage

Some digital cameras have built-in memory (although it has been replaced by Removable Media on most models).

Interpolation

Increasing the number of pixels in an image or filling in missing colour information by averaging the values of neighbouring pixels. This 'resampling' cannot add new detail.

Jaggies

The jagged stepped effect often seen in images whose resolutions are so low that individual pixels are visible.

JPEG

A file format that stores digital images in a very space-efficient way. Used by virtually all digital cameras, JPEG uses a form of 'lossy' compression to reduce file sizes at the expense of fine image detail. The level of compression (and thus the loss of quality) is varied, and this forms the basis of digital camera quality settings.

Lasso

A selection tool used to draw a freehand selection around an area of an image.

LCD Monitor

A small colour screen found on many digital cameras that allows previewing/reviewing of images as they are taken.

Lossy

A type of compression that involves some loss of data, and thus some degradation of the image. JPEG is a common lossy system.

Lossless
File compression that involves no loss of data and therefore no loss in quality. LZW is a lossless compression system used in TIFF files. Lossless compression produces lower space savings than lossy.

Macro
Description used to indicate a lens that can focus closer than normal (usually nearer than about 30cm).

Manual Override
The ability to alter the automatic setting on a camera (exposure or focus).

Marquee
Outline of dots created by an image-editing programme to show an area selected for manipulation, masking or cropping. Most applications also call their basic selection tools (rectangles and squares) marquee tools.

Mask
In digital imaging this is an 8-bit overlay, which isolates areas of an image prior to processing. The mask is used to define an area of an image to which an effect will not be applied by 'masking out' those areas and thus protecting them from change. The areas outside the mask (in other words, those not protected) are called the selection.

Menu
Range of functions displayed on the LCD monitor of a camera.

Megapixel
One million pixels – a measure of camera resolution.

Mode Dial
This dial is found on the back of digital cameras and holds a selection of functions, including recording, playback and movie modes.

Moiré
Ugly patterns appearing in scans of printed materials.

Morphing
Effect where one image smoothly changes into another.

Network
Where two or more computers and peripherals are connected (by direct cable links or over phone lines using modems).

Noise
Unwanted electrical interference that degrades analogue electrical equipment. In digital cameras this most often occurs in very low lighting or shadow areas in the form of pixels of the wrong colour appearing at random in dark areas.

Optical Resolution
In scanners, the maximum resolution possible without resorting to interpolation. Also describes a digital camera's true CCD resolution.

Optical Viewfinder
Viewfinder system showing a similar view to that seen by the lens. Uses no power, but can cause parallax and focus errors.

Parallax Error
Mis-framed photographs (especially close-ups) caused by the different viewpoints of the lens and the optical viewfinder.

Peripheral
Any item that connects to a computer (for example: printer, scanner).

Photoshop Plug-In
A small piece of software that adds extra features or functions to Adobe Photoshop or other compatible applications. Common uses are to add new special effects (filters).

Photosite
A single photo-sensitive element in a CCD which translates to one pixel in the resultant image.

Pixel
(PICture ELement.) Smallest element of a digitised image. One of the tiny points of light that make up an image on a computer screen.

Power-Up Time
Measure of a digital camera's speed of operation; how long it takes from turning on until it is ready to take the first picture.

Ppi
Pixels/points per inch. A measure of the resolution of scanners, digital images and printers.

Quick Mask
A special Adobe Photoshop mode that allows a mask to be viewed as a colour overlay on top of the image. This mask can be edited using the standard paint and selection tools.

RAM
(Random Access Memory.) The computer memory where the CPU stores software and other data currently being used. A large amount of RAM usually offers faster manipulation of images.

Recovery Time
The time delay during which a new picture cannot be taken on a digital camera while the previous one is being saved.

Refresh Rate
In digital camera terms, how many times per second the display on the LCD preview monitor is updated. A refresh rate of under about 15 fps (frames per second) will look 'jerky'.

Removable Media
Small memory chips which store the captured images. The two main formats are Compact Flash and Smart Media – Compact Flash cards offer higher capacities, but Smart Media cards are smaller. Other types of removable media used include Multimedia/ Secure Digital (MM/SD) and Sony's Memory Stick.

Resample
To change the number of pixels in an image. Upsampling uses interpolation to increase the number of pixels; downsampling throws away pixels.

Resize
Changing the resolution or physical size of an image without changing the number of pixels, for example, a 2x2in image at 300 dpi becomes a 4x4in image at 150 dpi. Often confused with resampling.

Resolution
Measure of the amount of information in an image expressed in terms of the number of pixels per unit length (in other words, pixels per millimetre or pixels per inch). Camera resolution is usually defined as the actual number of pixels in an image ie 640x480 (see dpi and ppi).

RGB
Red, Green and Blue. TV sets, monitors and digital cameras use a mix of RGB to represent all the colours in an image.

ROM
(Read-Only Memory). ROM is fixed memory that can be read, but not written. Inside a computer or peripheral it contains the basic code that allows the CPU to work.

Rubber Stamp Tool
See Cloning.

Saturation
The amount of grey in a colour. The more grey there is, the lower the saturation.

Selection
In image-editing, an area of an image isolated before an effect is applied. Selections are the areas left uncovered by a mask.

Serial Transfer
Connecting a digital camera to a computer via the serial ports in order to download images.

Shutter Lag or Delay
The delay between pressing the shutter and a picture being taken.

Shutter Release
Button on a camera that, when pressed, activates the shutter, taking the photo. When pressed halfway, it refocuses the subject.

Shutter Speed
The time for which the CCD or film is exposed during an exposure. High shutter speeds (hundredths or thousandths of a second) prevent camera shake and can freeze motion in photos. Slow (long) shutter speeds allow exposures in low light.

Subject Modes/Scene Modes
Special fully automatic exposure modes which use the optimum settings for specific subjects, for example: sport.

Telephoto Lens
Makes subjects seem closer than they are.

Thumbnail
A small, low-resolution version of a larger image file used for quick identification or showing many images on a screen.

TIFF
Standard file format for high-resolution bitmapped graphics.

TWAIN
Protocol for exchanging information between applications and devices such as digital cameras.

Unsharp Masking
A software feature that selectively sharpens a digital image in areas of high contrast while having little effect on areas of solid colour. Increases the apparent detail and sharpness.

USB
(Universal Serial Bus.) New type of connector for attaching peripherals such as keyboards, scanners, printers. Offers faster data transfer and easier (plug 'n' play) connections than PC parallel port or Mac serial ports. Works with Windows 98/Mac OS 8.5 or above.

Video Output
Ability to display digital camera images on a standard TV or record images on videotape.

Viewfinder
The eyepiece on the back of the camera through which you view your subject. Can be a rangefinder type (small separate lens found above the main lens) or SLR type (through the main lens) or even an electronic viewfinder (small monitor).

VRAM
(Video Random Access Memory.) The more megabytes of memory you have, the quicker you can perform operations on your PC.

White Balance
In digital camera terms, an adjustment to ensure colours are captured accurately (without 'colour cast'), whatever the lighting used. Can be set automatically using presets for different lighting types or measured manually, depending on the camera.

Wide-angle Lens
A lens of short focal length giving a wide-angle of view, allowing more of a scene to be fitted into a photo.

Zoom Lens
Variable focal length lens that allows the user to adjust his field of view ('zoom in or out') without moving. Not to be confused with a digital zoom.

Index

Picture Credits

Many thanks to all those who have contributed to the making of this book.

All photos supplied by Nigel Atherton, Steve Crabb, www.istockphoto.com and www.ablestock.com except:

Page 38–41 All images by Annabel Williams

Page 64 Florian Reimann by Matze Schmidbauer. www.matzeschmidbauer.de

Page 80–83 All images by Peter Searle

Page 102–5 All images by John Freeman

Page 122–5 All images copyright of Jamie Marland. jamie@jmimages.co.uk www.jmimages.co.uk Tel: 07966 086 022

Page 126–9 All images by Roger Bamber

Page 130 Original photo of Lauren-Eden by Carolyn Davis

Page 164–7 All images by Martin Evening. www.martinevening.com

Additional product photography by Alan McFaden.